Wonderful World *of*
WATERCOLOR

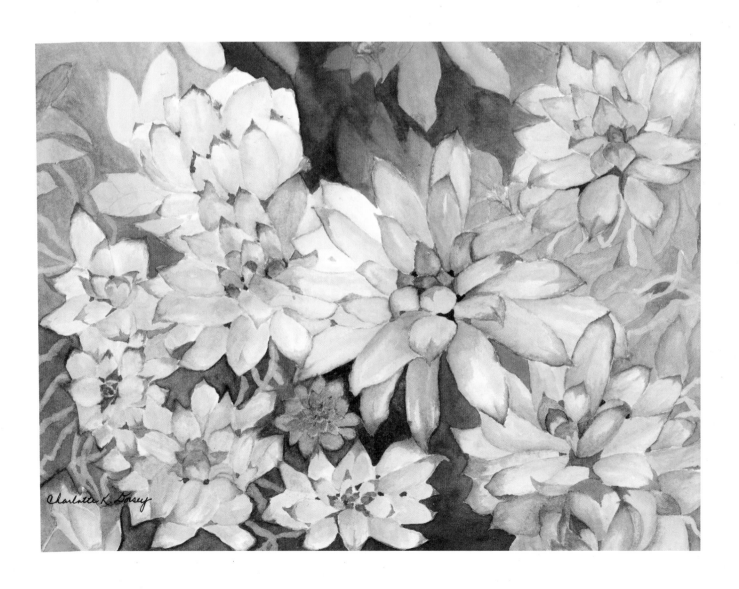

Mary Baumgartner

Wonderful World *of* WATERCOLOR

Learning and Loving Transparent Watercolor

WATSON-GUPTILL PUBLICATIONS/
NEW YORK

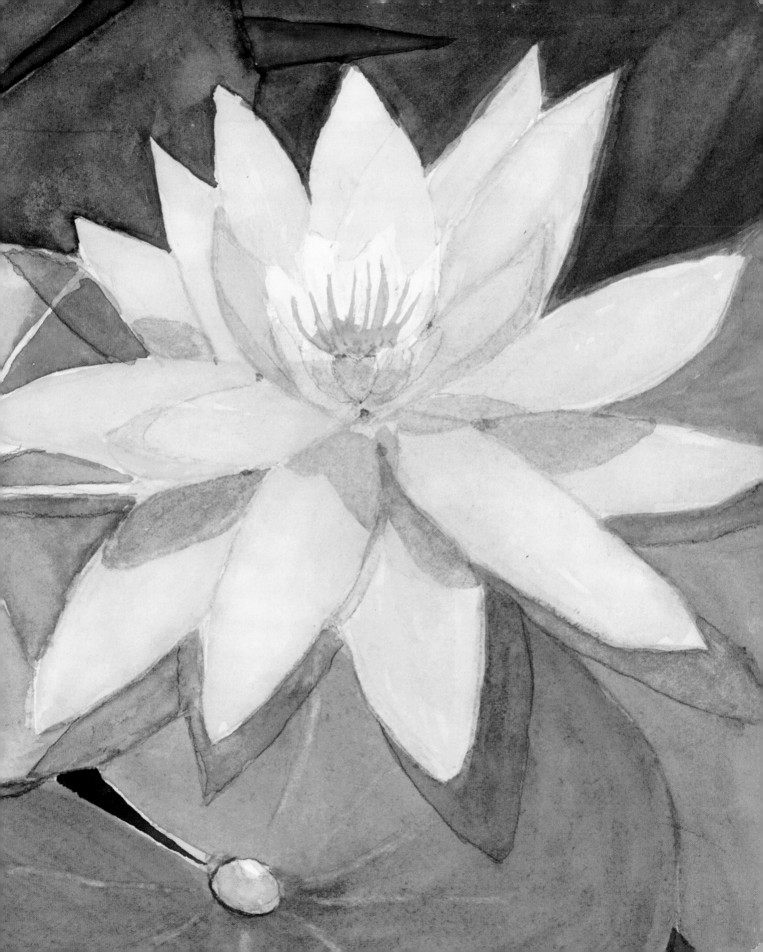

Page 1:
HENS AND CHICKS
Charlotte Dorsey

Pages 2–3:
PRINCESS
Ginger Baxter

Pages 6–7:
FRENCH TULIPS
Joan Clark

For my husband, Stan—
Brilliant, loving, supportive,
and my best friend.

This book would not have been possible without the help of Jim Wells, photographer and computer expert extraordinaire. His help with all the reproductions of paintings and other illustrations has shown transparent watercolor as truly transparent, and his knowledge of book production has saved me countless hours.

Senior Editor: Candace Raney
Editor: James Waller
Designer: Bob Fillie

First published in 2008 by Watson-Guptill Publications,
Nielsen Business Media,
a division of The Nielsen Company
770 Broadway, New York, NY 10003
www.watsonguptill.com

ISBN-10: 0-8230-9910-5
ISBN-13: 978-0-8230-9910-8

Library of Congress Control Number: 2008925424

Watson-Guptill Publications books are available at special discounts when purchased in bulk for premiums and sales promotions, as well as for fund-raising or educational use. Special editions or book excerpts can be created to specification. For details, please contact the Special Sales Director at the address above.

Printed in Malaysia

First printing, 2008

1 2 3 4 5 6 7 8 9/11 10 09 08

FROM THE AUTHOR

The greatest joy in my life has been my experience teaching watercolor to beginners, helping intermediate students improve, and polishing advanced students' work. I wrote this book because I want to pass on to others the joy and intricacy of watercolor, along with the pleasure of this complex subject.

Many years ago, before I decided to teach, I, too, was a struggling artist, going to workshops across the country, taking endless classes, and crying over my lack of success. During all that time, however, I kept listening for words of encouragement and advice that would help me grow.

Unfortunately, many of the workshops I attended just gave me new reasons to feel like a failure. I'll never forget one teacher standing in front of the class and saying, "If you paint every day, five days a week, for five years, you may turn out one or two paintings that are good enough to show." This was the most discouraging sentence I ever heard during all the years I studied art. Right then and there, I decided that one day I would teach.

I also once overheard a painter/teacher saying to another painter, "Well, I just have to go back to teaching because I can't make enough money exhibiting my work in a gallery." For me, teaching isn't something to fall back on. It's the greatest joy I have. I love seeing the wonder a student feels when a painting is finished. The way my students communicate with me through their words and facial expressions is enough to keep me going for a lifetime.

One student of mine, whenever she'd walk into class, would say, "Another day in paradise." I asked her why. She said it was because I didn't just give her questions, but I gave her the answers, too. Why can't all art classes be that way? Is there some kind of rule that you have to suffer for a certain number of hours or months or years before your work is good enough to be exhibited —or before you can feel satisfaction in what you have produced?

There is a famous story about a successful artist who was discovered crying over a painting he'd just completed. Someone asked him if he was crying because he felt it was so bad. His reply was, "No, I'm crying because it is so good." I'd like to think that completing a successful painting could bring tears of joy. And, you know, the teachers of successful artists might cry with joy, as well, since they give their students self-esteem and show them that the works that they imagine in their heads really can flow from their hands. That's what I call success!

MARY BAUMGARTNER

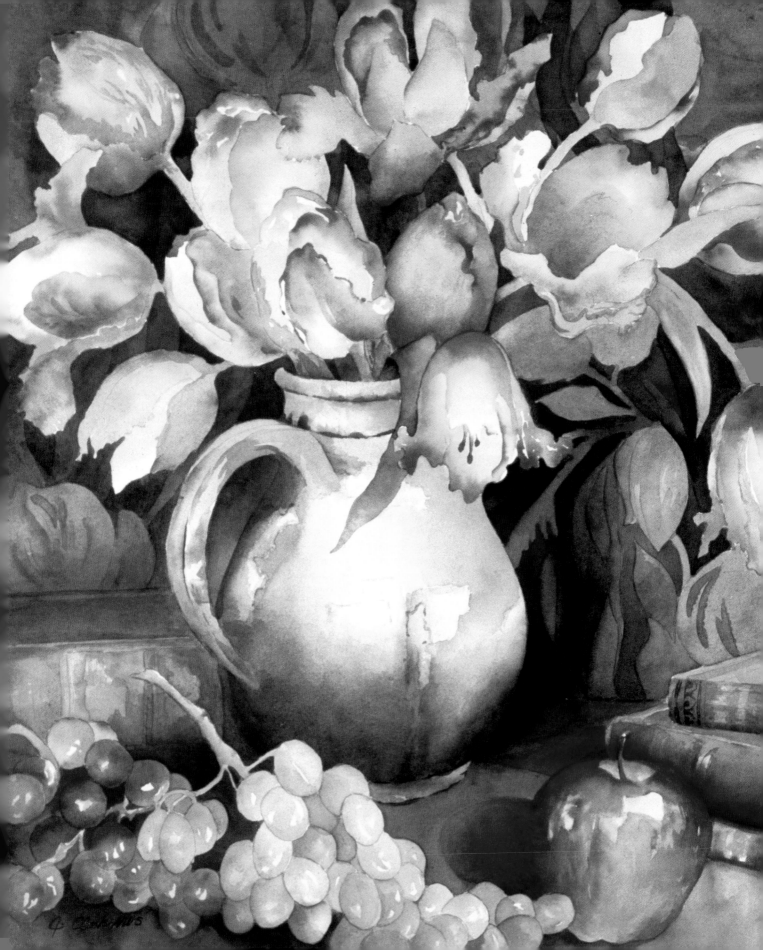

CONTENTS

COLOR—THE PLACE TO LOOK FIRST 8
Choosing Colors 9
Setting Up the Palette 13
Mixing Colors—A Few Basics 14
Understanding Pigments 16
Understanding Color Temperature 18
Painting Color Charts 22

YOUR SUPPLIES AND YOUR STUDIO 34
Choosing Watercolor Paper 35
Stretching Paper 36
Selecting Brushes 37
Using the Brushes 39
Controlling the Edges and "Veiling" the Paint 40
Using Masking Fluid 41
Optional Supplies and Equipment 44
Setting Up Your Studio 45
Painting on Location—Supplies 48

COMPOSITION—YOUR BUILDING BLOCKS 50
Making Thumbnail Sketches 51
Using Shapes 54
Understanding Perspective 57
Making a Composition Work 61

ESSENTIALS FOR SUCCESS 64
Success through Contrasting Values 65
Success through "Negative" Painting 67
Success through Shapes 68
Success through Use of White Space 70
Success through Use of Transparent and Opaque Colors 72
Success through Glazing for Depth and Value 76
Success through Glazing for Dimension and Perspective 78
Success through Lifting Paint 82

DRAWING SKILLS 84
Drawing Shapes 85
Selecting the Right Thumbnail 86
Creating the "Working" Drawing 88
Learning about Light 89
Using Reference Images 94
Taking Drawing Workshops 95

THE HARD STUFF—MADE EASY 96
Painting Silver 99
Painting Pewter 100
Painting Brass 101
Painting Crystal 103
Painting Water Droplets 106
Painting Baskets 108
Painting Rocks 110
Painting Clouds 112
Painting Sunsets 113
Creating Volume in Foliage 114
How to Paint Your Cat 116
Making Corrections 119

PAINTING A STORY 120
Speaking to Your Viewer 121
Communicating the Essence 122
Using Shadows 124
Making a Statement 126
Enhancing Your Paintings 128

YOUR CAREER AS AN ARTIST 132
Entering Competitions 133
Selling through Galleries 135
Doing Commissioned Work 136
Naming and Signing Your Work 137
Making Promotional Materials 137
Certifying Authenticity 138

GLOSSARY 141

CONTRIBUTING ARTISTS 142

SUGGESTED READING
AND RESOURCES 143

INDEX 144

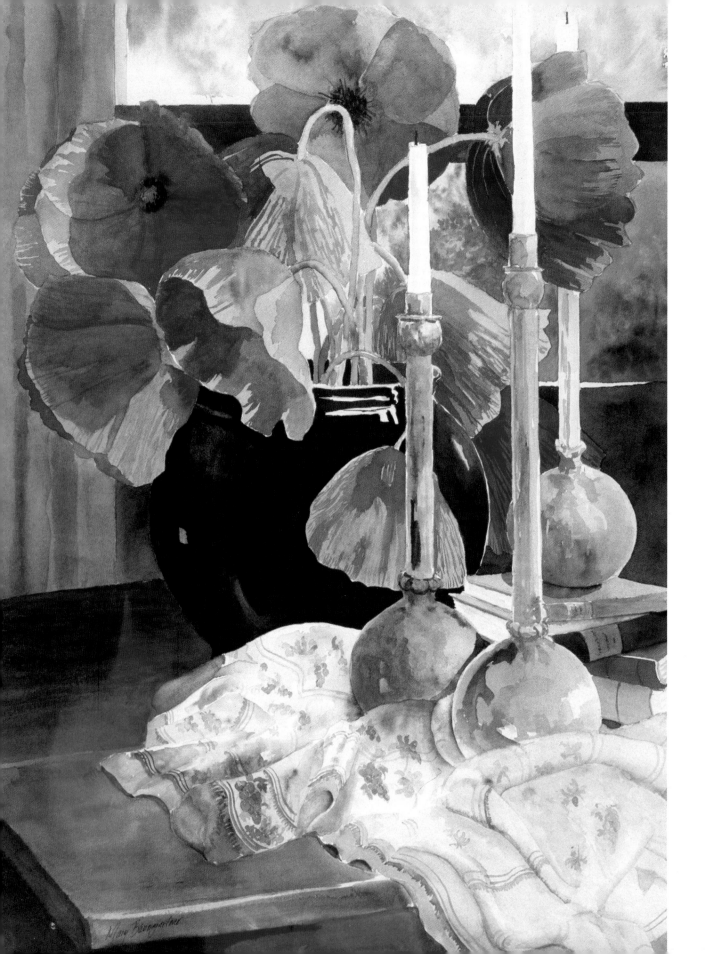

COLOR

The Place to Look First

Strolling through galleries, art exhibits, and sidewalk art shows, you sometimes see a "painting to die for"—but not very often. Since we have only a limited number of ways to make an image on a flat piece of paper look three-dimensional—color, value, texture, and perspective—a painting that catches the eye will have to use all these elements effectively. And the most important element is color—*high-contrast* color.

Studying the use of color in transparent watercolor begins with the basic palette. But what, first of all, is *transparent* watercolor? It is color that, when applied over other color, allows the color beneath to show through—and that allows the white surface of the paper itself to illuminate the colors applied to it. Transparent watercolor creates an effect that glows—much like light shining through stained glass. In a well-executed watercolor painting, it looks as if light is shining through the painting.

All the colors in the watercolor palette do not, however, have the same degree of transparency. Some are more opaque than others. But every watercolor artist also needs these comparatively opaque colors—sometimes called "covering" colors.

Choosing Colors

The Recommended Palette on pages 10 and 11 lists the colors that I recommend that beginning watercolorists buy and explains a bit about each. All these colors are relatively "pure," meaning that they're not composed of too many other colors. Because of their purity, it is difficult to make "mud" from these colors. (Combining colors with their complements can create ugly, muddy browns—a topic to which we'll return.) I also recommend these particular paints because of their durability, effectiveness, and wide availability. When buying watercolor paints, choose tube colors (in the larger, 14 ml or 15 ml tubes) rather than solid "cake," or "pan," colors, and make sure you buy only "artists' grade" paints. (Some manufacturers also produce cheaper, "student grade" watercolors, which are of inferior quality and contain less pigment, resulting in less vibrant colors. For example, Winsor & Newton makes student-grade colors marketed under the company's Cotman brand; avoid these.)

RECOMMENDED PALETTE

Some of the colors in the list below are described as *permanent,* which means that they are very stable and not affected by light or elements in the atmosphere. Colors described as *stainers* tend to dye the colors they cover and can be difficult to scrub out if applied in the wrong place or in the wrong density. Except where noted, all the colors below are made by Winsor & Newton. All can be ordered from most art supplies catalogs and online art supplies retailers, and all are available at most reputable arts supplies stores throughout the United States.

Alizarin Crimson A beautiful, cool red-blue color, permanent, and a stainer, Alizarin Crimson mixes well with the blues, and is a stronger red than Rose Madder. When it is mixed with Winsor Green, a deep, dark green-black is achieved. Using this color alone or with other transparent colors produces nice transparent passages in your flowers or skies.

Aureolin This cool yellow is permanent and very transparent. Use Aureolin as a base wash to give a deep cool color to your green passages. Make beautiful browns and greens with it. Wash it over other colors to liven them up. Use in three-stage washes as the first wash, followed by Rose Madder and Cobalt Blue.

Brown Madder This transparent reddish-gold color is like magic in a painting. It is produced from the same ingredients used in Alizarin Crimson but with iron oxide added, making it a warm color. Use it alone or with French Ultramarine or Winsor Blue. Or add yellow and go in a different direction. Brown Madder is a stainer and can be used to glaze over a dull color to bring it to life.

Burnt Sienna This is a tertiary color, meaning it contains the three primaries. Because of this, Burnt Sienna can become muddy quickly when other primary colors are added to it. Also, it doesn't have carrying power: You can't really distinguish it in a painting viewed from more than 10 feet away. It does, however, produce a wonderful base color for tree trunks, and when mixed with French Ultramarine it makes the color of old wood and fence posts. (When using this combination for wood, it is best to have both colors on the brush with hardly any mixing.) It is also a staining color.

Cadmium Red This warm red has a slightly yellow cast and is deadly when mixed with most of the blues. It also contains quite a bit of pigment and is therefore not as transparent as some of the other reds. When Cadmium Red is mixed with Raw Sienna and either Viridian or Winsor Blue, a wonderful brown results. You can use Cadmium Red alone for any red passages that don't require total transparency. Do note that it is hard to remove.

Cerulean Blue For those distant hills, Cerulean Blue mixed with Rose Madder produces the most perfect color. It is grainy and cool and makes a good shadow color when mixed with Rose Madder or Alizarin Crimson. Mix it with French Ultramarine and get exciting skies. Use it with Yellow Ochre and thin the mixture with water, and you've got the haze for an overcast day. (The same mixture also makes a lovely silvery color.) It is a permanent color, and it is hard to remove if you make an error or want to lift color from a given area.

Cobalt Blue This is our only neutral-temperature color, neither warm nor cool. It is a bit grainy when thinned with water, but it makes a variety of beautiful spring greens when mixed with Aureolin, New Gamboge, or Winsor Yellow. Use Cobalt Blue with Winsor Red to produce mauve. It lifts easily and is considered permanent by Winsor & Newton. Use it in your shadows or as the final color in a three-part glaze, over layers of Aureolin and Rose Madder.

French Ultramarine This is a lovely, cool, fairly transparent blue that can make an electric sky when used as a continuous wash. French Ultramarine is exactly the color of a clear blue sky directly overhead, so use it if you want to create the illusion of a round world. Use it with Alizarin Crimson to make deep purples. Add it to yellow to make interesting greens. And use it with Burnt Sienna to make wonderful cave openings and old, battered wood. It is a stainer, though, so be careful.

Indian Red This warm red color, made from iron, has heavy pigment, which makes it a covering color. Mixed with French Ultramarine, it can produce a beautiful dark blue. Mixed with Cerulean Blue and watered down a bit, it makes the exact color of pewter. You will find it used several times in the dark charts at the end of this chapter. It is very permanent and is also a stainer.

Light Red This warm red is made from natural and synthetic oxides of iron. Light Red can be mixed with Cobalt Blue to produce a variety of sky colors—or with French Ultramarine to get darker shades. It is not transparent but can be used alone, thinned with water, to make natural wood colors. It also is a high stainer.

New Gamboge This warm, buttery yellow makes exciting greens when mixed with Winsor Blue. Add a little water and get deep, dark greens. By itself, New Gamboge is gorgeous in sunflowers, and dropping in a bit of Brown Madder can create a sensational passage. It is considered a permanent color by Winsor & Newton and is transparent when water is added to it.

Opera (made by Holbein) This hot pink is the warmest color in our palette. Use it sparingly, and always mix it with other colors (or your painting will "reek" of Opera). When painting flowers, use it to add a spot of brilliance. Water it down and add it to Rose Madder to liven up that color. If a flower painting needs variety, use it as a glaze over some of the blossoms. It is a stainer.

Quinacridone Gold One of the best yellows on the market, Quinacridone Gold is a powerful color and needs to be mixed with at least one other color to keep it from overtaking a painted passage. Used with Winsor Blue it can produce the most exciting greens in our palette. Watered down and used sparingly, it produces a nice effect if used as a glaze over passages that need a bit of lift.

Raw Sienna A warm earth color, Raw Sienna is the same hue as Yellow Ochre but is highly transparent. When mixed with Cadmium Red and Winsor Green, it makes beautiful cool browns. When mixed with Viridian, it produces silvery, soft greens; mixed with Winsor Blue, it results in passages of subtle, pastel blue-green. It isn't hard to lift and is considered permanent.

Rose Madder Genuine Made from the rose color extracted from the madder root, Rose Madder is highly transparent. It lifts out fairly easily and has permanency. This color makes a wonderful, protective glaze when laid on top of Aureolin, allowing blues to be added without producing greens. It is considered a cool red.

Viridian (made by Grumbacher) By itself, Viridian is not a natural-looking color, but it is highly transparent and mixes well with yellows to make interesting greens. If used by itself as the first wash when painting a deep green velvet dress, it can then be painted over with Winsor Green to make stunning-looking folds. Add it to Cadmium Red and Raw Sienna to get wonderful browns. Use it as a wash over weak areas; it will enhance them. Do make sure to buy only the Viridian made by Grumbacher, as the Winsor & Newton version of this color has too much binder and creates lumps on your palette.

Winsor Blue (Red Shade) This staining blue is transparent, cool, and great for glazing. Paint it over a color that has lost its luster and watch it come back to life. Use it with New Gamboge or Quinacridone Gold to produce the most exciting greens you've ever seen. You can go from a deep, dark forest green to many other shades of green with either of these combinations. It has great permanency and also makes a wonderful skin shade for darker-skinned people when mixed with Cadmium Red and Raw Sienna.

Winsor Green (Blue Shade) A bright, electric, cold green stainer that has wonderful power in washes because of its permanency, Winsor Green can enliven any part of your painting. When mixed with Cadmium Red and Raw Sienna, it produces terrific browns. Mixed with some of the yellows, it produces electric greens. Mix it with Alizarin Crimson and Winsor Blue to produce deep, dark, but colorful blacks. Use it with Viridian to produce a beautiful green velvet shade. It is difficult to remove and is considered permanent by Winsor & Newton.

Winsor Red Like the Winsor colors, this is a high stainer. It is also very transparent and can give wonderful impact when used as a final wash over colors that seem to have become dull. It is especially useful when you need to enhance or distinguish one section of a passage containing several very similar colors. Mixed with Cobalt Blue, it produces a beautiful mauve. It has a slightly yellow cast and is warm. It is considered a permanent color by Winsor & Newton.

Winsor Violet This color is a "must" for our palette. Use it as a wash over a green passage that has become too dominant; because it is the complement of green, it will dull down a too-vivid color. Because it is a high stainer, it produces vibrant color when mixed with some of the reds. It can give a new dimension when used as a wash over already-painted backgrounds and skies. Try it with Winsor Blue for a cold, wintry sky. It is considered permanent by Winsor & Newton and is also a stainer so it is hard to remove.

Winsor Yellow This is a highly transparent, cool, staining color that is used mostly as a wash. It is permanent, and it mixes well with blues to make spring greens. Liven up a leaf that seems too dull by adding a wash of Winsor Yellow.

Yellow Ochre Yellow Ochre is the same hue as Raw Sienna but is a covering, or hiding, color. Mix it with Cadmium Red and Cobalt Blue and lots of water to create interesting off-whites. It is warm and considered absolutely permanent. It is hard to remove.

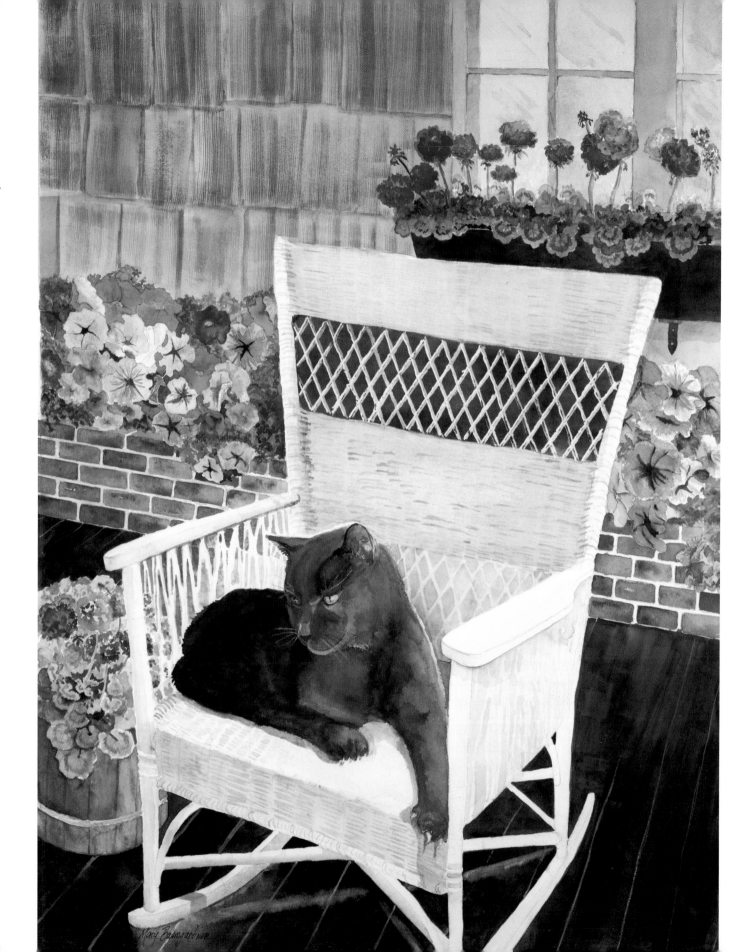

Setting Up the Palette

Once you've bought your colors, you must properly arrange them in your palette. Like many watercolorists, I use a John Pike palette—available through many catalogs, online retailers, and art supplies stores—but other palettes are acceptable if they are large enough to accommodate all the colors and have airtight lids.

When adding colors to your palette, open each tube and squeeze it from the end, as you would a tube of toothpaste, letting a bead of paint drop into the back side of the paint well.

The diagram below shows my suggested arrangement of colors in a John Pike palette. The reason for this manner of arranging the colors is fairly simple: The yellows are placed on the left side of the palette, across from the blues, which allows you to cross back and forth, from side to side, to make various shades of green. The reds, aligned across the top of the palette, can be dragged toward the yellows on the left to create oranges; if they're dragged toward the blues on the right, various shades of purple result.

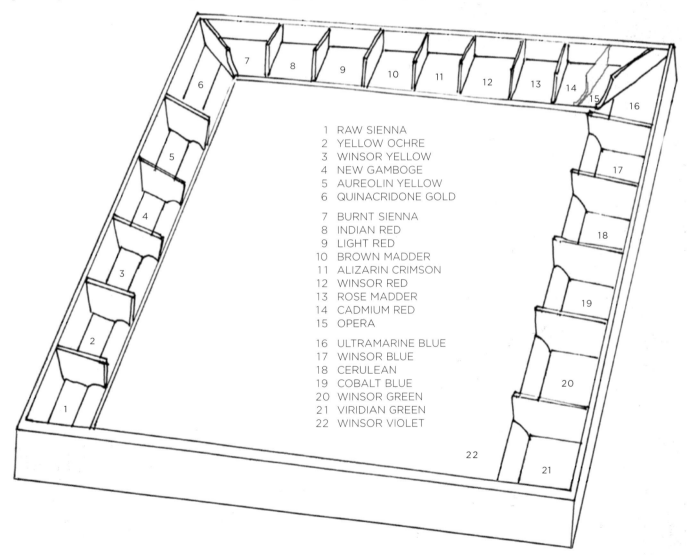

1	RAW SIENNA
2	YELLOW OCHRE
3	WINSOR YELLOW
4	NEW GAMBOGE
5	AUREOLIN YELLOW
6	QUINACRIDONE GOLD
7	BURNT SIENNA
8	INDIAN RED
9	LIGHT RED
10	BROWN MADDER
11	ALIZARIN CRIMSON
12	WINSOR RED
13	ROSE MADDER
14	CADMIUM RED
15	OPERA
16	ULTRAMARINE BLUE
17	WINSOR BLUE
18	CERULEAN
19	COBALT BLUE
20	WINSOR GREEN
21	VIRIDIAN GREEN
22	WINSOR VIOLET

SIMPLE COLOR WHEEL

NO. 1	NO. 2

NO. 3	NO. 4

NO. 5	NO. 6

CREATING PURPLES AND SHADOWS OVER YELLOW

Swatch number 1 is French Ultramarine + Cadmium Red; number 2 is Cadmium Red + French Ultramarine; number 3 is Winsor Red + French Ultramarine; and number 4 is Alizarin Crimson + French Ultramarine. For swatch number 5, New Gamboge was laid down first and allowed to dry and then Winsor Violet was added to the lower half to create a shadow color. In number 6, Aureolin was laid down first; after it dried, Winsor Violet was added as a shadow color.

THE PEACE OF WINTER
Kay Alexander

14

Mixing Colors—A Few Basics

Let's begin with a very simple color wheel, top left. Every beginning painter must know the three primaries (red, blue, and yellow) as well as the secondary colors (purple, green, and orange) that result when two primaries are mixed together. Just as important, though, is the knowledge that any color mixed with its complement—that is, the color that's opposite it on the color wheel—will produce gray. That's especially important because many of the colors in our palette aren't absolutely "pure"; they contain small amounts of other colors. And the fact that colors are often made up of other colors becomes very important when mixing.

Let's look, for example, at purple. If you take a quick glance at the Purple Chart on page 29, you'll notice the many formulas for creating different purples. If you were to analyze the constituent colors in all the reds and blues on your palette, you would find that some reds contain blue while others contain yellow; similarly, some blues contain red while others contain yellow. If you mix a red containing blue with a blue containing red, it produces a shade of purple. If, however, you mix a red containing yellow with a blue, you end up with an unpleasant color that looks like mud. Why? Because purple is the complement of yellow, and mixing complements ultimately makes mud. (Mixing a blue that has red in it with yellow to make green creates the same muddy result.)

Now, take a moment to study the series of rectangular swatches of color at left. The first four rectangles show the shades of purple that result when different blues and reds are mixed together. As you can see, only swatch number 4—a mixture of Alizarin Crimson and French Ultramarine—is a glowing, vibrant purple color. From swatches 5 and 6, you can also see how difficult it is to find a color that makes a good shadow over yellow.

All the paintings reproduced in this book were created using my recommended palette. Used correctly, these colors—pure, subtle, and durable—will electrify the viewer. Just look, for example, at the painting entitled *The Peace of Winter,* by Kay Alexander. Kay would never have been able to make this painting work without a comprehensive knowledge of how to create purples and how to keep the colors from becoming muddy.

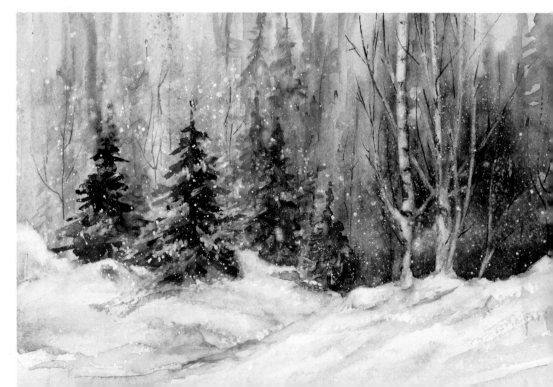

The series of color swatches at right shows what happens when you try to create shadows over various orange or yellow-orange shades—which is what you must do, if, for example, you're painting pumpkins or other fruit of a similar color. To create the orange shade, you must first lay down a wash of yellow and then "seal" it with some kind of red, but as the samples on the right show, this can create a muddy color if you use the wrong combination.

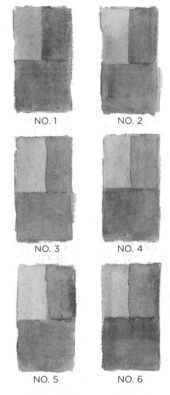

NO. 1 NO. 2

NO. 3 NO. 4

NO. 5 NO. 6

CREATING SHADOWS OVER ORANGE

Here, the three swatches on the left were originally covered with a wash of Aureolin, the three on the right with a wash of New Gamboge. Then, after they were allowed to dry, number 1 was washed with Rose Madder, number 2 with Cadmium Red, number 3 with Opera, number 4 with Cadmium Red, number 5 with Winsor Red, and number 6 with Opera. Again, the washes were allowed to dry, and the bottom half of each sample was covered with a wash of Winsor Violet. Finally, the top right half of each sample was covered with a wash of Cerulean Blue combined with Alizarin Crimson.

PAINTING A TOMATO THREE WAYS

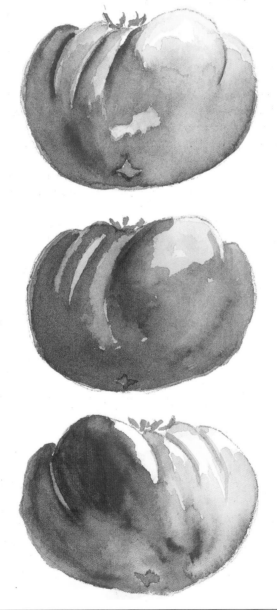

How many ways can a tomato be painted? Well, the number is probably infinite, but here are three exercises for you to try—and to see for yourself what transparent watercolor can do. Getting the right mixes of colors—and knowing how much water to use—will, of course, come with experience.

The tomato at the top was begun with a wash of Aureolin. When the wash had dried, the red was added—specifically, glazes of Winsor Red. (A *glaze* is a thin wash laid down over a layer of dried paint.)

The tomato in the middle began with a wash of Winsor Red; the deeper colors are glazes of Alizarin Crimson.

Finally, the tomato at the bottom was created with a wash of Aureolin, which, after it had dried, was glazed with Cadmium Red. Here, the highlights were left blank (just the white of the paper shows), and Winsor Green was used for the crevices and shadowed areas. (Green, remember, is the complement of red.)

Understanding Pigments

Nature has produced color since the beginning of time—just look around at the sky, the ocean, and the changing colors of foliage as one season passes into another. But color was also produced *from* nature by early human beings, using pigments they found *in* nature. Some of the pigments used by paint manufacturers today still originate in nature: For example, for its Rose Madder Genuine color, Winsor & Newton uses pigment derived from the madder plant, which was used to dye fabrics in ancient Egypt.

Rose Madder pigment is extracted from the root of the madder plant, which once grew wild throughout Europe. The root produces the color when the plant is between eighteen and twenty-eight months old, and it takes twelve weeks to process the plant material into the pure pigment. No other color is added during processing. This results in a pure, transparent color that is excellent for glazing, or layering, over other colors, especially yellows. Rose Madder also *seals* yellows extremely well—meaning that other transparent color can be added without turning the yellows green. If you lay down a wash of Aureolin, let it dry, and then apply a thin layer of Rose Madder on top, you can then add blues with the assurance that the colors will remain clear.

TOMATO ART
Mary Baumgartner

French Ultramarine—a highly transparent blue of remarkable luminosity—comes from a semi-precious stone called lapis lazuli, which is mined in only a few regions of the world. The breath-taking blue in the wall art inside the pyramids has held up for over 4,500 years. That's because the color came from the earth, was ground by hand, and was applied directly to the wall. It has been protected for many years from the elements—air, heat, and water—but even now, when it is subjected to all these elements because of tourism, it continues to retain its strength and beauty.

Black isn't listed as one of the colors recommended for your palette, but you might be interested to know that at one time it was made from burned bone. I don't recommend that you buy premixed black watercolor colors, because very little light can penetrate them—meaning that you can't see any other colors in them, and this tends to make them look flat and dull. Making blacks by combining colors produces exciting darks that can be wonderful complements to other colors.

Watercolor colors will always be made with organic materials from plants and the earth—with a little help from chemistry! For our purposes, we don't really need to know where each color originates, but we do need to know which colors are the purest and longest lasting, which are transparent, and which provide the most covering power.

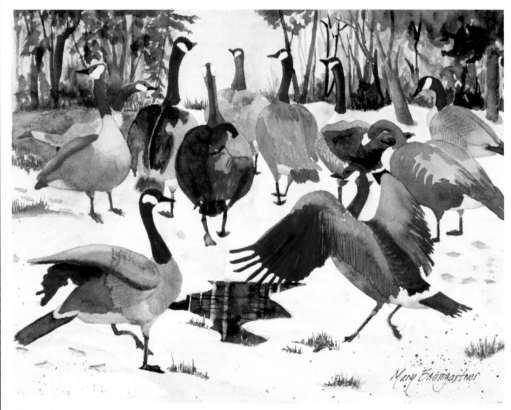

GOING HOME
Mary Baumgartner

THE DIFFERENCE COLOR CAN MAKE

Beginning watercolorists often don't realize that a painting that might otherwise be drab and uninteresting can be made effective and exciting through the use of unexpected colors. My painting *Going Home* would have been boring if the Canada geese had been rendered in ordinary, dull shades of brown and gray, and so I painted the birds' plumage in a surprising array of purples, greens, oranges, blues, and yellows. But, as you look at this painting, also note that some of my color choices remain more or less constant: The similar browns, reds, and reddish browns of the geese's necks help tie the painting together.

Understanding Color Temperature

Remembering these four attributes of color will help make you a better painter:

• Transparency versus opacity

• Complements (colors that are across from one another on the color wheel)

• Mixing (using two primaries to create a third color)

• Color temperature

Of these attributes, color *temperature,* is the most difficult to understand. The physics of color temperature, however, lie outside the purposes of this book—and it is not necessary for painters to study this topic. What we need to know about color temperature boils down to three things: (1) Colors range in temperature from "hot" to "warm" to "neutral" to "cool." Reds, yellows, and (especially) oranges are the warmest colors; greens and blues are cooler. (2) The temperature of a color affects its emotional impact on the viewer: A hot red will create a much more intense impact than a cool blue. And (3) warm colors appear to advance—to come closer to the viewer —while cool colors appear to recede.

The Temperature and Transparency Table opposite gives you details about the transparency, temperature, and opacity of many of the colors I've recommended for your palette. Of course, the table provides only basic direction; to really understand the colors' effects, you'll have to try painting with them yourself. To a certain extent, you'll control what the viewer sees—and how he or she interprets your work. If you paint a cold, wet-weather scene, using cool, transparent colors in the reflections of rain on the pavement or ridges in the snow, the viewer might even feel a chill. If you want the viewer to "feel the beat" in a nightclub where dancers are dancing amid vivid, swirling colors, you'll use hot, transparent colors and maybe a mix of cools and hots—such as Winsor Blue and Indian Red—in the background. (Effective use of paint often requires using a cool and a warm together.)

One of the reasons I selected the colors in the recommended palette on pages 10 and 11 is that these colors can be easily controlled when painting. For example, both Rose Madder (a relatively cool red) and Cobalt Blue (a more or less neutral color, temperature-wise) have properties that allow them to stay put and not bleed into other colors; they are, however, too weak to stand alone in most paintings and are therefore best used for glazing—that is, for being laid down on top of other colors. On the other hand, the hot-pink color called Opera (made by Holbein) is extremely strong and volatile. On its own, Opera is almost like a laser pointer, directing the viewer's eye to those sections of the painting where it is used. The color can be subdued, however, if mixed with other shades of red, such as Rose Madder or Winsor Red; mixed with Alizarin Crimson, the change is subtly effective. When you mix Opera with Winsor Blue, you get exactly the shade you need for certain Iris blossoms; when Opera is mixed with Cobalt Blue, French Ultramarine, or Cerulean Blue, the most exquisite lavenders result. If you are painting day-lilies in the summer or trying to master the oranges in a Halloween pumpkin painting, try adding an Opera wash to your oranges to snap them out of the doldrums. If you're having trouble with the darks in these paintings, try laying down a glaze of Opera and then follow it with Winsor Violet to create the shadow color.

TEMPERATURE AND TRANSPARENCY TABLE

Red Color	Temperature	Transparent or opaque?	Contains yellow?
Rose Madder Genuine	Cool	Transparent	No
Alizarin Crimson	Cool	Transparent	No
Winsor Red	Warm	Transparent	Yellow cast
Cadmium Red[a]	Warm	Opaque	Yes
Light Reda	Warm	Opaque	Yes
Indian Red[a]	Warm	Opaque	Yes
Brown Madder[a]	Warm	Transparent	Yes

Blue Color	Temperature	Transparent or opaque?	Contains red?
French Ultramarine	Cool	Transparent	No
Winsor Blue (Red Shade)[b]	Cool	Transparent	Yes
Cerulean Blue	Cool	Opaque	No
Cobalt Blue	Neutral	Transparent	No

Green Color	Temperature	Transparent or opaque?	Contains yellow?
Winsor Green (Blue Shade)	Cool	Transparent	No
Viridian[c]	Cool	Transparent	No

Yellow Color	Temperature	Transparent or opaque?	Contains red?
Winsor Yellow	Cool	Transparent	No
Lemon Yellow hue	Cool	Transparent	No
Aureolin	Cool	Transparent	No
New Gamboge[d]	Warm	Transparent	Yes
Yellow Ochre[d]	Warm	Opaque	Yes
Raw Sienna[d]	Warm	Transparent	Yes
Burnt Sienna[d]	Warm	Transparent	Yes

NOTES: [a] Because these reds contain yellow (the complement of purple), do not try to mix them with blue to make purple.

[b] When used alone, this color has a cool, bluish cast; when mixed with red, it creates a deep violet.

[c] When used alone, this color has a cool, bluish cast; when mixed with yellow, it creates an exciting spring green.

[d] When mixed with red to create purple, a muddy color results.

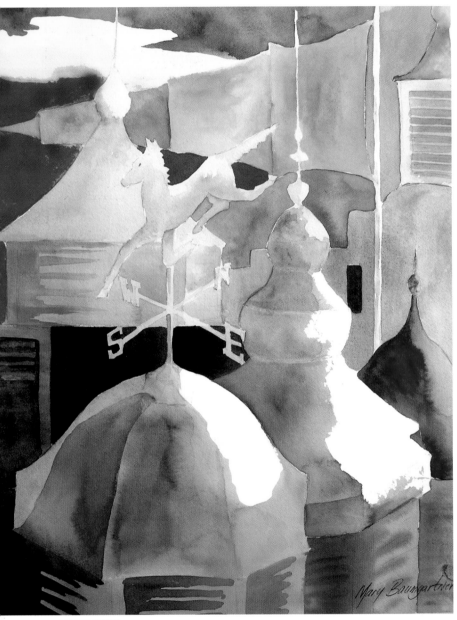

BIRD'S EYE VIEW
Mary Baumgarten

The Directional Color Flow Chart opposite first shows which colors can be mixed to create a third color; it then shows what happens when cool colors are mixed with other cool colors, warm colors are mixed with other warms, and cools and warms are mixed together. The arrows pointing back and forth indicate how to mix the colors to create a third color; the descriptions tell you something about what the mixed colors will look like. For example, when Cobalt Blue (a neutral transparent) is added to Rose Madder (a cool transparent), the resulting color isn't very strong. As you move down the chart, however, you see that mixing Cobalt Blue (a neutral transparent) with Alizarin Crimson (a cool staining color) produces a stronger color.

Proceeding across the chart, you see that mixing Aureolin and Rose Madder (two cools, both transparent) creates a soft orange color. As you go down the chart, you can view the results of other mixes of colors of the same and different temperatures and transparencies and begin to become aware of how significant a color's temperature can be when you're combining it with other colors. This chart can be photocopied and posted above your worktable so that you can quickly refer to it when mixing colors.

Let's talk about this a little more. And let's get a little more personal. Suppose you decide to paint a rainy-day scene, and that you've scouted out a location from which to paint. It's a cloudy, cool day, and to produce the right mood in the scene you'll have to carefully select the correct cool colors. The chart can help you do so.

Another scenario might be a bright autumn day when all the colors are vibrant and sparkling in front of you. To produce a painting of such a scene, you'll need to select primarily warm colors, although you may also need to toss in a few cool colors if, for example, your scene includes a stream or lake. The viewer will feel the contrast between warm and cool when looking at the finished painting.

DIRECTIONAL COLOR FLOW CHART

Reds	Purples	Blues	Greens	Yellows	Oranges	Reds
Rose Madder →	1 cool + 1 neutral (both transparents) yields true but weak purple	←Cobalt Blue→	1 neutral + 1 cool (both transparents) yields beautiful spring green	←Aureolin→	2 cools (both transparents) yield soft orange	←Rose Madder
Alizarin Crimson →	1 cool + 1 neutral (both transparents) yields stronger purple because Alizarin is a stainer	←Cobalt Blue→	1 neutral + 1 cool (both transparents) yields beautiful spring green	←Winsor Yellow→	1 cool + 1 warm (both transparents) yields stronger orange	←Winsor Red
Alizarin Crimson →	2 cools (1 transparent + 1 opaque, both stainers) yield deep purple color	←French Ultramarine→	2 cools (both transparents) yield stronger spring green	←Aureolin→ (or Winsor Yellow)	1 cool + 1 warm (both transparents) yields nearly true orange	←Brown Madder
Alizarin Crimson →	2 cools (1 transparent, 1 opaque) yield dusty purple	←Cerulean Blue→	1 opaque + 1 transparent (both cools) yields spring green	←Aureolin→	1 cool + 1 hot (1 transparent, 1 opaque) plus lots of water yields dull orange	←Cadmium Red
Brown Madder →	1 warm + 1 cool (both transparents) yields rich, staining purple	←French Ultramarine→	1 cool + 1 warm (both transparents) yields dull green	←New Gamboge	2 warms (both transparent) yield bright orange	←Opera
Winsor Red →	1 warm + 1 cool (both transparents) yields dark, rich, staining purple	←Winsor Blue→	1 cool + 1 hot (both transparents) yields rich, dark green	←Quinacridone Gold→	2 hots (both transparent) yield true orange	←Winsor Red

DARKS MADE WITH ONE TRANSPARENT AND ONE OPAQUE

Reds	Darks	Blues
Indian Red→	1 warm + 1 cool yields deep, dark staining color	←Winsor Blue
Light Red→	1 warm + 1 cool yields dark, brownish staining color	←Winsor Blue
Indian Red→	1 warm + 1 cool yields deep, dark color	←French Ultramarine
Light Red→	1 warm + 1 cool yields deep, dark color	←French Ultramarine

DARK MADE WITH THREE TRANSPARENTS

Colors	Resulting Dark
Alizarin Crimson + Winsor Green + Winsor Blue[a]	3 cool staining colors yield a deep, dark color

NOTE: a To achieve a beautiful silver color, mix Alizarin Crimson with Winsor Green and lots of water; for a rich, dark green, mix Alizarin with Winsor Green.

Painting Color Charts

Now your study of color should become a little more thorough. At the end of this chapter are nine color charts (see pages 25–33). When I started studying color, the color charts I had to copy were my nemesis. I want you to have an easier and more enjoyable time of it, which is why I've provided these sample charts. The formula for each swatch of color is given directly under each block. You'll find that when you mix colors, striving to match the colors shown, a whole new world of color will open for you.

Everybody who comes to my watercolor classes is required to paint these color charts. In the beginning there is always a bit of complaining and grumbling, but after the students do the first couple of charts, they just can't seem to get enough of them. Instead of spending years trying to master color mixing on their own, they immediately begin to understand what happens when two or more colors are combined. The charts they produce become part of their equipment and go along with them to every painting site.

The charts in this book aren't just for reference. The only way for you to really gain the knowledge they convey is to copy them yourself. To do that, use a pencil and ruler to redraw the grid of each chart on a sheet of watercolor paper that's about 8½ × 11. If you're skilled at making charts on the computer, do it that way; this has the advantage of allowing you to type the formula for each color at the bottom of each square. If you do use the computer to make your charts, print them out on sheets of watercolor paper that have been cut to 8½ × 11. But take note: Inkjet printers use water-soluble ink, which may bleed into the wet colors and muddy them as you paint. Also, the thickness of watercolor paper can cause problems for printers into which paper is fed from the front. Top-loading printers seem to work better for this purpose.

When you paint the squares, skip a square between each color. Then go back and paint those blank squares after the squares on either side are dry. In reproducing each swatch, dip your brush into water and then into the first color given in the formula, transferring it to the white area of your palette. Then, clean your brush in water, dip it into the next color in the formula, and mix that color with the first. When you really get into the process of painting these charts, you'll find that you'll learn fast. But the experience can be somewhat brutal. For instance, it can be difficult to gauge just how much color and water are in your brush, and you may find that your results differ from mine even though you're using the formulas given. It may take you several tries—and several discarded charts!—to match my sample colors. Note, too, that several of the formulas use the same colors but give them *in reverse order.* That's because the order in which colors are added to the mix on your palette can alter the resulting hue. Also, you'll find that using a brush to measure out equal parts of two different colors can be very difficult.

What will you learn as you mix the colors according to the formulas given in the charts? Many things. You'll notice how the yellows change when they are mixed with different blues and reds. You'll see the differences in transparency among the different reds. You'll notice the differences in temperature between the mixed colors and the colors you used to create them. All these lessons will help you enormously when you begin to mix colors for use in actual paintings.

When the color charts you paint satisfy you—when, that is, the colors you mix start to closely resemble those of the sample charts—you'll want to keep them, storing them in a three-ring binder for future reference.

17 SWANS A-SWIMMING
Mary Baumgartner

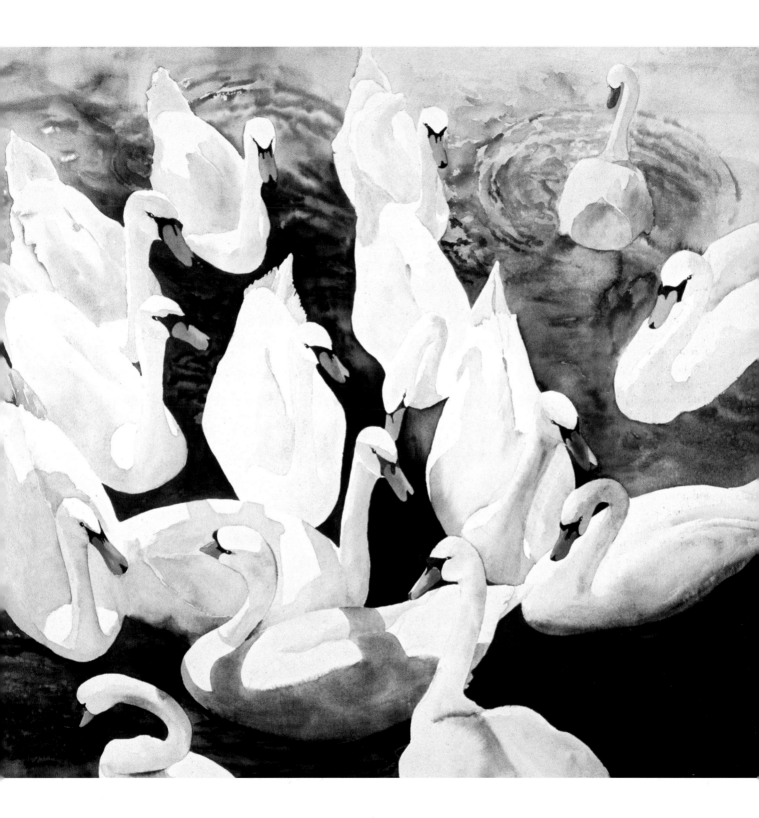

A FEW MORE NOTES
ON THE COLOR CHARTS

Study the painting of swans on page 23 while flipping back and forth to the color charts on the following pages. How many off-whites can you see in the painting? How many purples can you find? How many shades of green? All those gradations of color were achieved by using the formulas given in the charts. The painting's drama results, in part, from the interplay of warm and cool colors and from the way deep, dark colors appear alongside whites and off-whites. It may surprise you that no white or black paint was used in this painting. It's all made of color. Of course, the painting's success doesn't have only to do with the specific colors used. The wide scale of values plays a role, as does the strength of the composition—but we'll learn more about these subjects in subsequent chapters. Meanwhile, here are just a few notes about some of the charts that follow:

About off-whites: If you use factory-made grays for the off-white passages in a painting, those areas may end up looking like cement. By contrast, the subtle colors shown on the Off-White Chart (page 25) will add magic to areas that need a little color—but not a dead color.

About the grays: Surrounding a painting's center of interest with a gray that is the complement of the center of interest's dominant color is a highly sophisticated way to paint. And your darks will dazzle the viewer if they are the complements of the light colors in the center of interest. Consult the two charts on page 26 for enlightenment on how to do this.

About the greens: You'll notice that the Green Chart (page 27) includes a number of shades whose formulas call for the addition of a red. Not

only does this give you a wider variety of greens, but it also shows you how to fix greens that are too bright. Adding just a bit of red will dim the color immediately. You can achieve a nice variety of simple greens by mixing blues and yellows according to the formulas given on the Brown and Blue/Green Chart (page 28).

About the browns: Among other purposes, the Brown Charts (pages 28 and 30) give you the information for creating an incredible range of skin colors. For darker skin tones, try adding Winsor Blue to some of these formulas. For the sometimes lighter tones of babies' and old people's skin, water the mixtures down a bit.

About shadows: I guarantee you that the Shadow Chart (page 31) will come in handy again and again. For example: Use the Cerulean Blue and Rose Madder mixture when painting far distant mountains. It works like a charm. For those delicate shadows that lurk behind chairs on a front porch, which need some grainy color, try the French Ultramarine and Alizarin Crimson mixture. (If you want to calm the color down a bit and not have it look so purple, add in a tiny bit of Viridian.) The Cerulean Blue and Alizarin Crimson mixture makes a similarly wonderful shadow color.

About the darks: Our palette doesn't contain a premixed black or a Payne's Gray or any other factory-made dark. But you'll find that achieving rich, vibrant darks is a piece of cake if you practice mixing the colors on the Dark Chart (page 32) and always have it handy to check the formulas.

Color charts are among the best tools that a watercolorist has. By executing them yourself, you'll quickly become a superior painter.

OFF-WHITE CHART

Mix all colors in sequence, very thinly.

Aureolin + Viridian	Cobalt Blue	Winsor Yellow	Rose Madder + Cobalt Blue	Viridian + New Gamboge
French Ultramarine	Aureolin	French Ultramarine + Alizarin Crimson	Cobalt Blue + Winsor Red	Viridian
Rose Madder	Viridian + Cobalt Blue	Cadmium Red	Winsor Blue + Aureolin	Alizarin Crimson
Cobalt Blue + Raw Sienna	Indian Red	Viridian + Rose Madder	Light Red	Rose Madder + Aureolin + Cobalt Blue
Aureolin + Cadmium Red + Viridian	Aureolin + Viridian + Light Red	Cadmium Red + Yellow Ochre	Viridian + Winsor Blue + Light Red	Aureolin + Rose Madder + Viridian
Viridian + Cadmium Red	Aureolin + Light Red + Viridian	Alizarin Crimson + Winsor Blue	Viridian + Raw Sienna	Alizarin Crimson + Cobalt Blue + New Gamboge

GRAY CHART SHOWING COMPLEMENTS
Mix in sequence shown, with starred color(s) dominant.

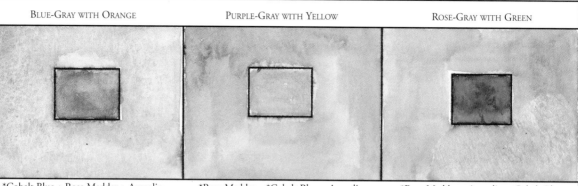
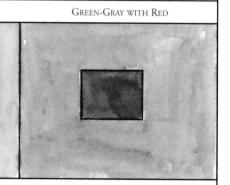

BLUE-GRAY WITH ORANGE	PURPLE-GRAY WITH YELLOW	ROSE-GRAY WITH GREEN
*Cobalt Blue + Rose Madder + Aureolin	*Rose Madder + *Cobalt Blue + Aureolin	*Rose Madder + Aureolin + Cobalt Blue

BROWN-GRAY WITH BLUE	YELLOW-GRAY WITH PURPLE	GREEN-GRAY WITH RED
*Rose Madder + *Aureolin + Cobalt Blue	Rose Madder + Cobalt Blue + *Aureolin	Rose Madder + *Cobalt Blue + *Aureolin

DARK CHART SHOWING COMPLEMENTS
Mix in sequence shown.

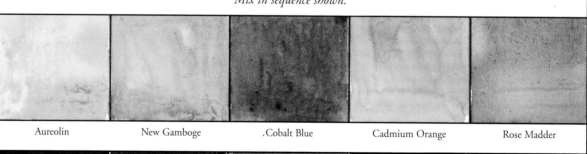

Aureolin	New Gamboge	.Cobalt Blue	Cadmium Orange	Rose Madder

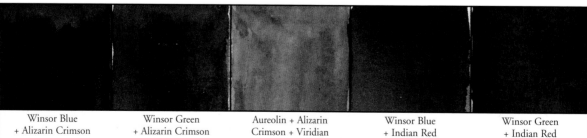

Winsor Blue + Alizarin Crimson	Winsor Green + Alizarin Crimson	Aureolin + Alizarin Crimson + Viridian	Winsor Blue + Indian Red	Winsor Green + Indian Red

GREEN CHART

WARM GREENS

Viridian	Viridian + Aureolin	Aureolin + Viridian	Aureolin + Viridian + Rose Madder	Aureolin + Viridian + Light Red	Aureolin + Viridian + Indian Red
Quinacridone Gold + French Ultramarine	Aureolin + Viridian + Cadmium Red	Viridian + French Ultramarine	Winsor Green + Winsor Blue + Light Red	Cobalt Blue + New Gamboge	Quinacridone Gold + Cobalt Blue

STAINING GREENS

Quinacridone Gold + Winsor Green	Winsor Green	Aureolin + Winsor Green + Light Red	Aureolin + Winsor Green + Indian Red	Aureolin + Winsor Green + Cadmium Red	Quinacridone Gold + Winsor Blue

GRAY GREENS

Viridian + Quinacridone Gold	Viridian + Rose Madder	Viridian + Light Red	Viridian + Indian Red	Viridian + Cadmium Red	Quinacridone Gold + Viridian

POWERFUL STAINING GREENS

Winsor Green + Light Red	Winsor Green + Indian Red	Winsor Green + Cadmium Red	Winsor Green + Alizarin Crimson	Winsor Blue + New Gamboge	Winsor Green + Burnt Sienna

BROWN AND BLUE/GREEN CHART
Browns using two primaries + secondary

Warm Browns	Cool Browns	Greens Using Two Primaries Only	
		All greens start with blue.	
Aureolin + Rose Madder + Viridian	Aureolin + Light Red + Winsor Green	Cobalt Blue + Aureolin	French Ultramarine + Winsor Yellow
Aureolin + Light Red + Viridian	Aureolin + Cadmium Red + Winsor Green	Cobalt Blue + New Gamboge	Winsor Blue + Aureolin
Aureolin + Cadmium Red + Viridian	Aureolin + Indian Red + Winsor Green	Cobalt Blue + Winsor Yellow	Winsor Blue + New Gamboge
Aureolin + Alizarin Crimson + Viridian	Aureolin + Alizarin Crimson + Winsor Green	French Ultramarine + Aureolin	Winsor Blue + Winsor Yellow
Burnt Sienna	Raw Sienna + Cadmium Red + Winsor Green	French Ultramarine + New Gamboge	Winsor Blue + Raw Sienna

PURPLE CHART
Mix all colors in sequence shown

Winsor Blue + Opera	French Ultramarine + Opera	Cobalt Blue + Opera	Cerulean Blue + Alizarin Crimson
Cerulean Blue + Rose Madder	Cobalt Blue + Winsor Red	Cobalt Blue + Alizarin Crimson	Cobalt Blue + Rose Madder
Winsor Violet	French Ultramarine + Burnt Sienna	Winsor Blue + Indian Red	Winsor Blue + Brown Madder
Winsor Blue + Winsor Red	Winsor Blue + Alizarin Crimson	French Ultramarine + Winsor Red	French Ultramarine + Alizarin Crimson

BROWN CHART

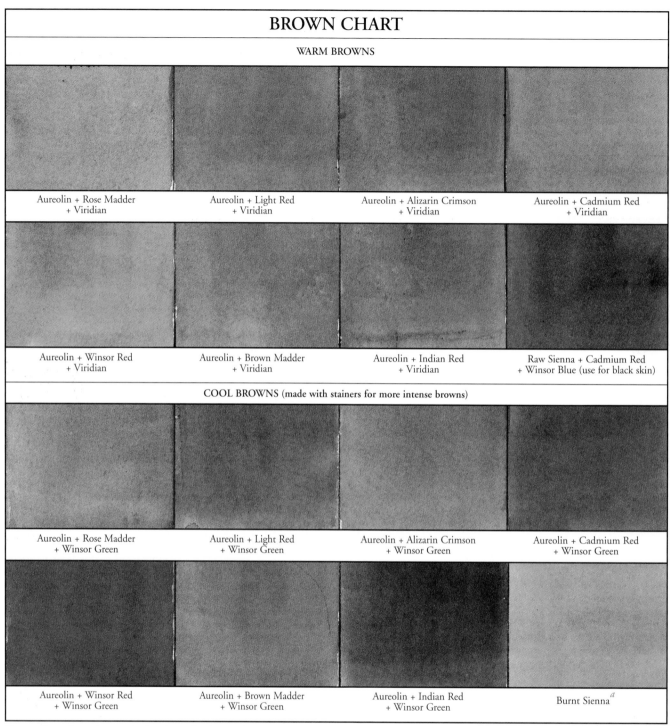

WARM BROWNS

| Aureolin + Rose Madder + Viridian | Aureolin + Light Red + Viridian | Aureolin + Alizarin Crimson + Viridian | Aureolin + Cadmium Red + Viridian |

| Aureolin + Winsor Red + Viridian | Aureolin + Brown Madder + Viridian | Aureolin + Indian Red + Viridian | Raw Sienna + Cadmium Red + Winsor Blue (use for black skin) |

COOL BROWNS (made with stainers for more intense browns)

| Aureolin + Rose Madder + Winsor Green | Aureolin + Light Red + Winsor Green | Aureolin + Alizarin Crimson + Winsor Green | Aureolin + Cadmium Red + Winsor Green |

| Aureolin + Winsor Red + Winsor Green | Aureolin + Brown Madder + Winsor Green | Aureolin + Indian Red + Winsor Green | Burnt Sienna[a] |

NOTE: *a* Burnt Sienna is a premixed tertiary color. From a distance, it does not have as much visual carrying power as the other browns shown above.

SHADOW CHART

Cerulean Blue + Rose Madder	Winsor Green + Winsor Violet	French Ultramarine + Brown Madder	Cobalt Blue + Rose Madder + Viridian
Cerulean Blue + Winsor Red	Cobalt Blue + Light Red	Viridian + Alizarin Crimson + Raw Sienna	Winsor Blue + Alizarin Crimson + Viridian
Winsor Blue + Winsor Red	Winsor Blue + Opera + Winsor Green	Winsor Blue + Light Red	Winsor Blue + Indian Red
French Ultramarine + Burnt Sienna	Winsor Blue + Brown Madder	Winsor Blue + Burnt Sienna	Winsor Green + Winsor Red
Winsor Blue + Alizarin Crimson +Winsor Green *mixed on the paper*	French Ultramarine+ Alizarin Crimson + Viridian *mixed on the paper*	Cerulean Blue + Rose Madder *mixed on the paper*	Viridian + Alizarin Crimson + Raw Sienna *mixed on the paper*

DARK CHART

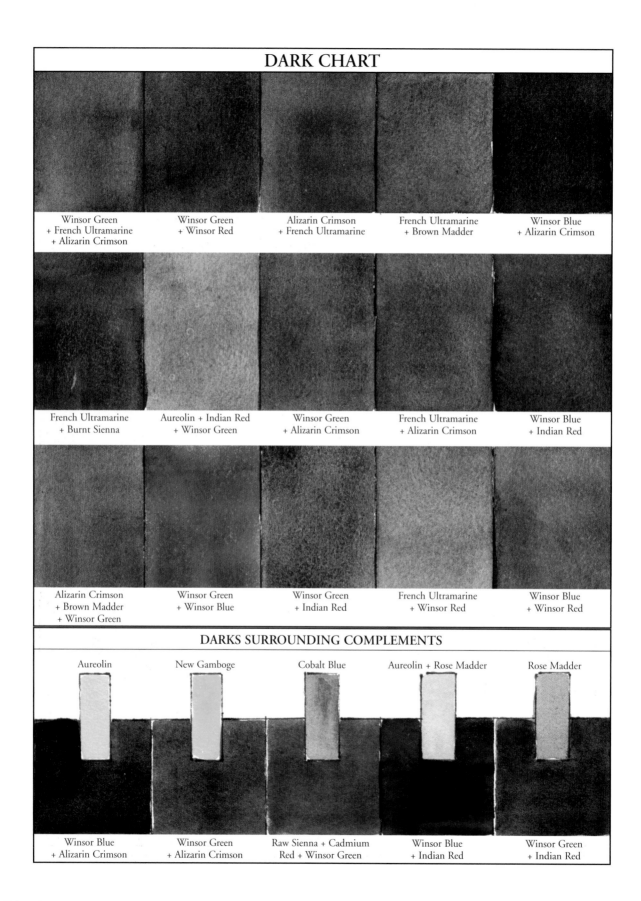

| Winsor Green
+ French Ultramarine
+ Alizarin Crimson | Winsor Green
+ Winsor Red | Alizarin Crimson
+ French Ultramarine | French Ultramarine
+ Brown Madder | Winsor Blue
+ Alizarin Crimson |

| French Ultramarine
+ Burnt Sienna | Aureolin + Indian Red
+ Winsor Green | Winsor Green
+ Alizarin Crimson | French Ultramarine
+ Alizarin Crimson | Winsor Blue
+ Indian Red |

| Alizarin Crimson
+ Brown Madder
+ Winsor Green | Winsor Green
+ Winsor Blue | Winsor Green
+ Indian Red | French Ultramarine
+ Winsor Red | Winsor Blue
+ Winsor Red |

DARKS SURROUNDING COMPLEMENTS

| Aureolin | New Gamboge | Cobalt Blue | Aureolin + Rose Madder | Rose Madder |

| Winsor Blue
+ Alizarin Crimson | Winsor Green
+ Alizarin Crimson | Raw Sienna + Cadmium
Red + Winsor Green | Winsor Blue
+ Indian Red | Winsor Green
+ Indian Red |

RED CHART

WARM REDS (containing yellow or yellow cast; mixed with yellows for brilliant and subtle oranges)

Winsor Red	Winsor Red + Opera	Cadmium Red	Cadmium Red + New Gamboge
Winsor Red + Aureolin	Cadmium Red + Aureolin	Winsor Red + Raw Sienna	Cadmium Red + Raw Sienna
Winsor Red + New Gamboge	Opera + New Gamboge	Winsor Red + Quinacridone Gold	Cadmium Red + Quinacridone Gold

COOL REDS (mixed with blues or with reds that contain blue or have blue cast)

Alizarin Crimson	Rose Madder	Alizarin Crimson + Winsor Blue	Alizarin Crimson + Cerulean Blue
Opera	Rose Madder + Opera	Winsor Red + Cobalt Blue	Rose Madder + Cobalt Blue
Rose Madder + Cerulean Blue	Winsor Blue + Opera	Alizarin Crimson + Brown Madder	Alizarin Crimson + Opera

YOUR SUPPLIES
AND YOUR STUDIO

In the first chapter, we looked at the colors you need, and we talked about how to set up your palette. Now, we'll look at the other supplies—paper, brushes, and so on—that you'll have to purchase, as well as something of vital importance to any artist: choosing and organizing the space in which you'll do your painting.

Choosing Watercolor Paper

When selecting paper as well as all other supplies, it is extremely important to choose high-quality products made by reputable art supplies manufacturers. This cannot be emphasized too strongly: First-rate supplies will greatly improve results, even when you're first beginning, so buy the best art supplies you can afford.

In any good art supplies store, catalog, or website, you'll find lots of different brands of watercolor paper, including Arches, Canson, Fabriano, Lanaquarele, Larroque, Saunders, Strathmore, and Winsor & Newton. After much experimentation, I've found the papers made by Arches to be the sturdiest and most suitable for all levels of painting. Arches papers hold up under constant erasing, scrubbing, soaking, and bleaching, and the papers' surface absorbs watercolor well. Some of the other papers are too soft, so they cannot withstand the abuse that painters often give them.

Made in the small French town of Arches, which is dominated by the papermaking company that shares its name, Arches papers are created on cylinder mould machines that produce paper that looks handmade. Arches watercolor papers are of three basic kinds: hot press, which has a smooth surface; cold press, which has a moderately rough surface; and rough, which is a rougher-surfaced cold-press paper. The papers, both natural white and bright white, are available in various weights: 90 pounds, 140 pounds, 300 pounds, 400 pounds, and 555 pounds. They can be bought in 16 × 20, 22 × 30, and 29½ × 41 sheets; the papers are also sold in rolls, for larger paintings. Most watercolorists use 140-pound cold-press paper, since this weight and surface are conducive to many different styles of watercolor painting. Paper of this weight does, however, buckle when wetted, and it will offer a better painting surface if stretched before use—a topic we'll return to in a moment. Papers with weights of 300 and 400 pounds, by contrast, are so heavy and stiff that they do not require stretching.

LITTLE CHURCH IN THE WILDWOOD
Mary Baumgartner
The photo shows the painting stretched on a commercially made stretching board.

Stretching Paper

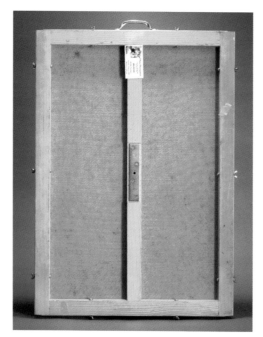

STRETCHING BOARD
The photo shows the back side of a commercially made stretching board.

Except for the extremely heavyweight papers, watercolor paper needs to be stretched because of how it is made and because of the wet nature of the medium. Because the paper is made of cotton fiber, it swells when wet, creating hills and valleys on the surface. This buckling of the surface can cause unwanted effects, including backwashes where wet paint puddles and "blossoms" where it bleeds in uncontrolled, flowerlike patterns into other colors.

To achieve a flat, tight surface that won't buckle when paint is applied, soak the paper in water for about 5 minutes in a tray or pan large enough to accommodate the full sheet; make sure that the paper is completely covered with water. Then lay the paper on a piece of plywood or Gatorboard that's longer and wider than the paper by about 2 inches all around. Pull on each corner to position and smooth the paper, and then staple one end of the paper to the board; the staples should be about 2 inches apart. Next, move to the opposite end of the paper; pull on the paper to stretch it tight, then staple that end, again at intervals of 2 inches. Now move to one

side of the paper, stapling it to the board at intervals of about 3 inches. Pull on the other side and staple it, as well.

Set the board on a level surface until the paper is dry. When completely dry, the paper will be flat and tight and will feel warm to the touch. Now the painting may begin!

Commercially made stretching boards (left) come in various sizes fitting a full sheet (22 × 30), half sheet (15 × 22), and quarter sheet (11 × 15). When using such a board, you're still performing the same pulling and stretching process, but the metal strips along the sides of the board hold the paper in place, and it is secured to the board with wing nuts rather than staples.

If you're impatient and can't wait for the paper to dry naturally, you can speed up the process by drying it with a hair dryer after the soaked paper has been attached to the board. Lay the board, with the wet paper attached, on the floor or a waist-high surface, and hold the hair dryer, set on "high," about a foot above the paper. Move the dryer across the paper from end to end and from top to bottom for several minutes until it feels neutral—neither warm nor cold—when touched with the back of your hand. If it feels cool, it is not yet dry.

If any dampness remains, the paper will be hard to work with, especially when drawing. Long experience has taught me that drawings should be made only *after* the paper has been stretched and is completely dry. If you draw in pencil on the paper before you soak it, you will not be able to erase your pencil marks after the stretching and drying process. If you do your sketching after soaking and stretching but before the paper is bone dry, the pressure of the pencil point may damage the paper's surface. And if you try to erase a pencil mark from the still-damp paper, the erasing will abrade the paper's surface, and smudges will be created when the loaded brush glides over the surface of the paper. So do make sure the stretched paper is absolutely dry before beginning. If the paper feels even slightly cold or damp (or both), give it some more time.

Most watercolor teachers make recommendations regarding which brushes their students should buy. Just as a doctor tends to prescribe certain medications to treat certain conditions, each watercolor teacher tends to have preferences, gained through his or her own experience, about which brushes students should use. Over time, you, too, will find that you prefer certain brushes over others, but when you're just beginning it's best to stay with the teacher's recommendations.

A good watercolor brush should retain its shape after it is touched to the paper and lifted. It should have a long ferrule, which is the metal part of the brush between the hairs and the handle. Usually steel- or brass-colored, the ferrule is there for reinforcement, helping to keep the individual hairs from splitting apart. Watercolor brushes are made from various natural and artificial fibers. Some of the most popular among professional artists are brushes made from "sable"—actually, mink fur.

But sable brushes can, depending on the manufacturer and the quality, be very expensive. For example, some of the larger Winsor & Newton Series 7 brushes—which are made only from hairs taken from the very tips of minks' tails—can list for hundreds of dollars. Be aware, however, that "most expensive" does not necessarily equal "best"—or not for all purposes. Brushes made from other parts of the mink's pelt may hold their shape better. And there are many less expensive brushes that contain a mixture of synthetic and sable fibers that perform very well. Do avoid brushes made with squirrel hair, however. Squirrel hair does not have enough resilience to enable the brush to spring back into shape after you've made a stroke.

Watercolor brushes come in several different shapes, but the basic two shapes are *rounds* and *flats*. Recommended rounds range in size from 000 (with a diameter of 1/32 of an inch) to 24 (9/16 of an inch in diameter). Recommended flats range from 1/4 inch to 2 inches. Flat brushes made of synthetic fiber can be a bit risky, since the hairs sometimes split apart, giving you an

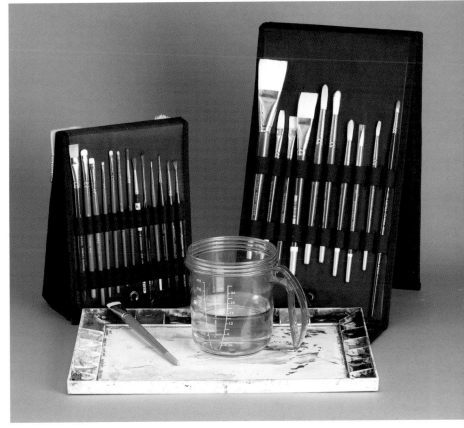

unwanted sawtooth effect when you paint a wash. My specific recommendations for the brushes you should buy—including types, sizes, and makers—appear in the Suggested Basic Supplies sidebar (page 38).

You should also own a canvas or nylon brush holder or easel. These holders have spaces for brushes, scrubbers (for lifting paint off watercolor paper), pencils, and other "handle"-type tools, including a toothbrush, which is sometimes handy for scrubbing large areas to correct mistakes that happen when you're well into a painting.

Be sure to keep your brushes clean. Keeping them clean will prolong their lives. When you've finished a session of painting, wash your brushes with a mild detergent and lay them flat to dry. And *never* leave them standing on their points in a cup of water: This will quickly destroy the points.

BASIC TOOLS
Brushes, a palette full of colors, and, of course, water are the watercolorist's basic tools. The brushes here are displayed in handy brush-easels.

SUGGESTED BASIC SUPPLIES

Here are all the basic supplies that I suggest my students buy. These supplies have worked successfully in my many years of teaching. Art supplies retailers are listed in the Resources section at the end of the book (page 143). The recommended watercolor paints are made by Winsor & Newton except where noted.

PAINTS

Alizarin Crimson
Aureolin
Brown Madder
Burnt Sienna
Cadmium Red
Cerulean Blue
Cobalt Blue
French Ultramarine
Indian Red
Light Red
New Gamboge
Opera (Holbein)
Quinacridone Gold
Raw Sienna
Rose Madder Genuine
Viridian (Grumbacher)
Winsor Blue (Red Shade)
Winsor Green (Blue Shade)
Winsor Red
Winsor Violet
Winsor Yellow
Yellow Ochre

PALETTE

Frank Webb palettes, John Pike palettes, and Stephen Quiller palettes are all good. Each has a lid to keep watercolors fresh and dry and twenty or more wells—a sufficient number for the colors I've recommended. Also, all these palettes can be easily carried in a shoulder bag for "on location" painting.

PAPER

I recommend 140-pound cold-press Arches watercolor paper, which comes in 16 × 20 and 22 × 30 sheets and can also be bought in rolls.

STRETCHING BOARD

A plain plywood board, 18 × 24 × 3/8, will work well. Or you may choose any of the watercolor stretcher boards sold by art supplies retailers.

BRUSHES

For your basic set of brushes, get four rounds (numbers 1, 4, 6, and 10), a 1/2-inch flat aquarelle, a 1-inch or 1½-inch flat wash brush, a number 2 or number 4 rigger (sometimes called a liner; used for loosely painting small tree trunks, branches, and twigs). Brushes can be made of sable, nylon, or mixed hairs; sable is the finest. Of sable brushes, Winsor & Newton Series 7 brushes are the most expensive; Grumbacher and Robert Simmons brushes are less expensive but great. Winsor & Newton Series 233 ("University" series) brushes, Sceptre 101 rounds, and Sceptre 606 flats are inexpensive brushes with lots of spring and point. Loew-Cornell brushes are wonderful, inexpensive brushes made of mixed hairs.

SCRUBBERS

These short-bristled, white nylon brushes come in several sizes, both flats and rounds. In an emergency, an old toothbrush can be used for "heavy duty" scrubbing.

SKETCH PAD

I use Strathmore 400 series pads. The 6 × 8 size is best. You may use a larger pad, if you like, but it should not be bigger than 8 × 10.

PENCILS

Get a selection of relatively soft (number 2B) and relatively hard (4H) pencils.

ERASERS

Make sure you have a kneaded eraser or, alternatively, a Pentel Clic retractable eraser.

WATER CONTAINER

Any plastic container that holds about 12 ounces will suffice. Tupperware containers and Cool Whip tubs work well.

SPRAY BOTTLE

You'll need a pump-type spray bottle to fill with water to moisten your palette before beginning to paint.

Once you've purchased your brushes, you must learn how to use them properly. By holding the brush in the right way, you'll get the kind of brushstrokes you've always wanted to make but never thought you could. I use French Ultramarine paint to practice with, since this rich, blue color is more challenging to use than other colors. It will quickly tell you whether you are holding your brush correctly and whether you've added enough water to the paint.

USING THE ROUNDS

For practice, use a number 10 round, holding it as you would a pencil. Position the brush slightly more vertically than you would a pencil, however; this will give you greater control of the point. First, dip the brush in water, then into the paint, and transfer the color onto the mixing area of the palette, adding more water to the mixture if needed.

Now, making sure that the brush is loaded with paint, lay down a stroke of paint on your paper as if you were drawing with a pencil. Notice, however, that the harder you push down on the brush, the wider the stroke; lifting the brush slightly will produce a narrower stroke.

USING THE FLATS

Now it's time to try doing a wash. For practice, use a 1½-inch flat wash brush. You'll hold it about the same way you did the round, but this time it should be vertical—perpendicular to the surface of the paper.

There are two basic ways to do a wash: on damp paper or on paper that is dry. Doing a wash on damp paper is easier, so try it that way first. I advise students to use French Ultramarine when practicing washes, because it's a little more challenging than other colors. Here are the steps for doing a wash on damp paper:

Step 1. Before beginning, make sure that you have plenty of paint, watered down to the appropriate thinness. (This is especially important if your wash is of a mixed color: Mix *lots* of that color, perhaps in a separate white ceramic bowl or enameled container, before beginning. You really do not want to have to remix the color in the middle of doing a wash, since it's doubtful that you'll be able to re-create exactly the same shade.)

Step 2. Now, wet your watercolor paper by brushing its entire surface with plain water. Do not begin the wash, however, until the paper has dried somewhat. Begin the wash when the paper has lost its shine.

Step 3. Load your brush with paint. Holding the brush in a vertical (straight up) position, and beginning at the top left-hand corner of the paper (if you are right-handed), pull the brush across the paper to the top right-hand corner, creating an even band of color. (If you are left-handed, as I am, you'll work in the opposite direction, going from right to left.)

Step 4. Now, reload your brush with paint and, beginning at the bottom edge of the first band, again pull the brush across the paper, making sure to overlap the bottom of the first band of color by about 1/8 of an inch. Because the paper is still damp, the bands will blend together as you go.

Step 5. The object, now, is to continue creating bands of color—bands that slightly overlap and blend into the bands you've previously laid down—all the way down the sheet, so that when you finish the entire surface will be covered with a single, even color.

The technique for doing a wash on dry paper is basically the same, although it is more difficult because the dry paper will draw more of the moisture and color from your brush—meaning that your brush may run out of paint before you make it all the way from one side of the paper to the other. If that happens, reload the brush and complete the band of color by reloading the brush and working inward from the *opposite* side of the paper. When doing subsequent bands, remember to again overlap the bands by about 1/8 of an inch.

Controlling the Edges and "Veiling" the Paint

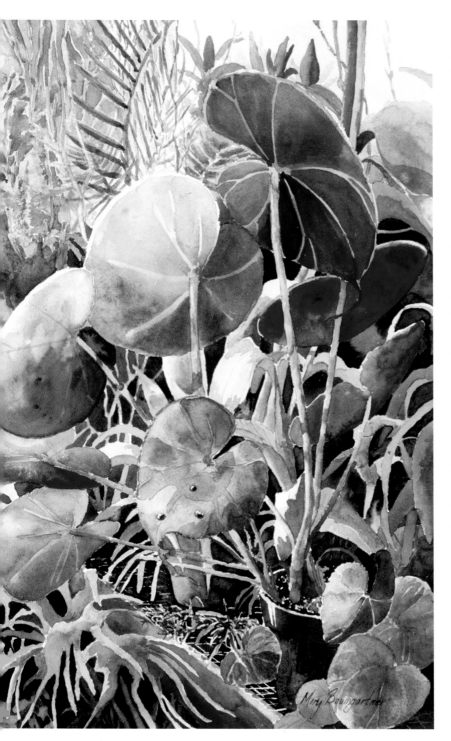

It is very important to learn to control the edges between one area of a painting and another. Usually, when painting a particular area, you'll want to lead into that area from the edges so that "blossoms" don't occur. Blossoms appear when a freshly loaded brush touches the edge of another area in which the paint has not dried completely, causing the newly applied color to bleed back into the already painted area. If this happens, allow the whole area to dry and then paint over that area again.

Paintings have more eye appeal if they contain both soft and hard edges. To attain soft edges, carefully wet the place where you want the soft edge to occur, and then paint into the edge of the wet area. The paint from the brush will spread into the wet area, and a soft, feathery line will result. You can control how far the soft edge spreads by modifying the amount of water in the brush when you wet the paper before laying down the color.

To paint the "negative" (very dark) areas of the painting, simply paint around a given form with small areas of a much darker color. You can see how I've done this in *The Hothouse*, left, around the leaves and stems of the cyclamen plant.

To "veil" an area, paint around the area you want to veil, leaving that area totally white. Then, after the paint has dried, paint the same area again, but now paint over the part that you'd left white before, using the same color you've used for the area surrounding it. This subtle way of dividing space adds dimension and depth to a painting. In *The Hothouse*, you can see "veiling" in the lower left corner, where the layers of plant life overlap.

These techniques require only the most common brushes. However, you should use several sizes of rounds and several sizes of flats when trying them. If you get into the bad habit of using just one size of brush, your finished work will look like it has been painted with just one size of brush!

THE HOTHOUSE
Mary Baumgartner

Using Masking Fluid

Many watercolorists use masking fluid to protect areas of a painting that they want to remain white until a later stage in the painting process—or to stay white when the painting is finished. Of course, it's possible to keep the white areas white simply by painting around them, but this can be hard to do with watercolor. Applying a protective layer of masking fluid over the area until you're ready to reveal it can ensure that the white areas remain pure white. Masking fluid can be tricky to use, however, so a few tips may be helpful.

There are several different brands of watercolor masking fluid on the market, but I think that Winsor & Newton's Colourless Art Masking Fluid is the best. Many painters prefer to use pink masking fluid, which is easier to see against the white of the paper, and this is fine as long as the painting can be finished within a couple of weeks. If you leave the pink mask on the paper for too long, there's the risk that it may leave a pinkish stain on the areas it was used to cover.

Masking fluid can be frustrating to use because, like rubber cement, it begins to dry and harden as soon as it comes into contact with the air. If you apply masking fluid with a brush, make sure it's an old brush—and mark the brush so that you use it *only* for applying masking fluid. Prepare the brush by cleaning it with liquid soap or a commercial brush cleaner and rinsing it thoroughly before dipping it into the masking fluid. When you're finished masking, wash the brush immediately with a soapy brush cleaner (such as "The Masters" Brush Cleaner) to remove the residue. If you don't, the masking fluid will glue the brush hairs together, making it impossible to use again.

There's a new item on the market that can make masking easier: It's the Masquepen masking fluid applicator. The "pen" has a long pointed nozzle through which you squeeze the fluid onto the paper; several different sizes of "nibs" are available. The Masquepen is especially helpful when the areas you need to mask are very narrow

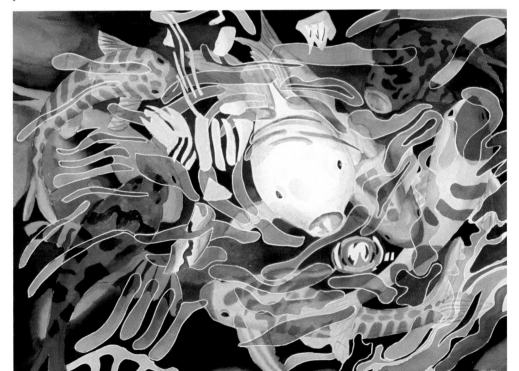

DANCING KOI
Mike Dowell

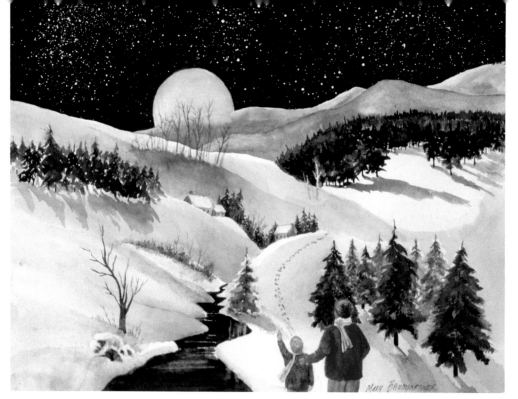

SILENT NIGHT
Mary Baumgartner

and you must be especially precise, as in the white edges surrounding the waves in the painting of koi on the previous page.

The very first step when applying masking fluid is deciding whether it is really necessary. That's not to say that it isn't sometimes essential. For example, say you're painting a black-faced cat whose whiskers must be left white. In such a case, you'll definitely want to use masking fluid. For such thin lines, you'd be wise to apply the mask with the point of a toothpick or the end of a paper clip or with a Masquepen applicator. Once you've made the drawing (and leaving the pencil lines in place), apply the fluid in gently curving lines out from the area where the whiskers begin, and let it dry completely before beginning to paint. After the paint has been applied and allowed to dry, the masking fluid can be peeled off by hand or lifted off with a crepe rubber cement pickup (an eraser-like tool designed for this purpose).

The nighttime snow scene above shows another use for masking fluid. With masking fluid, I created the stars in the sky in this painting before I started painting. To achieve a similar effect you'll need a small-weave screen, such as the wire mesh from a tea strainer. Open your bottle of masking fluid and fill the cap halfway with fluid, adding enough water to fill the cap. Then load a brush with the fluid and drop a few

drops onto the screen. Holding the screen about 4 inches from your mouth, blow gently onto the screen to force tiny droplets through the mesh and onto the paper. (Some art supplies purveyors now carry a small circular-weave screen with a handle, which makes it easier to apply masking fluid in this manner.) Practice this procedure on scrap paper until you know just how close the screen must be to your mouth for the correct amount of fluid to reach the paper and create stars of different shapes and sizes.

For the *Silent Night* painting, I soaked and stretched the paper first. After it was dry, I masked out the moon and the tops of the mountains. When the masking fluid was dry, I spread plain newsprint over the bottom part of the painting (where there was no masking fluid), and then I blew in the stars. When the masking-fluid stars were dry, I painted the sky using Winsor Blue and French Ultramarine, laying the colors down in layers (or "glazes"). Each subsequent glaze was added after the previous glaze had completely dried. It was only when the painting was finished and totally dry that I removed the masking fluid—and the starry sky was the result.

Masking fluid can also be used to suggest falling snow. For the falling snow in the painting *Little Church in the Wildwood* (see page 34), I used the same method described above. Since the snow was to cover the whole image, it wasn't

necessary to cover up other sections of the painting before blowing on the droplets of masking fluid.

Caution: When you use masking fluid, making changes to the painting becomes a daunting task. The painting therefore needs to be planned carefully before you begin, and it may even require that you do a test painting first to work out the problem areas.

In some cases, you'll want to remove the masking fluid before finishing painting. To create the icicles in the painting at right, I applied masking fluid to the branches before beginning to paint. But before the painting was finished I removed the mask and added some color to settle down the whites, to define the icy drips, and to make the ice seem to coat the tree branches.

Masking fluid is not the only substance you can use to protect the areas of a painting that you want to remain white. You can also use wax, in what is called a "resist" technique. To create the cloud patterns in the painting above, I rubbed the end of a white birthday candle on the paper before I began to paint the sky. If you move your wrist freely when marking the paper with the candle wax, a lovely formation will appear as you add more and more layers of sky color. This method is risky, however, since the candle wax cannot be removed from the watercolor paper. If you make a mistake when applying the wax, it cannot be corrected.

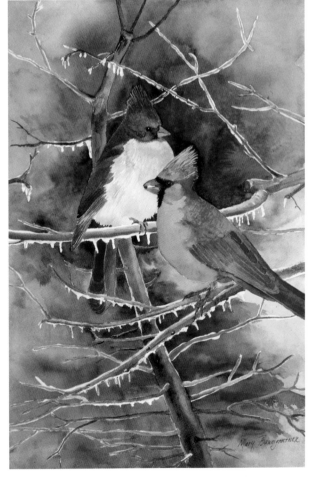

Optional Supplies and Equipment

The Suggested Supplies list on page 38 contains most of the things you'll need when beginning to paint with watercolors. A few optional items have already been mentioned, including a bottle of Winsor & Newton Colourless Art Masking Fluid and a crepe rubber cement pickup for removing the mask. In addition, you may want to have a three-ring binder for notes (and for class handouts if you take a watercolor course) and for your color charts, which can be hole-punched and placed in the binder. A reducing glass will allow you to see a small image of your painting—as if you're seeing it from a distance—and help you evaluate the strength of the composition. A magnifying glass comes in handy when you're painting from photographs. And I also recommend getting a piece of blue glass; if you look at your work through blue glass, the colors will

THE FLYING NUNS
Mary Baumgartner

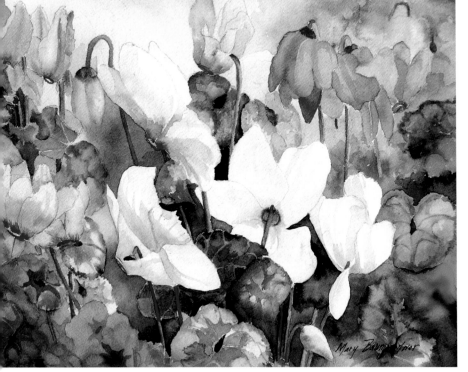

disappear and the "black and white" image you see will show how the light and dark areas relate to one another.

When you're just beginning to draw, tracing paper and transfer paper can also be extremely useful. Completing your drawing on tracing paper first will let you avoid having to make erasures on the stretched watercolor paper. You'll also need masking tape to fasten the tracing paper as an overlay atop your watercolor paper. Attach the tracing paper to the watercolor paper with four 1-inch lengths of masking tape placed across the top edge, leaving the bottom free so that transfer paper can be inserted later. Then begin your drawing, in pencil. Once the drawing is finished and no more changes need to be made, slip a sheet of transfer paper under the tracing paper and redraw the whole image using a red ballpoint pen. (I use a brand of transfer paper called Sally's Artists' Graphite Paper.) Using red ink lets you make sure you're transferring all the lines of your drawing. As you redraw, be careful not to press down too hard with the ballpoint pen. You might want to check from time to time to make sure you're not transferring too much graphite onto the watercolor paper. What you want is just the "ghost" of the drawing. If the graphite is too heavy in spots, use a kneaded eraser to lift some of it away before starting to paint. Or, even better, use the crepe rubber cement pickup recommended in the section on masking fluid, above. Just by touching the pickup to the areas that are too heavily drawn, you'll be able to remove any excess graphite. And one more suggestion: Several versions of a new product called a dry cleaning pad have recently appeared on the market; rubbed across the surface of a drawing, these pads absorb dirt and graphite. The Alvin Dry Cleaning Pad and the Lineco Document Cleaning Pad can be found at art supplies stores or ordered from catalogs or online vendors.

Setting Up Your Studio

It is of the utmost importance that a painter have a space that is entirely his or her own. Ideally, it should be a space that's away from distractions—including the telephone. And it should be a space that doesn't always have to be neat and tidy. If you're lucky, your home will have a room that can easily be converted into a studio, but even if you don't have that much extra space, there are ways to make do.

Watercolor painting requires only a relatively small space—but, even so, you must have a space that's totally dedicated to your art. The kitchen table just isn't the answer, since that's where the family gathers for meals. Even if you live in a small apartment, don't work at the kitchen table! To be truly creative, you need a space that's free of reminders of daily life and family obligations. Your private space should inspire you to do work that's truly personal—truly your own.

If you shouldn't paint in the kitchen, where

should you set up your work space? Few people have the luxury of a real studio—with a northern exposure and/or a skylight, a sink, and tile flooring that won't be damaged by spilled or dripped paint. If you do have such a space, good for you! Enjoy!

For those of you who don't, the next-best place is probably an unused bedroom. The bed should be the first thing to go—it's too tempting to stop those creative juices from flowing and have a little nap. If the room is carpeted, the carpet should go, too. I know it's hard to rip out expensive carpeting, but it's much easier to get on with your work when the floor no longer presents a worry. Your work space shouldn't be devoid of all "ordinary" furniture, however. Do leave behind a comfortable chair so that family members have a place to sit if they visit while you work.

Assuming you don't have a spare bedroom, what's the next-best place? Well, if there's a win-

dow in the master bedroom with a space below it that could be cleared for a drawing table, this could become your work space. It's not ideal, because of the bed nearby, but with discipline it can work.

CHOOSING LIGHTING

Whatever space you decide on, it has to be well lighted. A skylight is ideal, but, of course, skylights provide light only during the daytime.

If you don't have a skylight, consider an overhead fixture with fluorescent tubes—but make sure you use Verilux tubes. Verilux fluorescents provide "full spectrum" light, so that you'll have the feeling of daylight even when you work at night.

Halogen lighting is also an excellent choice. If you don't have a skylight and a ceiling-mounted fluorescent fixture isn't an option, choose a tall halogen floor lamp. Most ordinary ceiling fixtures—you know, the ones that came with the house—don't provide adequate light for painting. You can augment them with a halogen floor lamp situated near your worktable.

Then, add Ott-Lite task lighting to the ensemble. Like Verilux fluorescents, Ott-Lite bulbs and tubes produce full-spectrum light that simulates daylight. A wide variety of Ott-Lite fixtures are available in stores, through catalogs, and on line. I find the floor lamps with long, flexible necks to be best, since these enable you to position the light source directly over your artwork while you paint, letting you see what your colors look like in "daylight." (By the way, Ott-Lite illumination can substitute for outdoor light when you're taking digital pictures.)

Having the right lighting is so important that appropriate fixtures and lamps simply have to be included on the "must have" list for your work space.

CONFIGURING AND FURNISHING THE SPACE

Now we come to the arranging and furnishing of your work space. Before I moved into an 1,800-square-foot condo, I was one of the fortunate few who had her very own studio, with a skylight and built-in shelves. Now, I'm reduced to using one side of a 13 × 14–foot room, which I share with my husband.

If your workspace is large enough, one whole side should be outfitted with built-in cabinetry, including drawers for supplies and vertical slots for paintings that have been matted but not framed. (If by chance you mat your own work, these slots can also be used to store mat board and foamcore for backing artwork.) The cabinetry should also include flat files or deep shelves to hold art paper and paintings that have been completed but not yet matted or framed. There should also be shelf space for a coffee maker, a CD player, and photographic equipment.

If you have the room and want to mat your paintings yourself, think about installing a hinged, drop-down platform big enough to hold a large (48-inch) mat cutter and a full sheet of mat board (30 × 40). Because the platform is hinged, you'll be able to swing it up and secure it to the wall when you're not using it. Place a worktable under the platform where you can do the actual positioning of the artwork in the mat and where, if you wish, you can frame it and prepare it for hanging. Under the table, install horizontal shelving; each shelf should be slightly larger than 30 × 40, and make sure the shelves are no more than 4 inches apart so that the weight of the material being stored doesn't cause them to sag.

If you have the luxury of building a real studio, be sure to include a sink that's large and deep enough to soak paper before stretching. And there should also be a place to lay the stretching board flat while the paper is drying.

Countertops in the studio space should be covered with Formica or some other water- and stain-resistant material. Cabinets can be both above and below eye level. The floor should be tiled—or, at the least, should not be carpeted. As you can probably see by now, the general effect is similar to that of a kitchen—but designed for an artist rather than a cook. You can purchase ready-made plans for art studios, but, really, you as the

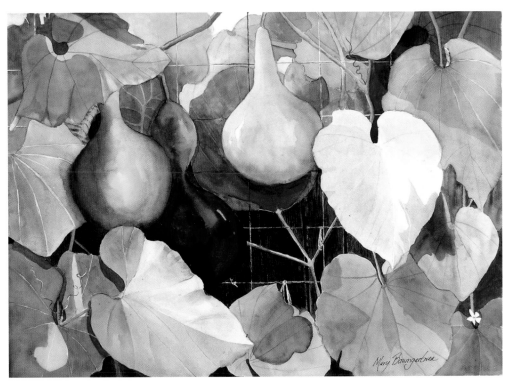

MIRACLE OF THE GOURDS
Mary Baumgartner

artist will be the better designer, since you know your own work habits and needs. Because this may be the only space in the house that's truly your own, reward yourself with the best drawing table, taboret, stool (or work chair), and lighting that you can afford. Art supplies catalogs and online vendors offer a very broad selection of these items. If you're pinched for space, consider buying one of the readymade "art stations" that these suppliers carry. If you choose an art station (which is much like a drafting table), the top should measure at least 30 × 42. These stations, which have adjustable-height legs and whose tops are also adjustable (in case you prefer working on a slanted surface), range in price from $200 to $500. In my own studio, I use simple 6-foot-long tables, bought at Home Depot, that have waterproof tops and that can easily be collapsed when I need more space.

A taboret is a small storage cabinet, often wheeled, that sits right beside your worktable. Taborets usually have several small drawers for sorting out your art supplies; made of plastic or wood, they range in price from about $100 to about $800.

Frankly, now that I live in a condo with limited space, the only thing I have that conforms to the suggestions above is a tiled floor. A nearby guest bathroom furnishes the sink, and the bathtub is where I soak full sheets of paper. I stow my camera equipment in drawers, and my paper, mat board, mat cutter, and so on are all stashed in a closet in the room I share with my husband. I do have my own worktable, as well as a smaller table that forms an L with my worktable and provides throw-off space. As I've said, watercolor really does require very little space—unless you are into very large paintings. Painting on "double elephant" size paper (measuring 29½ × 41) would be difficult, to say the least, in my little work space. And there's no space in my condo to cut large sheets of mat board. Although I used to mat and frame my own work, I've compensated: There's an excellent, reasonably priced frame shop nearby that now does all my matting and framing.

When I leave my workroom, my work stays behind—well protected by a closed door. I don't have to clean up or put anything away, so the next time I come into the room, the painting I'm working on is waiting for me just where and how I left it. The trash cans are emptied occasionally, and the shavings drawer in the electric pencil sharpener is frequently emptied. Each time I start to paint, I get a container full of water from the faucet in my kitchen, and I'm ready to begin once again.

Painting on Location—Supplies

My *Merriam-Webster's Collegiate Dictionary* defines *plein air* painting as "relating to a branch of impressionism that attempts to represent outdoor light and air." In fact, many artists (not just Impressionists) have preferred to paint out of doors, because there's such a difference between painting in the open air and painting in the studio.

American artist Winslow Homer (1836–1910) knew this well. Homer painted some of his most profound and cherished art between 1885 and 1898 at Prout's Neck, Maine, and he was so bent on painting storms and rough seas that he had a portable painting booth built at the shore. The little 8 × 10–foot cabin was fitted with a large plate-glass "viewing window" and a stove, so that he could work even in bitterly cold weather. Homer thoroughly believed that, as a painter of the sea, he needed to be on location, *en plein air*, to capture nature accurately.

The experience of plein air painting can be a real pleasure if you have the right equipment, including a carrying case for your supplies. Land's End (www.landsend.com) makes a perfect bag for watercolor equipment. It is called the Cotton Canvas Classic Attaché and costs about $60. Everything a watercolor painter needs will fit into this bag: palette, brushes (in a separate, small canvas carrying case so they don't lose their points), water container, pencils, sketchpad, paper, and camera. If you need to take along larger sheets of paper and an easel, these can be carried separately—perhaps in a portfolio.

By the way, you will also need to carry along a good supply of water. I recommend that you buy a one-quart multipurpose spray bottle, which is large enough to contain all the water you'll need to replenish your brush water when it gets dirty while also providing a spray for moistening your paints.

Folding campstools, available in camping stores, collapse to a size small enough to fit into your tote. I've used one for years—it's the little striped thing shown in the photo (opposite above). When unfolded, it's comfortable enough to sit on for two or three hours.

There are also collapsible rolling bags that have folding chairs attached and plenty of storage space. The one shown in the photos (opposite below) is called the ArtComber. Check your local art supplies store or online vendors for the availability and price of this item.

Some painters prefer standing while painting. If you like to stand, a folding aluminum travel easel or even a collapsible photographer's tripod may work well for you. Photographers' tripods (which even "big box" stores like Wal-Mart and K-Mart sell) have a screw-in mount for securing a camera. But this mount can also be attached to a small metal plate (available at Home Depot) to which a board can be fastened with screws.

When painting on location, do take along a sandwich and a soda or a bottle of drinking water slipped into plastic bags. Refreshments are important items in your painting-on-location "gear." Be sure to also include some paper towels, some tissues, and a few Wash 'N Dri packets for cleaning your hands after lunch.

A camera is also an essential piece of equipment. Take your camera with you everywhere. The digital cameras made by Olympus are good choices, but, really, there are many good cameras on the market at prices for all budgets. Most current models of digital cameras come with plug-in remote battery chargers, but if yours doesn't, be sure to buy a battery charger and rechargeable batteries, since digital cameras use up batteries quickly. (The use of digital photography in promoting your work is discussed in the chapter "Your Career as an Artist.")

Not only should you take a lot of photos when painting outdoors, but you should also do a lot of sketching of the scene. Also, for future reference, try to capture the precise colors of the scene by painting color swatches in your sketchpad. Use your time outside fully, so that you'll have plenty of ideas when you return to your studio.

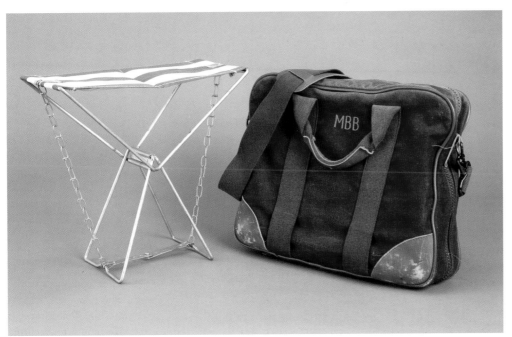

OUTDOOR EQUIPMENT

Here are the campstool and carrying case I use when painting out of doors. (My old Land's End bag isn't available anymore, but the company sells roughly equivalent models at great prices.)

ART ON THE GO

ArtComber rolling bags like the one depicted here are perfect for location painting.

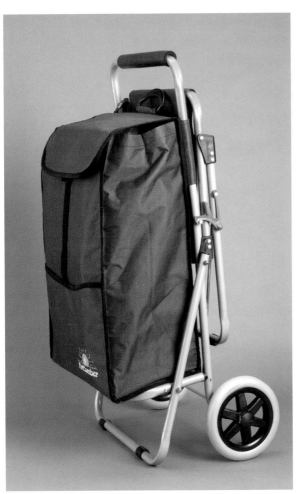

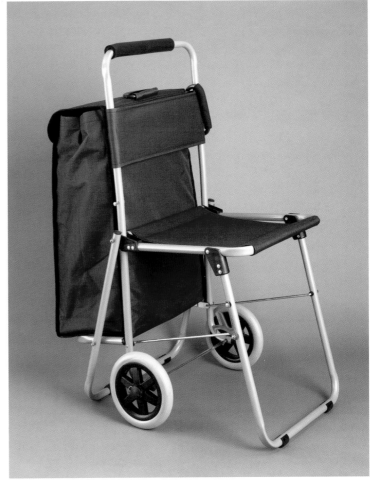

Christine S. Harness

COMPOSITION
Your Building Blocks

A good painting is a "brain teaser." A painting does not start with your putting lines on paper, drawing circles or curves. It begins in your mind. A painter must first have a desire to paint something; then, the painter has to start thinking about how the painting will work on paper.

Just like a well-constructed building, a good painting must begin with a good foundation. All the elements needed to make a painting successful must work together to give the work of art its flow and harmony.

Good planning makes a painting work. Among the things you've got to plan out in advance are the subject matter, of course, but also the center of interest, the interaction of the darks and the lights, and the way you'll apply the paint. Note, however, that a skilled application of the paint won't rescue a painting that's been poorly planned.

Good planning certainly shows in the painting by Christine Harness, opposite. Christine, a retired middle-school art teacher, took my Wonderful World of Watercolor classes to sharpen her understanding of watercolor. Her painting *Fresh from the Garden* was inspired by a pile of radishes and rhubarb that her husband had just picked. But Christine didn't just paint what was laid in front of her. Before beginning, she had to carefully design her center of interest and plan where her darkest darks and lightest lights would appear in the finished piece.

Making Thumbnail Sketches

Color schemes can be worked out later, but they need to be *thought out* at the beginning, as you're deciding on the painting's basic composition. The best way to begin is to make what are called "thumbnail" sketches on newsprint or sketching paper. Take one or two sheets of paper from your sketch pad, and divide each sheet into four equal quadrants by drawing lines through the center of the sheet in both directions. Of course, you'll want to keep the sheets vertical if you're thinking of doing a tall painting and horizontal if you are thinking of a landscape painting.

After dividing the drawing paper into four equal sections, draw a smaller rectangle inside each quadrant, about half an inch in from each edge, letting this margin serve as a "mat" for each thumbnail.

Now, in each thumbnail, sketch in the major shapes that will define the composition. Place them differently each time. At this point, you don't need to spend time perfecting your drawings. You're mainly searching for the arrangement of shapes that will make the painting work.

After four to eight thumbnails—a page or two of sketches—it will become apparent what will work and what won't. You'll see how the shapes and their arrangement—not just the objects but also the spaces between the objects—matter.

TIP

When you're painting a horizontal picture and using a photograph for reference, it's important to make the proportions of the drawing the same as those of the photo. There's an easy way to do this.

First, position the reference photo at the lower left corner of your drawing paper, aligning its edges with those of the paper. Then place a ruler diagonally across the photograph, lining it up with the photo's lower left and upper right corners. Then follow the line the ruler makes as it extends beyond the photo. Decide how large you want the painting to be, and mark a point on the paper—anywhere along the ruler's edge—that will indicate your painting's upper right corner. Now, remove the photograph and draw straight lines through that point from the paper's horizontal and vertical edges. You'll paint within the area marked out by those lines and the paper's left and bottom edges, which has the same proportions as your photograph.

Opposite page:
FRESH FROM THE GARDEN
Christine Harness

SPECIAL MOMENTS
Mary Baumgartner

Certain thumbnails will seem more balanced and harmonious, and you'll begin to get a feeling as to what will result in a good painting.

The eye delights in seeing things in odd numbers: threes, fives, or even a single object. It's usually better to place things off-center rather than putting them right in the middle of your page (unless you're doing a portrait). Also, when painting a landscape, make sure that the spaces above and below the horizon line are unequal. Show either more of the sky or more of the scenery, but do not give them equal space.

There are some teachers who think you should throw out all the rules. "Paintings work better if there are no rules," they say. I disagree. Most paintings produced "without rules" simply do not work. And it's also true that many good

paintings that look as if they were painted with no thought to the rules of composition have, in fact, been meticulously thought out—sometimes for days on end.

Now it's time to think about color, shadow, and values—the contrasting dark and light areas. After you've arrived at what you think is the right composition, use colored pencils to fill in the areas you're pretty sure about. Remember the angle of light so that the shadows it creates will be drawn properly. Also, the value of each corner of a painting should be different from the others, with heavy, darker colors closer to the bottom.

Then turn the colored pencils on their sides and use the sides of the pencils' leads rather than their points to shade in the differing values. Try to come up with at least five different shades of

lightness/darkness to see whether the relations between the light and dark areas work. This doesn't always happen with the first thumbnail you choose. If it does, great. Get on with it!

By the way, your compositions won't always work, even when you've gone through all these steps. My first painting of the subject in the painting *Special Moments,* (opposite), was a complete failure. The design was good, but the painting contained "too much information." (It was too long horizontally, and the focus wasn't worked out properly—it didn't lead the eye where I wanted the viewer to look.) So I did the painting again, eliminating a lot of excess space that was taken up with useless visual information. The painting you see here—a portrait of my newest grandson and his mother—is the tighter version.

Once you've got a thumbnail that satisfies you, the next step is to make a final drawing of the same size as the watercolor paper you'll be using and to transfer it to the watercolor paper. Let's face it: Most of us have "white paper shock," so we'll get around that problem by using the tracing- and transfer-paper technique described in the previous chapter (see page 44). When you do the drawing on tracing paper and then transfer it to the watercolor paper using graphite transfer paper, there are no errors, no erasures, and no mess on the art paper itself. And, please, save all your tracing paper drawings. I was very happy that I'd retained the first drawing for *Special Moments* so that I could easily redo it.

The painting above was done just for fun, but it had all the elements of a good composition from the very beginning. The rabbits are all looking into the painting; the basket's handle makes for a nice balance with the rabbit on the left; and the flower in the lower right keeps the color moving. Moreover, the composition created an element of mystery without my fully realizing it. It almost seems as though the rabbits and basket are floating inside a ball of glass. The light Cobalt Blue wash at the top of the painting suggests sky and coolness and enhances the impression that the scene is enclosed in a glass ball. (The painting also satisfied my desire to make a painting that wasn't rectangular.)

Using Shapes

The inspiration for the painting below was a photograph a student brought me of a bunch of elephants gathered around a watering hole near a campsite she'd stayed at in Africa. Immediately, I was excited about the photograph and couldn't wait to get started on my interpretation of it.

How did it come out? Well, my first version was an exact (though larger) replica of the photograph. I painted just what was in the photograph, including the elephants' bodies. And the elephants were all shades of gray and brown, the water was blue, and the land surrounding the watering hole was beige. Yuck! What a boring painting.

A few days later, when I was looking again at the photograph and the not-so-good painting I'd made based on it, I suddenly had a moment of insight: Why not concentrate on the elephants' heads—and on the shapes created by their tusks and overlapping trunks? And why do elephants all have to be shades of gray and brown, anyway? Why not put a little color into their lives?

The painting's title, *Zambezi Tuketela,* combines two words I learned while reading a book about South Africa by Wilbur Smith. In Smith's book, Tuketela is a rogue elephant; the Zambezi, of course, is a river in South Africa. Can you identify the rogue elephant in my picture? (Yes, he's the pink elephant in the right foreground.) The picture is a far cry from the original version, and it was the shapes—the elephant's trunks, tusks, and legs—that made this a prize-winning piece.

ZAMBEZI TUKETELA
Mary Baumgartner

REDUCING VISUAL COMPLEXITY

The visual complexity of the scene in the photo can be simplified by capturing the shapes. In this simple thumbnail, the artist has isolated the major shapes and has begun to identify their relative values. The darkest darks remain alongside the lightest lights, and the shadows give an indication of the time of day. (They also add another dimension to the patio tiles on which they fall.) The finished painting captures a slice of time that most of us are always looking for.

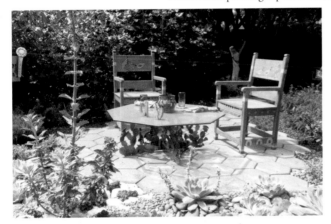

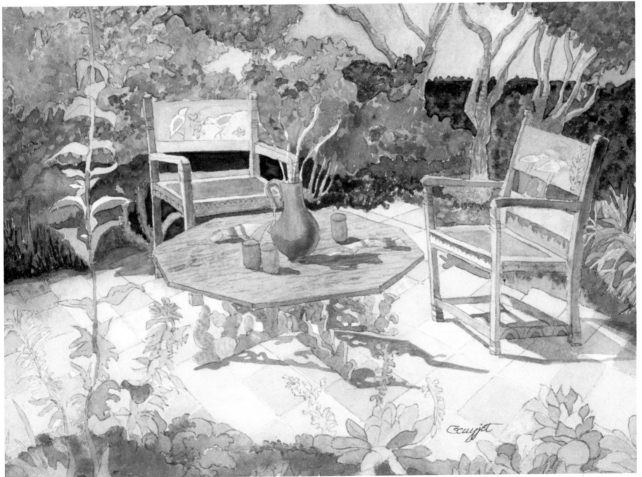

COME, SIT AWHILE
Carol Cuyjet

COMPOSING FROM PHOTOGRAPHS

Unless a painting has a strong composition, viewers will pass it by without a second glance. It becomes part of the wallpaper.

Let's take a look at two photographs taken from my personal photo collection. They are both strongly composed, but we need to "take them apart," dividing them into their constituent shapes, to really see this.

Take a piece of tracing paper and lay it over the photo of the barn. Trace the photograph, and then begin to "dissect" it by major shapes. In your outlined drawing, there should be at least thirteen distinct shapes (but no more than fifteen). Defining thirteen to fifteen major shapes forces the eye to see the center of interest as well as the supporting shapes that move the eye toward the center of interest.

Now look at my tracing of the barn photo. In making this outline, I took the sky as one shape, some of the trees as another shape, the barn as a set of shapes formed by the light patterns, and so on. Count the outlined areas, and you'll see that I did indeed end up with between thirteen and fifteen shapes (fourteen, to be exact). Seeing values—a subject we'll spend more time on in the next chapter—and then painting the picture will be much simpler if you've identified the shapes.

Now examine the photo of the dogs and my traced drawing of it. Observe that I joined the three dogs together as one shape. While searching for shapes, do as I do and always keep the values in mind. If you squint your eyes while looking at a photograph or scene you wish to paint, it will simplify the composition and help you decide what to paint and what to leave out.

Always think *simplicity*. Think *shapes* and how they interlock. Think *patterns*—putting the darkest dark against the lightest light, and letting the lights and darks travel through the image. Think of objects that *overlap* other objects—of how the space will be divided. Think *focal point*. Except in portraits, the focal point should be offset from the center of the painting. If you imagine the paper in front of you being divided into four equal parts, your focal point will be slightly off center, both horizontally and vertically.

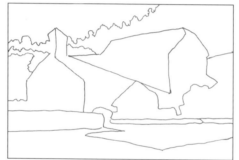

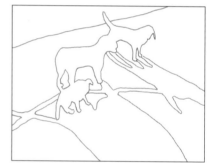

Understanding Perspective

There's nothing more annoying than a painting of a building in which the doorways or windows are at the wrong angles. I don't believe that paintings of buildings should look like architectural renderings prepared for a design competition, but some rules of perspective simply cannot be broken.

The painting at right is one that works. It has a good light pattern, good color balance, wonderful shapes, and all of it is *in proper perspective*. The light travels throughout the painting, which keeps the eye inside the image.

Artist Mike Dowell handled this painting with tremendous skill. His color balance is dynamic and exciting, the shapes all work together to make a dramatic statement, and the perspective is brilliant.

From the time that Mike started studying with me, it was apparent that all he needed was some guidance. He has a natural talent for painting structures, and, after he had proven this to me, I turned him loose, letting him choose his own subjects to paint. This was one of the results.

Shadows in the Ruins is based on a photograph I took while on a visit to Israel. It shows the Pools of Bethesda in Jerusalem. (These ruins are all that remain of the pools.) Look carefully at how Mike uses light to turn severe corners and at how he captures even the perspective of the building blocks. The incredible backlighting makes the painting very dramatic. It's a highly sophisticated piece—and one that I thought needed to be shared.

So what is perspective, anyway, and what do you need to know about it? In the simplest terms, perspective is the relation of objects in space, *as seen from a particular point of view.* It's perspective that gives an illusion of depth to a two-dimensional image. Artists speak of several different kinds of perspective:

Linear perspective, which uses converging lines

Aerial, or atmospheric, perspective, in which depth is communicated by changes in values as objects grow more distant

Relative perspective, in which the sizes of objects diminish as they recede in space

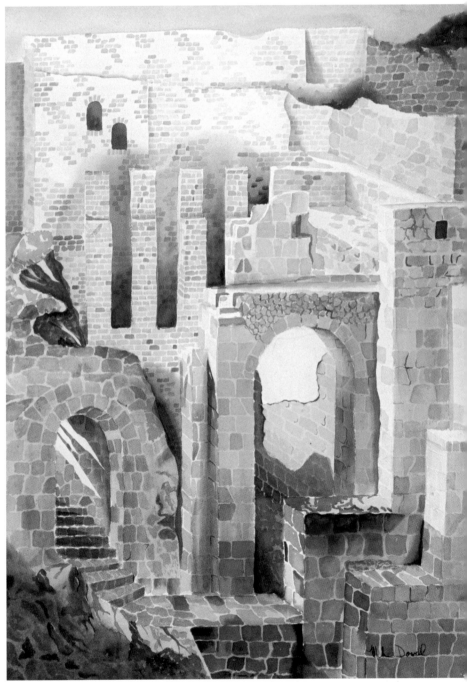

SHADOWS IN THE RUINS
Mike Dowell

Color perspective, which uses clear, warm colors in the foreground and hazy, cool colors in the background

Sharpness perspective, in which objects in the foreground are in focus but those farther away grow fuzzy

Anatomical perspective, which uses the relative sizes of human figures to indicate their position in space

The best reason to be concerned about perspective is that it will give a feeling of depth to an otherwise flat surface. Even casting shadows in perspective helps define shapes and suggests the thickness and curvature of objects.

We begin to understand perspective by remembering three primary things:

1. Eye level (EL). Eye level is an imaginary line extending from your eye as you look straight ahead, regardless of whether you are sitting or standing.

2. Vanishing point (VP). The vanishing point is the point at which a road, river, railroad, or any angle appears to vanish in the distance.

3. One-point, two-point, and (sometimes) three-point perspective. This is a somewhat complicated matter, and really requires a visual explanation (see the bottom drawing opposite).

In one-point perspective, every angle in an image may be connected to a single vanishing point at eye level. In two-point perspective, the angles in an image extend back to two vanishing points—one at the left and one at the right—both at eye level. In three-point perspective, the angles in an image may also extend toward another vanishing point above or below eye level—high in the sky or in the depths of the ocean. The diagram opposite illustrates all three types.

In this book, we're concerned only with one-point and two-point perspective, because these are what you'll use most frequently in drawings and paintings. You should practice drawing in perspective until you gain a good, working understanding of the concept, because this is the only way your paintings of buildings and other structures will improve. But don't use a ruler when drawing buildings or fences and railroads that recede into the distance. Relying on this crutch will slow down the flow of your creative juices.

When you finish a drawing, check the accuracy of the perspective by laying a piece of tracing paper on the drawing, marking the vanishing point or points on the tracing paper, and then drawing lines from the angles in your drawing out to the vanishing point(s). But note: Sometimes it's more interesting to be just a little bit incorrect than to be *too* correct.

For the painting on page 60, artist Lisa Curry picked out thirteen shapes from a photograph of the scene, created a value study after identifying the shapes, and then transferred her drawing to a quarter-sheet (11 × 15) of Arches watercolor paper. The scene in the photograph was much more complicated than what appears in this painting. Because Lisa began by *simplifying* the image, the painting has the snap, eye appeal, and variety of color to capture a viewer.

Despite this simplification, however, the scene seems real: It isn't hard to imagine being there. The day seems to be hot, although the vegetation provides a refreshing coolness. The tree extending from the right across the top of the painting is instantly recognizable as a common California tree—a eucalyptus. The color of the foliage—a desert sage green—was achieved by adding Rose Madder to Viridian.

The perspective is accurate—especially that of the wagon wheels. They have been used so much that they appear to have flattened out on the bottoms. The angle of the roofline of the white house is stopped by the white column, and the object on top of the column breaks the line created by the wall of building behind, making the composition interesting.

PERSPECTIVE DRAWING MADE SIMPLE

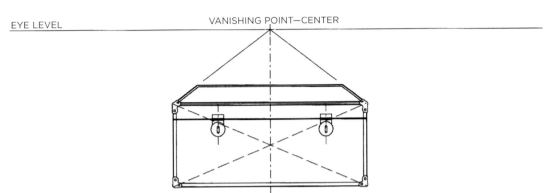

EYE LEVEL VANISHING POINT—CENTER

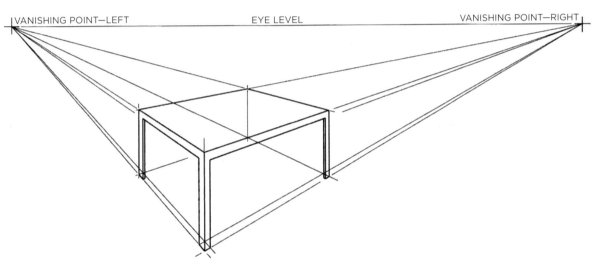

1. The old college footlocker (otherwise known as a box), drawn using one-point perspective.

VANISHING POINT—LEFT EYE LEVEL VANISHING POINT—RIGHT

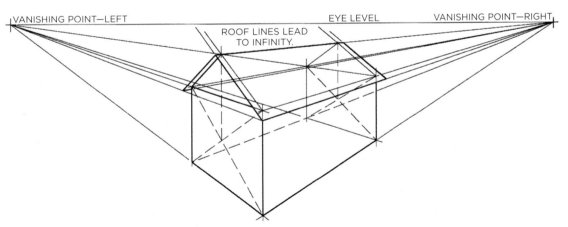

2. The old card table (otherwise known as a box with four legs), drawn using two-point perspective.

VANISHING POINT—LEFT EYE LEVEL VANISHING POINT—RIGHT

ROOF LINES LEAD
TO INFINITY.

3. The little old house by the side of the road (otherwise known as a box with a triangular top), drawn using three-point perspective.

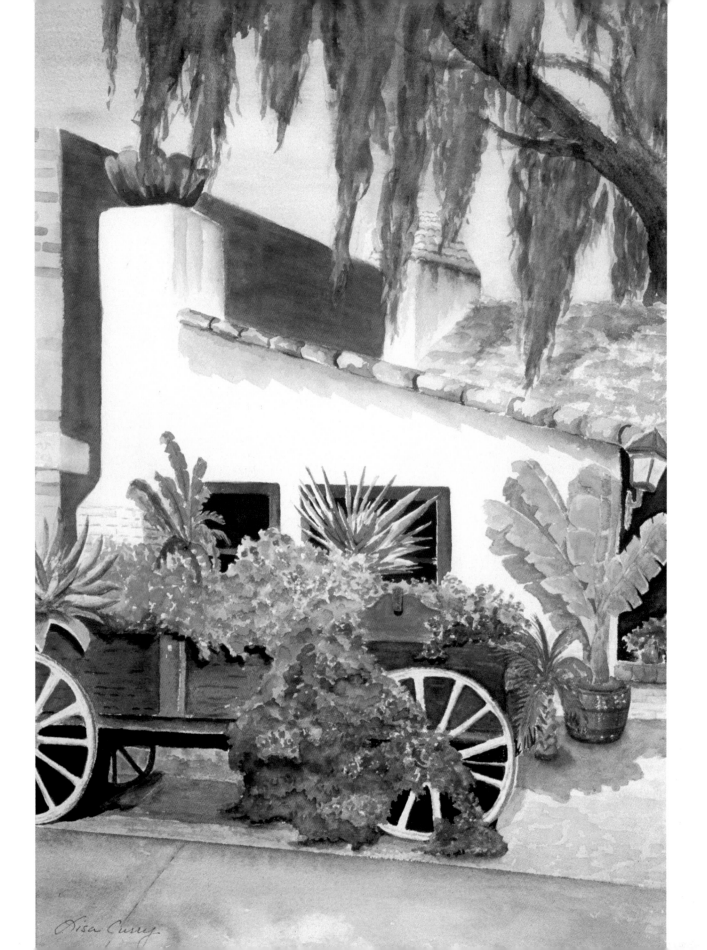

Lisa Curry

Making a Composition Work

A successful painting must have a few elements that will stop viewers dead in their tracks. Since you as a painter have only three tools for creating the needed drama (color, value, and perspective), you'd better use them wisely. Here are some of the elements that make for a successful painting:

• Interesting shapes, including the shapes between objects

• An odd number of things—one, three, five, or seven

• Exciting light patterns

• A variety of colors

• A mood that's conveyed by the colors: happy (yellows and other warm colors), somber (blue-grays and other cools), or mysterious (thin colors in the midtonal range, such as Yellow Ochre mixed with Cerulean Blue, which leans toward gray but is not neutral)

• A center of interest

In addition, there should be no visual "escape" from the painting. An easy way to capture and hold the viewer's eye is to use the whitest white at the main point of focus and then to continue leading the viewer through the painting with the whites.

The first color to catch the eye is the *lack of color,* so make good use of the whites in your paintings.

The carousel painting below dramatically shows what I mean by leading a viewer through a painting with the whites. I spent two full days studying the oldest carousel in the United States, which now resides at Seaport Village in San Diego, California. The music of the calliope and the sight of the sculpted wooden animals going round and round absorbed me, but I was also overwhelmed by the talent and artistry displayed in each and every carving. During this experience, I became determined to make a painting of the carousel that would so involve viewers that their eyes could not "escape" the picture. I sketched the horses and took two rolls of film as the carousel revolved in front of me.

On a later painting trip to Mendocino, I was unable to paint on location because of a brief illness. But I preferred to paint rather than to stay in bed, so I used this time to develop the composition for *The Past Remembered* based on my sketches and photographs, and to start the painting. (By the way, the bright white horses in the painting have been restored to their original splendor; the grayer, bleached-looking wooden horse in the foreground had not yet been restored when I visited the carousel.)

Opposite page:
OLD TOWN SAN DIEGO
Lisa Curry

THE PAST REMEMBERED
Mary Baumgartner

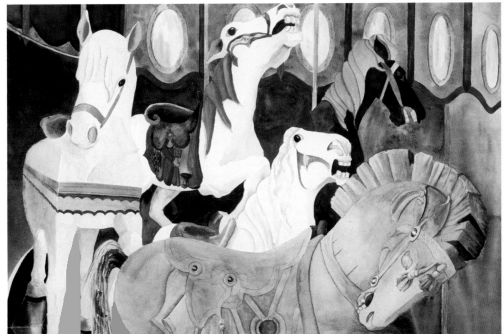

Composition is everywhere—in architecture, in the covers of the catalogs that come in the mail, in displays in florist shop windows, and, of course, in the arrangements of paintings hung on the walls of our houses. Learning the fine points of composition will make your paintings more dramatic and hold your viewing audience's attention for longer periods of time. Think about first impressions—think, for example, of the business cards, brochures, and catalogs that have made such a strong impression on you that you couldn't just toss them away. Now think about the paintings in your home or ones you've seen in an art gallery: Which ones seem to be so much wallpaper, and which seem to have a life of their own—and to seek out your eyes as you move through a room?

One concluding note: A good composition does not have to reproduce reality exactly. The picture here is a commissioned piece that I painted on location at the San Luis Rey mission in San Diego County. One day when I was sitting on the mission's grounds doing some preliminary sketches, a tourist stepped behind me to observe my work. He got pretty incensed when he noticed that I had moved the fountain from its actual location far to the left of the mission and placed it within my image. He told me that his photos of the place were better because they showed the fountain just where it was and did not move it to a new, incorrect location. Well, he's entitled to his opinion, I guess. But for the sake of the painting's composition, I felt that I just had to move the fountain well to the right, to break up the repeating pattern of the arches. In my view, artists may certainly take "artistic liberties" with the scenes they're depicting, but only if it makes their paintings better.

MISSION SAN LUIS REY, SAN DIEGO
Mary Baumgartner

MYSTERIOUS DEEP
Mary Baumgartner

ESSENTIALS FOR SUCCESS

You have only four tools to make your paintings look three-dimensional: value, shape, color (and the absence of color), and perspective. For your paintings to succeed, you'll have to understand each of these essentials. To begin this chapter, let's return at greater length to *value*, which, again, has to do with the relative lightness or darkness of a color.

I admit that when I began painting, I didn't understand light and dark patterns. I painted what I *thought* I saw. Then I began to realize there really were lights and darks, midtones, and whites everywhere I looked. All I needed to do was to tame them!

Success through Contrasting Values

If you're reading this during the day, try the following exercise: Squint your eyes and look out a nearby window. By squinting, you'll focus less on color and more on the relative lightness or darkness of the forms you see—their values. Certain areas within your field of vision will appear very dark, others moderately dark, others moderately light, and still others very light. How many different values can you count in the scene outside your window?

Similarly, the different areas of a painting will differ in value. Every successful painting has a discernible contrast in values, and the stronger the contrast, the more effective the painting. Remember that value is relative: One area of a painting may be darker than some areas but lighter than some other areas. And it's common to talk about values as being on a *scale* in which darker colors are assigned lower numbers and lighter colors are assigned higher numbers.

This all sounds more complicated than it really is. Look at my painting of sharks, opposite. Squint again. If you do, you'll see that there are about five different values in this painting, ranging from the very bright white of the shark in the center of the painting to the very dark areas in the coral reef at lower left and in the figure of the

shark swimming in the background at the upper right. If we wished to, we could assign numbers to each of these values: The white area of the central shark would be number 5 (lightest), and the area formed by the smaller shark at the upper right would be number 1 (darkest). All the other values in the painting would fall somewhere on this 1–5 scale.

I think that every successful painting has a minimum of five values. You can easily create a scale of five different values using just a single color. Look at the series of color swatches at the right. Block #1, at the top, has the darkest value. This is the value of the paint as it appears taken directly out of the tube, with only enough water added to make the paint pliable. We'll call this the "tube color." If we add more water to the paint, as in block #2, the value becomes lighter; this block is about 85 percent of tube color. Block #3, to which even more water has been added, is 55 percent of tube color, and block #4, to which a lot of water has been added, is 10 percent of tube color. Block #5, the white swatch at the bottom, has been left empty.

You can make little charts like this for yourself. (As you did with the color charts in chapter 1, draw the basic grid on a sheet of watercolor

VALUE SCALE
This simple scale of five values was created with a single color, French Ultramarine. The darkest block (value #1), at top, shows the value of the paint taken directly from the tube. The lightest block (#5), at bottom, is pure white: No color has been added to this area.

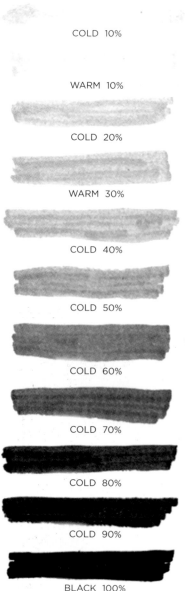

COLD 10%

WARM 10%

COLD 20%

WARM 30%

COLD 40%

COLD 50%

COLD 60%

COLD 70%

COLD 80%

COLD 90%

BLACK 100%

GRADATIONS IN VALUE
Subtle gradations in value
are visible in these swatches
made with Sanford Prismacolor
Markers. Note, too, the
differences in temperature
between the cool and warm
colors at the top.

paper.) Practice with different colors of paint, starting with French Ultramarine, then Winsor Red, then Aureolin, and then New Gamboge. Finally, paint one chart using Cerulean Blue. By practicing with each of these colors, you'll begin to see the difference between colors that become transparent when you add more water (like French Ultramarine) and those (like Cerulean Blue) that remain opaque even as their value becomes lighter.

You can also gain a quick understanding of relative value—and of subtle gradations in value—by creating swatches with Sanford Prismacolor Double-Ended Art Markers. Many different sets of these markers are available; among the choices are sets of twelve pens in cool grays and warm grays. Each of these sets contains markers of ten different values: 10 percent, 20 percent, 30 percent, 40 percent, 50 percent, 60 percent, 70 percent, 80 percent, 90 percent, and 100 percent. (The 100-percent value is black; there are three black pens in each set.) It's easy to set up a value scale using these pens—and to use them when doing value studies for your paintings. Using both the cool gray and warm gray sets will help you understand the difference between value and temperature (discussed in the first chapter). Cooler grays have a bluish tone, warmer grays a reddish tone—and you'll immediately see that two grays of the same value but different temperatures create very different effects.

As I say, contrasting values are essential to a painting's success. My painting of the sharks, *Mysterious Deep,* is successful in part because of the sharp contrast in value between the large, bright white shark (the obvious center of interest) and the painting's darker areas. But contrasting

values are not, in themselves, enough to ensure success. Composition also plays a very large role in making this painting so effective. A lot of thought and planning went into the painting, especially regarding how to create the bubbles rising above the central shark. Without those bubbles, the painting wouldn't be nearly as effective.

Also notice the edges in the shark painting. Objects in focus—such as the central shark—have sharp edges. More distant objects have soft, indistinct edges. Objects with very irregular surfaces, like the coral, have rough edges. *Lost edges* are borders between areas of equal value, where no real line between one area and the other is visible.

Note, finally, that each of the corners of the painting is different from the others—another principle of a successful composition—and that the center of interest is partly "framed" by the bright, vivid colors at the lower left. All these elements work together to help the viewer feel the water, the movement of the underwater plant life, and the intensity of fear as the little sunfish head for the coral's protection.

TIP

To help yourself see contrasting values more easily, make a viewfinder. You can do so by cutting a 3 × 4 hole in a 6 × 8 piece of mat board. If you squint while looking through the hole, you'll clearly see the interplay of values. For instance, if you're looking at a large tree, notice how the darks are gathered where the light doesn't reach. Notice the way the sunlight travels up the trunk on the sunny side. Notice the shapes of the shadows. (Yes, they have shapes and aren't just long streaks of gray, as some artists depict them.)

Success through "Negative" Painting

Negative painting is used successfully in many prize-winning pictures. You often see the technique used in forest backgrounds (in painting around tree trunks, for example) and in the fur of dogs and cats, where the clumps of fur are "described" by the paintbrush as darker colors worked into the lighter ones.

Put simply, negative painting is the painting of darker colors against lighter ones to define shapes and create the illusion of the darker areas receding in space. As you can see in my painting *Southern Lady,* below, I chose to paint the two lily pads in a medium value since the light was coming from the left. Then I painted around the lily pads and around the petals of the water lily and their reflections using the darkest darks—ensuring that the lily blossom would be the "star" of the piece. (By the way, reserving the whites and lights of your painting requires constant vigilance.)

TIP

In every scene you paint, always be aware of the position of the major source of light. Changing the location of the light relative to the center of interest will result in a completely different painting. For example, the midday sun, high in the sky, produces short, sharply defined shadows; late afternoon sun, by contrast, creates long, fuzzy shadows that become lighter in value as they grow more distant from the objects casting them. The sunlit sides of objects are generally about 40 percent lighter in value than their shadow sides. On buildings, the surfaces facing the sky are both lighter in value and cooler in temperature than are the vertical sides, which become darker and warmer as they descend toward the ground. Note, too, that shadows are often composed of several colors: Reflected light from nearby surfaces appears in shadows, which take on something of the tint of the object reflecting the light. If you don't incorporate these subtle variations of color into your shadows, they'll end up looking like slabs of cement.

SOUTHERN LADY
Mary Baumgartner

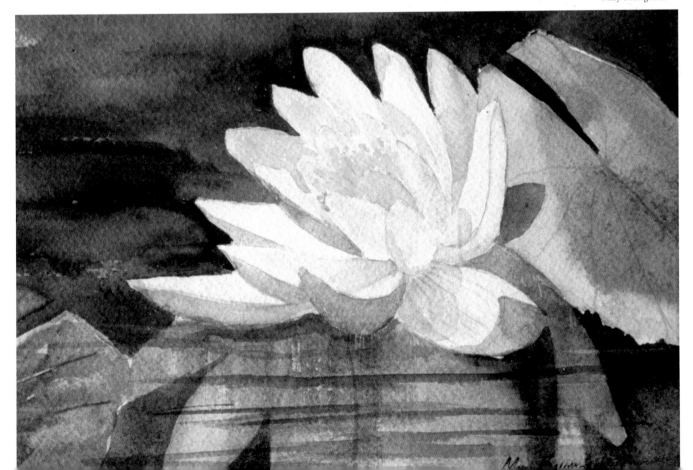

Success through Shapes

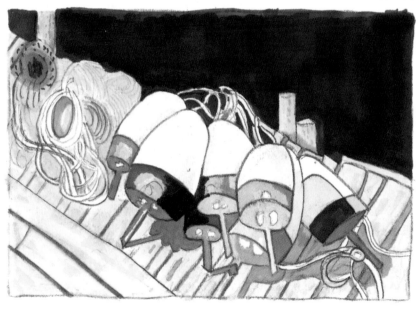

Let's return to the subject of shapes, which we began thinking about in the previous chapter. Now, we'll see how shapes can work together with value to create a successful composition.

For a painting of buoys gathered on a pier at the end of boating season, artist JoAnn Seipel-Finchum followed a method I often recommend to my students. First, she found a photo with strong eye appeal—and one in which the direction of the sunlight is clearly apparent. Then, she taped a sheet of tracing paper on top of the photograph and traced the major shapes.

I tell students to identify and trace at least thirteen to fifteen shapes at this stage. The shapes need not be individual objects; in JoAnn's traced drawing, the pile of buoys forms a single major shape.

Then, JoAnn did a value study for her painting. For her value study, she used the graded-value gray markers discussed above—both cools and warms, so that she could also begin identifying the temperatures of the colors she would use in her final painting. Note that, in the value study, JoAnn defined the painting's ultimate center of interest by reserving the whites and lightest lights for the pile of buoys. Note, too, that you don't really have to use markers for your value studies. You can get by with a standard number 2 pencil. Use the side of the pencil lead rather than the point so that you can shade in the various values rapidly and solidly. Then, after completing the value study, redraw the image in light outline on your watercolor paper.

Opposite is JoAnn's finished painting. You'll remember that, in the last chapter, I talked about how you don't have to slavishly reproduce all the particulars of the scene you're painting. Well, JoAnn has taken some very wise artistic license with the scene depicted in her reference photo. In that photo, the background beyond the edge of the pier appears to show stones and silt whose color is an unattractive brown. (I suppose the photo was taken at low tide.) Rather than using this background in her painting, JoAnn created the impression of water beyond the edge of the pier.

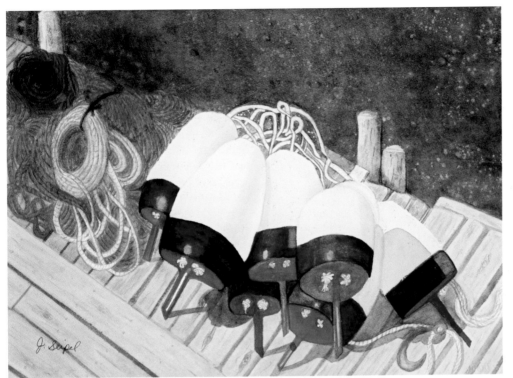

CLOSED TILL FATHER'S DAY

JoAnn Seipel-Finchum

As she worked on the painting, JoAnn remembered to leave the lightest lights and whites at the center of interest and to surround these with the darkest darks to ensure a very high contrast of values. Because the whites are so concentrated and flow from buoy to buoy, there's nothing that leads the eye out of the painting. By simplifying what was a rather complex photograph, JoAnn transformed the image into a charming painting.

STIPPLING TECHNIQUE

JoAnn created the impression of water with a stippled effect using the technique of blowing masking fluid onto the paper through a wire mesh screen, discussed on page 42. As the photos at left show, JoAnn first painted the masking fluid onto the wire. She made sure the rest of the drawing was covered so that the droplets would not land anywhere except where she wanted them. Then she blew on the screen, and little spatters landed in the area that would become the darkest dark. She then laid down a layer of color in that area, allowed it to dry, removed the masking fluid—and then repeated the whole process several times.

As she developed this area with several washes of several different colors, the value pattern began to emerge. Completing the darks in this painting took about five glazes and produced at least five values, which was a good beginning for the rest of the painting.

Success through Use of White Space

CONTROLLING THE VIEWER'S EYE

A well-planned composition keeps the viewer's eye within the painting. The general movement should travel from the center of attention in a counterclockwise direction around the painting, as shown by the path marked by the black arrows in the image at right. The image below shows the interplay of two S-curves—one marking the major lights, the other the major darks—in a carefully planned painting. Artist Mary Lynn Miller used this pattern of lights and darks in her painting of the purple gallinule, as can be seen when the S-curves are superimposed on the image at right.

Opposite page:
WEATHER WARRIOR
Mary Lynn Miller

Observe virtually anything—a parade, a housing development, a banquet table—and you'll notice that the whites are what first attract the eye. In a parade, a bandleader wearing white will seem most prominent—even if it is just a white hat. As you drive through a housing development, it's the white porches that will capture your attention.

As JoAnn Seipel-Finchum did with the painting of the buoys, artist Mary Lynn Miller has simplified a complex photograph to create her painting *Weather Warrior,* whose subject is a bird (a purple gallinule) that has lost its home because of Hurricane Katrina and that seems to be asking, "Now what do I do?" The center of interest is, of course, the bird's face, marked by the white area of its crown and the light red bill ending in a white point.

When beginning a painting, you must plan the center of interest very carefully. If many items or bits of scenery in the image contain whites, don't plan to paint all of them white. That would cause the eye to bounce all over the painting, and a viewer will feel unsure of where to look.

The eye should move through the painting without ever leaving the image, going first to the center of interest (which contains the lightest lights next to the darkest darks) and then traveling in a counterclockwise direction around the center of interest. If carefully placed, the lights in the painting will lead the viewer's eye around and around, not allowing the eye an exit.

The darks can lead a viewer's eye through a painting, too. If possible, plan your painting so that the darks and lights form two intertwined S-curves that move from the top of the painting to the bottom and back up again and that intersect at or near the center of interest. And always remember that the values of the corners of the painting should differ from each other; that heavier, darker colors naturally should predominate at the bottom of the painting; and that you should never use strong reds or whites at the corners, as these distract the eye and lead it out of the image.

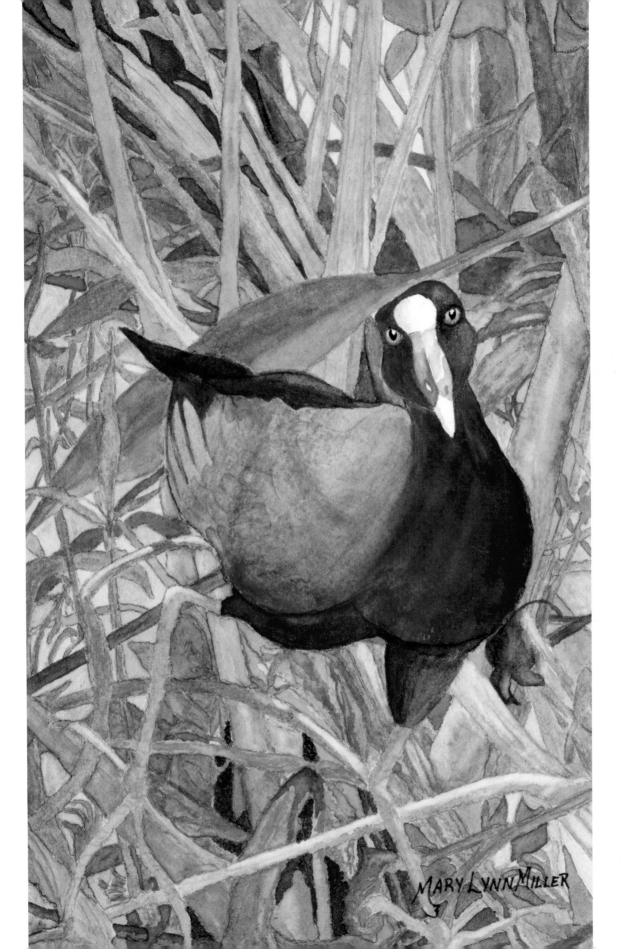

Success through Use of Transparent and Opaque Colors

When you look at a watercolor, your eye can distinguish the luster of the paper showing through the paint *if* the colors used are transparent. Opaque colors (including some of the cadmium colors), on the other hand, will saturate the white of the paper and prevent it from showing through. Their opacity will also obscure any underlying colors. It's important to practice with both transparent and opaque colors so that you understand their different effects. (Refer back to the Temperature and Transparency Table on page 19 to remind yourself which of the colors in the recommended palette are transparent and which opaque.)

The series of images on this spread shows an exercise that artist Jane Benson performed to discover the differences in the effects produced by opaque and transparent colors. Jane painted the same image of a flower twice, first using only opaque colors from our palette (both warms and cools) and then using only transparent colors (again, both warms and cools).

Understanding the effects of transparent and opaque colors (and of color temperature) will help you create paintings with emotion. Of course, some subjects seem to naturally stir emotional responses—an old, many-gabled house with a light burning in just one window; a beautiful sailboat with all its sails billowing in the wind; or a stand of colorful trees set against a sunny clearing in the woods. To get the most out of subjects such as these, however, you must understand your colors and how to use them.

Say you're painting a rooftop that must be left very light but needs dimension. Consider laying down a thin glaze of yellow. Let it dry. Then lay down another thin glaze on this area, this time using Rose Madder. Let it dry, too. Now, focus on the areas of your roof that fall into shadow, and glaze them with a thin glaze of Cobalt Blue. You'll have created magic simply by laying one transparent color on top of another and then another on top of that. The sky at sunset or sunrise can be painted in this same manner, but you've got to cover the yellow with Rose Madder—if the blue is added directly on top of the yellow, you'll create green. And the layers of paint must be transparent enough to let the luster of the white paper show through. This is the secret of transparent watercolor!

First, Jane drew the flower and used light blue masking fluid to protect the lines of the drawing.

Next, she used the opaque colors to paint the background all around the flower.

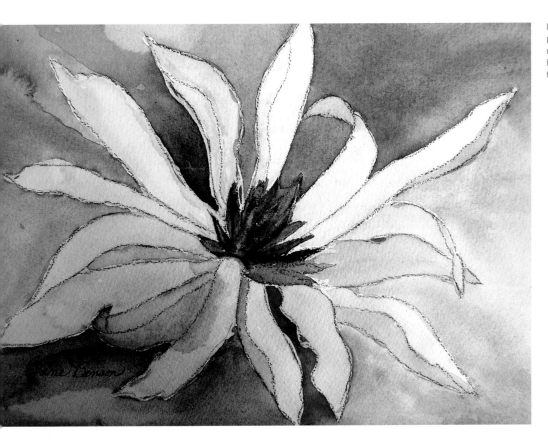

Finally, she completed the painting by removing the masking fluid and then using lighter washes of opaque colors for the flower's petals and center.

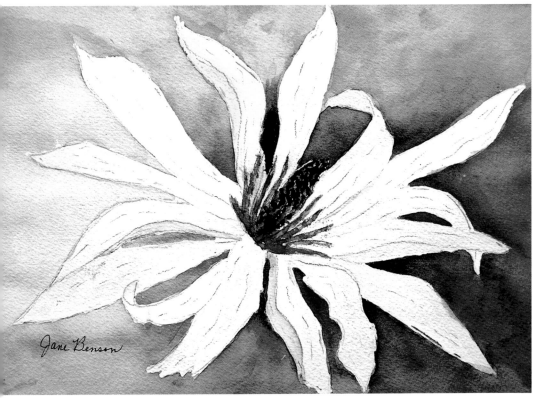

After doing the painting using only opaques, Jane followed exactly the same process using only transparent colors of similar hues. Just by glancing at the two finished paintings, you gain a good grasp of how different the effects are—even when the subject is the same and the hues are very similar.

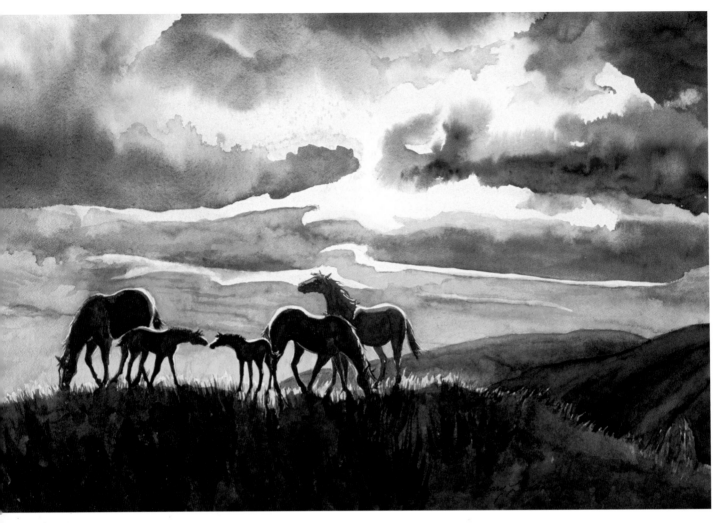

DEL MAR SUNSET
Mary Johnson

DEEP IN THOUGHT
Jossie Beck

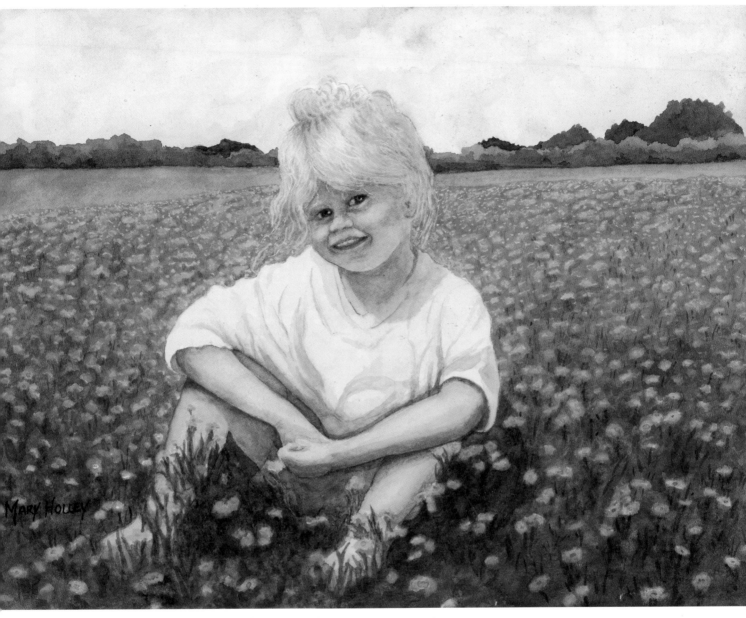

The painting of horses silhouetted against the sunset, opposite, by Mary Johnson, shows the magic that can be created by layering. In each landscape you paint, you will need to know the transparency and temperature of the colors you are using. Warm temperatures and transparent colors work very well in sunsets and in any full-leafed tree—spring, summer, or fall. Transparent, cool-temperature colors work well for scenes of the ocean, ponds, or swimming pools. Cool colors also work well in snow scenes, but, again, they must be highly transparent.

To create a moody, foggy or hazy atmosphere, you'll use grays—and knowing how to mix grays properly is absolutely necessary. Otherwise the fog will become too opaque—like cement—and not let other images show through. The Gray Chart Showing Complements (page 26) gives formulas for various grays.

You'll also need knowledge about the transparency and opacity of colors when doing portraits in watercolor, so that you'll know which paints to select for the skin, the hair, and, of course, the eyes.

LITTLE MISS SUNSHINE
Mary Holley

Success through Glazing for Depth and Value

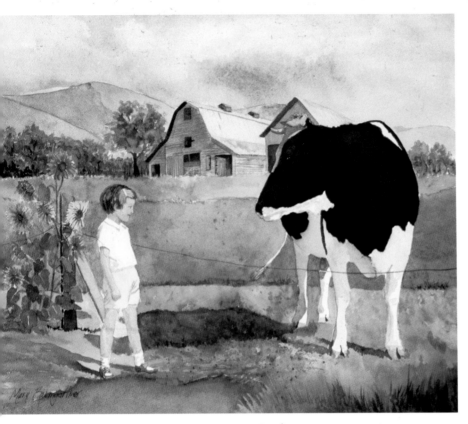

THE GRASS IS ALWAYS GREENER
Mary Baumgartner

The American Heritage Dictionary defines glazing as "a thin, smooth, shiny coating," and this is exactly how I usually use the term, since I mostly use glazes as finishing coats to build up the color in certain areas of a painting. Many watercolorists, however, define glazing differently, using the term merely to refer to the way watercolor is applied to paper—in layer upon layer of transparent color.

Let's stick with my definition for a moment, though. You may sometimes find that even when a painting is nearly finished, certain areas—particularly the dark areas—remain very dull-looking. From the color charts, you've learned how to mix darks that are very dark indeed, but this does not make them glossy or shiny, and if left alone, they'll be dull and boring. But if you simply lay a glaze over these areas, you can create colors that

are both dark *and* shiny. The secret lies in which colors you use to achieve this effect.

For glazing over dark colors, I often use Winsor Blue, Winsor Green, or Winsor Red. All these colors are made through chemistry (they're not natural pigments), and using them is like adding something to your car's engine to make it run better.

I used a technique like this when creating the cow in my painting *The Grass Is Always Greener.* I wanted to make sure that the black areas of the cow's hide were a glossy, lifelike black. (Black hair is never a true, colorless black. It always contains highlights of other colors, which is why it's essential to use other colors when creating the black.)

Paintings with problem areas can often be rescued by adding deeper backgrounds using glazes of Winsor Blue, Winsor Green, and, sometimes, Winsor Violet. Other glazing colors in our palette include Brown Madder, Cobalt Blue, Viridian, Raw Sienna, Winsor Yellow, and even Burnt Sienna. A Brown Madder glaze, for example, can be used to strengthen a brown that has "died" or to pop a color back to life in a flower painting. Cobalt Blue is usually used over a red to give a different cast to the passage. A glaze of Viridian can make a muddy green come back to life. (If this doesn't work, use Winsor Green.) A Raw Sienna glaze can be used to enhance the yellows in a painting or sometimes to tone them down. A Winsor Yellow glaze can make the yellows sparkle. Do be careful with Burnt Sienna glazes, though. Because Burnt Sienna is a tertiary color (composed of three primaries mixed together), it doesn't always help. Try it out on scrap paper first, and use it only to enrich the browns of baskets, tree trunks, or similarly colored objects.

The Glazing Charts on page 81 show how base colors are changed by adding glazes of one or more other colors. Because all the colors are transparent, the colors beneath continue to "glow" through the glazes laid on top of them.

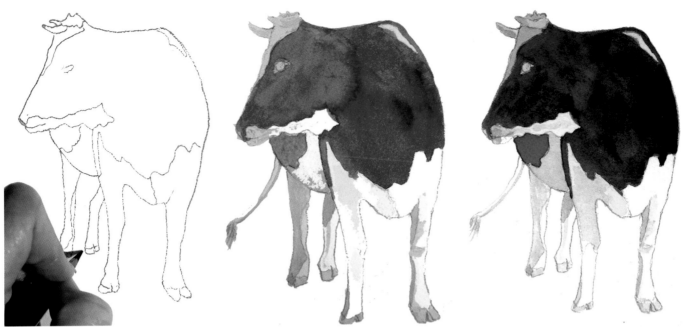

After drawing the cow (left), I laid down an initial layer of Winsor Blue over the areas that would become black (right).

After letting the layer of Winsor Blue dry, I covered it with a layer of Winsor Green, as shown.

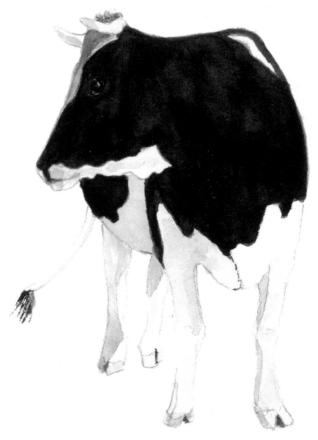

Next, I added a layer of Winsor Red. (Again, I let the previous layer dry before applying this color.) As you can see from the illustration, the dark areas of the hide have now become quite dark indeed, though some of each of the colors used glistens in the rich, dark "black" of the cowhide.

Even so, I found that the blacks were just a little too dull for my liking. To perk them up, I added yet another glaze—a thin glaze—of Winsor Blue to the dark areas, which resulted in the cow you see at left. Actually, a very thin coat of Winsor Green might have worked just as well to make the dark areas of the cow stronger and shinier.

Success through Glazing for Dimension and Perspective

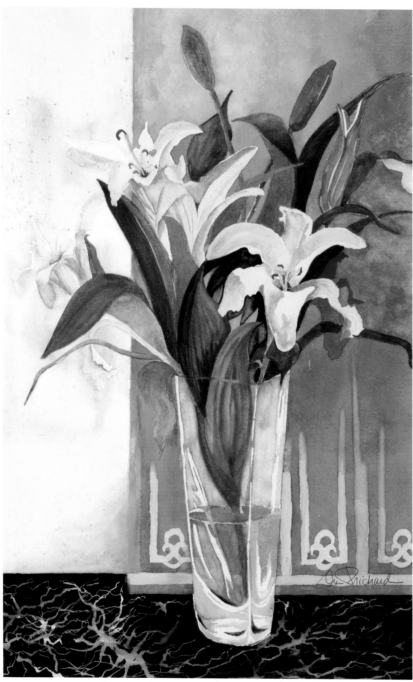

ORIENTALS
Doris Prichard

Paintings that are "flat" aren't as interesting as paintings with a definite foreground, middle ground, and background. Achieving this dimension is easy if you remember that warm colors appear to advance and cool colors appear to recede. Foregrounds should therefore be warm, incorporating some yellow hues—for example, Aureolin, New Gamboge, or Raw Sienna. The middle ground is still near enough to warrant using some warmer colors (such as Rose Madder). Backgrounds are normally cool, using colors such as Cobalt Blue.

For a still life painting, you can follow these principles by underglazing the foreground with a glaze of Aureolin, the middle ground with a glaze of Rose Madder, and the background with a glaze of Cobalt Blue. Doing this before you begin painting the objects in the scene will set the stage. (*Underglazing,* by the way, means applying a thin glaze of color to the white paper in areas that you will then paint on top of.) Artist Doris Prichard used this kind of technique for this painting of lilies, which won first prize in a juried show in which it was competing against 136 other works. Doris, however, reversed the procedure somewhat because she wanted the image to seem "backlit." To achieve that effect, Doris applied an underglaze of Aureolin to the background at the left.

When painting the flowers in her still life, Doris first gave an undercoat glaze to each flower and leaf using one of the three colors mentioned above—Aureolin, Rose Madder, or Cobalt Blue. Even if a composition has been well planned and the light and dark patterns have been resolved before you begin to paint, it still helps to "color code" the light, dark, and middle-ground areas. (And don't forget to leave the whites white!) A thin wash of Aureolin on the areas receiving the most light from the light source establishes the network of lights (which, as I've said, should follow an S-curve pattern through the painting). Then, paint the middle-ground flowers and leaves with a glaze of Rose Madder, followed by a thin coat of Cobalt blue on the background leaves and foliage.

INITIAL UNDERGLAZING

Doris applied a thin underglaze of Aureolin to the area that would become the screen behind the vase. In this image, the wash of Aureolin appears to have a slightly greenish tint, because Aureolin is such a cool yellow.

MASKING AND GLAZING

Here, Doris has applied masking fluid to the Oriental design on the screen behind the vase and also to the squiggly pattern of the veins in the marble. She then added a glaze of Winsor Violet to the marble and painted a light wash of Brown Madder over the screen.

ADDITIONAL GLAZING

Here, Doris has added a light glaze of Rose Madder to the area behind the screen. This will help produce the iridescent, "backlit" effect in the finished painting.

FINISHING THE MARBLE

After removing the mask from the marble, Doris dragged a damp flat brush over the marble, causing some of the surrounding color to seep or settle into the white veins. While the paper was still damp, she laid down touches of Winsor Blue and Brown Madder (very thin washes) on various places on the marble to create the variegated color of the stone. Then she removed the masking fluid from the screen behind the vase.

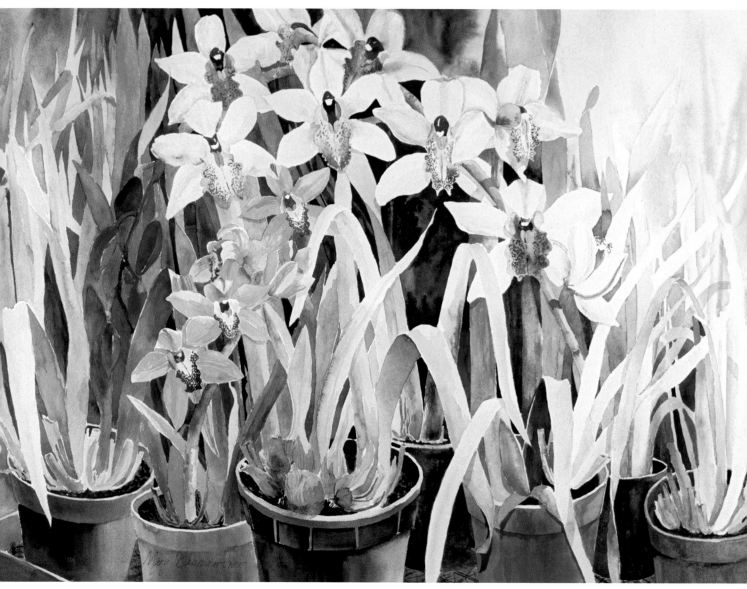

CYMBIDIUM SUNRISE
Mary Baumgartner

Initial glazes, or undercoats, can also be useful in scenes. If you're painting snow, wet the white paper and then dab the wet surface with Aureolin, Rose Madder, and Cobalt Blue, making sure that the colors have been watered down considerably. You want only a hint of color that will keep the snow from being totally white. In nature, sunlight shining on snow creates a prism effect that separates the light into primary colors. Although we think of it as pure white, snow actually shows a range of subtle hues. These underglazes, dappling the paper, will overlap in places and give the viewer hints of purples, oranges, and perhaps even greens.

I'm particularly proud of the still life shown above. For a watercolor, this is a huge painting—done on a 29½ × 41 sheet (the so-called double-elephant size). This painting required many glazes over the various leaves and stalks to get them to take their proper positions in the foreground, middle ground, and background of the image.

GLAZING CHART 1

The chart shows base colors, glazing colors, and combinations of color.

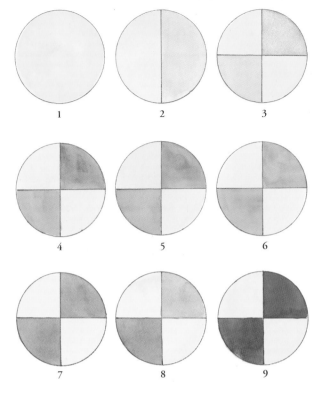

1
2
3

4
5
6

7
8
9

1. Begin by painting each circle with Aureolin. Let each dry before continuing.

2. Add Rose Madder on the right half of the circle.

3. Add Rose Madder to the lower left quadrant and Cobalt Blue to the upper right quadrant.

4. Add Brown Madder to the lower left quadrant and Burnt Sienna to the upper right quadrant.

5. Add Cadmium Red to the lower left quadrant and Winsor Red to the upper right quadrant.

6. Add Alizarin Crimson to the lower left quadrant and Opera to the upper right quadrant.

7. Add a mixture of Cobalt Blue + Aureolin to the lower left quadrant and a mixture of Cobalt Blue + Winsor Yellow to the upper right quadrant.

8. Add a mixture of Cobalt Blue + New Gamboge to the lower left quadrant and a mixture of Cobalt Blue + Light Yellow to the upper right quadrant.

9. Add a mixture of Winsor Blue + New Gamboge to the lower left quadrant and a mixture of Winsor Blue + Quinacridone Gold to the upper right quadrant.

GLAZING CHART 2

The chart shows base colors, glazing colors, and combinations of color.

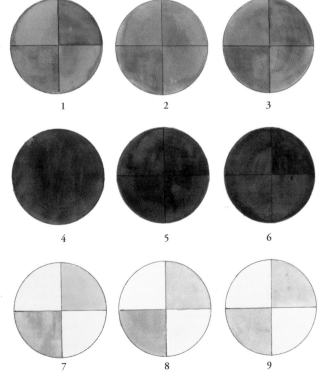

1
2
3

4
5
6

7
8
9

1. Begin with a dull green mixture of French Ultramarine + New Gamboge, let dry, and add Winsor Green to lower left quadrant and Winsor Blue to upper right quadrant.

2. Begin with a dull green mixture of French Ultramarine + New Gamboge, let dry, and add Raw Sienna to lower left quadrant and Winsor Yellow to upper right quadrant.

3. Begin with a dull green mixture of French Ultramarine + New Gamboge, let dry, and add Winsor Red to lower left quadrant and Winsor Violet to upper right quadrant.

4. Paint circle black with a mixture of Winsor Green, Winsor Blue, and Alizarin Crimson.

5. Paint black base coat, let dry, and add Winsor Red to lower left quadrant and Winsor Blue to upper right quadrant.

6. Paint black base coat, let dry, and add Winsor Green to lower left quadrant and a mixture of Winsor Green + Winsor Blue to upper right quadrant.

7. Begin with Aureolin, let dry, and add Raw Sienna to lower left quadrant and Yellow Ochre to upper right quadrant.

8. Begin with Aureolin, let dry, and add Winsor Violet to lower left quadrant and French Ultramarine to upper right quadrant.

9. Begin with Aureolin, let dry, and add Cerulean Blue to lower left quadrant and Viridian to upper right quadrant.

Success through Lifting Paint

Linda started by making a value study of the scene on sketch paper.

The image below shows the painting at a middle stage in its development. At this point in her process, Linda recognized that she wanted to make a number of changes, which she accomplished by manipulating the paint directly on the paper, using a large scrubber.

Lifting paint from the surface of a painting is another way to achieve color, value, and perspective—and to correct mistakes. This technique requires care, however, and is most easily performed on heavy paper. Painting on 300-pound paper is like painting on a wet sweatshirt. It retains a lot of water, and the paint can therefore be lifted relatively easily when necessary.

Let's look at the process that artist Linda Moreland followed when creating a painting of a waterfall in the Great Smoky Mountain National Park, in Tennessee. She intended to paint on a large (22 × 30) sheet of 300-pound paper.

Linda planned to create dimension in her piece by using masking fluid to save her lights, making sure that these areas would remain pure white until the final stages of the painting. (Some areas within the waterfall would, of course, remain white when the painting was completed.) She also wisely planned to incorporate many colors into the rocks and water. She therefore used lots of colors when laying down her initial glazes.

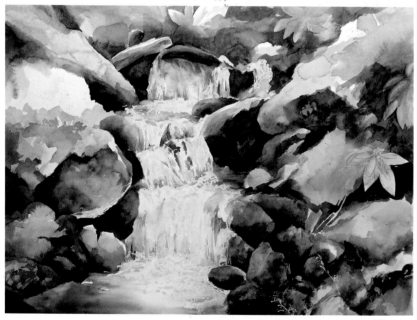

In the photo at right, Linda is lifting out part of a rock face that she feels needs to become a different color. She decided to change the pattern of the rock faces to the right of the waterfall because, as originally painted, the rocks made too vertical a line all the way down the side of waterfall. This nearly straight line distracted the eye from the painting's center of interest, which is the cascade in the middle. It took the eye too swiftly down the right side, not allowing the eye to linger on the center.

Above, Linda is repainting a portion of the large rock to the left of the center of the waterfall. By making it less jagged and having it blend in better with the surrounding rocks, she ensures that the focus remains on the waterfall itself and isn't distracted toward the left side of the painting.

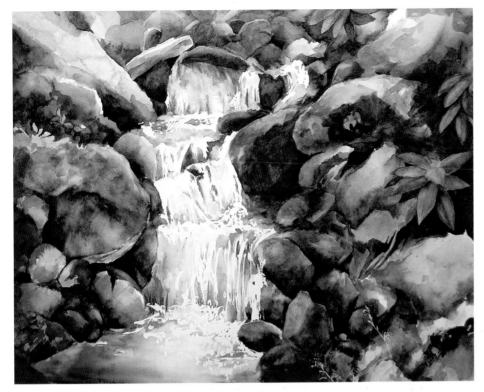

Here the picture has been "unveiled"—meaning that all the masking fluid has been removed. Real progress has been made: The values have been corrected so that the eye is attracted to the center of interest, and the rhododendron leaves, which Linda has also worked on, now look like real foliage.

At this stage, the artist must let the painting sit for a while before deciding how to finalize it. If you were critiquing the painting at this point, what would you change?

I advised Linda to lose some of the harder edges on the rocks at the lower right by scrubbing them out. I told her that the rocks needed to look as if they were actually sitting in the water and not tumbling down the incline.

Linda took the painting home with her, confident that it would require only a few minor changes. Her husband, however, immediately spotted a place where the painting needed a major change. Can you see it? It's a large shape just to the right of the middle of the waterfall— the shape that looks like the head of a very large snake!

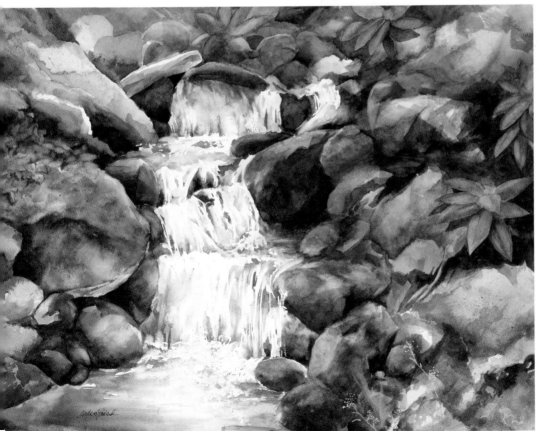

SMOKY MOUNTAIN SPRING
Linda Moreland

Needless to say, Linda had to remove that snake head. But she made other, subtler changes to the final version of the painting. As you can see, the waterfall contains many sparkling whites where the masking fluid was not removed until the very end. The shapes and sizes of the rocks near the bottom of the right side of the waterfall are better. Linda did keep the values and colors at the top of the painting the same, because these create the perspective needed to give the painting depth. The many lost edges near the top also convey a mystical feeling about the waterfall's source. The painting is now ready to be matted and framed.

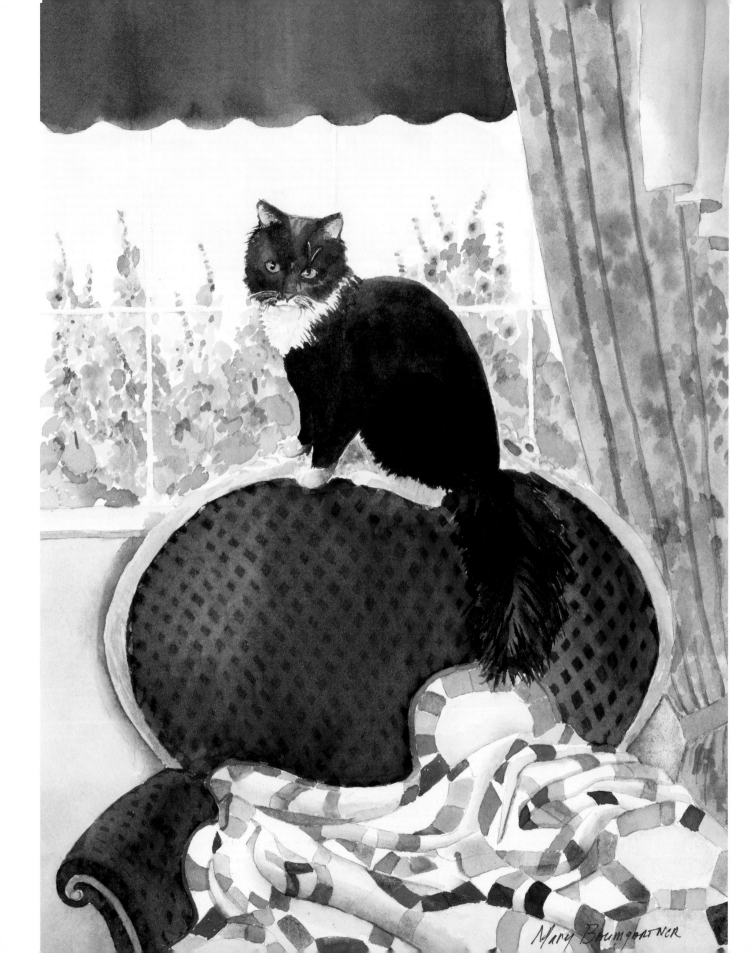

Mary Baumgartner

DRAWING SKILLS

Capturing shapes accurately is essential to good drawing. Before drawing from life, take your sketchbook and draw a bunch of circles using the top of a juice glass as your template. Now, see how many different things you can make from these circles—a tire, a spool, an orange, a wedding ring, or anything round that comes into your head. Then do the same thing with several squares, rectangles, or triangles, making them into real things—a wagon, a box, a kite, a computer screen, and so on. Now that you've seen how many things you can make from basic shapes, go on to the next stage—doing thumbnail sketches.

Drawing Shapes

Start with a couple of sheets of sketch paper. You'll do several thumbnail sketches on each sheet. Each thumbnail should be no bigger than 3 × 4.

The purpose of this exercise is to make a good composition. The first step, of course, is to decide on a subject for the drawing and, more specifically, what the focal point, or center of attention, will be. Once you've identified it, the next step is to draw this focal point—making sure it is in the correct position—followed by the supporting elements of the drawing.

Part of the fun at this stage of the game is that you have not yet committed pencil or paint to your pristine, expensive watercolor paper. You have simply drawn a few rectangles on sketch paper and are seeking a good composition.

Look at the setup or scene you're drawing and begin to identify the major shapes. If it's a still life, you'll see the shapes of the fruits or veggies and the other objects—the bowl, the candle, or whatever else the setup includes. Notice that a pear is basically a circle extended into an oval. A banana is a long rectangle whose ends curve. A bowl is a circle with the top cut off, and a candle is a vertical rectangle.

Landscapes can also be broken down into basic shapes. A two-story, pitched-roof house is two rectangles, one on top of the other, and its roof is a triangle with a rectangle attached.

The same goes for portraits. Human faces and bodies are also composed of basic shapes. Artists use various calculations to help them draw people. My favorite trick when drawing faces is to think of the head as an egg shape and then simply to angle it into any position, with the pointy end of the egg shape representing the chin.

In drawing the whole body of a standing figure, you have to pay attention to how the weight of the body is distributed. No matter how the head is positioned, follow an imaginary line from the head down to the feet and then position the legs in the proper places—the places, that is, that allow them to support the weight of the upper body and head. The top of the torso can be conceived as a square or a triangle; the bottom half as another square, or a reverse triangle for the pelvic area. Each leg is two long rectangles or cylinders joined at the knee. Studying the shapes of the things you draw simplifies the picture. Refining those shapes into the actual subject becomes a relatively easy matter if the basic shapes are right.

TIP

Often, artists can draw one side of a curved object well but have trouble replicating the curve on the other side, which makes the finished object look lopsided. If you have trouble drawing curved objects—pots, bottles, vases, chair seats or backs—try the following trick. After drawing the object on your tracing paper, mark the center of the object with points at the top and bottom. Then transfer the "good side" to your watercolor paper, not going beyond these center marks as you redraw the lines. Remove the graphite transfer paper. Now, flip the tracing paper over onto its back, and line up the two center marks with the half of the object that appears on your watercolor paper. Tape the tracing paper in place, slide in the transfer paper, and trace the same (good) side again. This will produce a mirror image of the satisfactory side. The technique works well with bottles, bowls, and other curved or circular items in a still life.

Opposite page:
LADY OF LEISURE
Mary Baumgartner

Selecting the Right Thumbnail

After you've drawn four or five thumbnails, it will suddenly become evident which has the best composition and will ultimately make the best painting. Remember to keep the focal point of the painting in your mind at all times, so you won't lose your way.

Here are three thumbnail sketches I did when preparing for a painting of a house called Bellwood. Can you tell by glancing at them which has the best composition and a clear focal point?

I thought the thumbnail at the bottom of this page was the best, and I based my painting *Bellwood* on it. In the finished painting, the focal point (the corner of the house and the area leading to the entryway) is surrounded by white snow and further defined by the use of complementary colors—the house's walls are mostly Raw Sienna, and the sky is a deep violet-blue color made of a mixture of equal parts Winsor Blue and Winsor Violet.

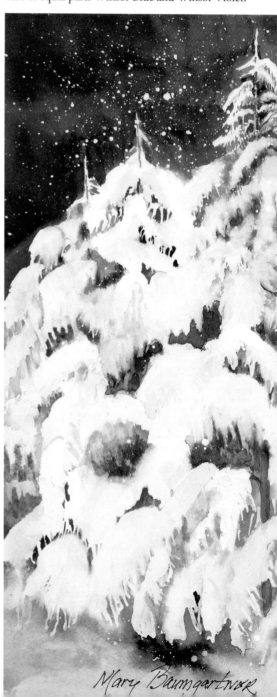

Mary Baumgartner

BELLWOOD
Mary Baumgartner

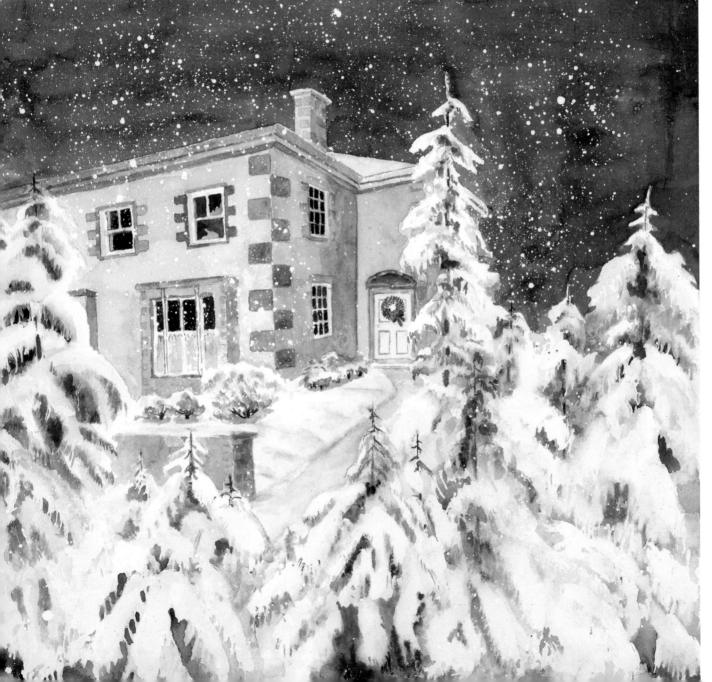

Creating the "Working" Drawing

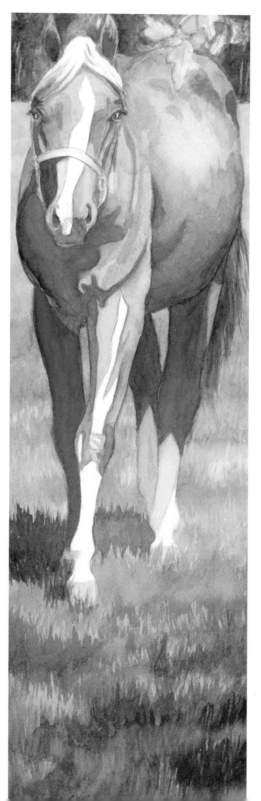

You shouldn't go directly from the thumbnail sketch to beginning the painting. You may want to do a value study, as described in the previous chapter, but at the very least you should create a full-size "working" drawing that you can then transfer to your watercolor paper.

Take a piece of tracing paper from your pad (or, if your painting will be very large, tape two or three sheets of tracing paper together). Now let the drawing begin. By working on tracing paper, you can erase, redraw, erase, and redraw again as often as you need to without worrying about ruining the surface of that expensive watercolor paper.

As described in an earlier chapter, once the tracing-paper drawing is complete you'll lay it over the stretched watercolor paper, slip a sheet of graphite transfer paper in between, and redraw every line of the drawing in red ink. Make sure the tracing paper is securely taped to your board at the top, and do check often to see that the drawing is transferring to the watercolor paper properly.

There are many ways to improve your drawing, but the best way is to draw frequently, especially "on location." Many artists don't like this experience, but it does sharpen your drawing skills and your awareness of the world around you. You can hear the birds singing and the bees buzzing, and you can sense the people who sometimes stop and stand behind you to observe your work. Studying shapes in natural settings and seeing how light falls upon objects cannot be beat for a learning experience.

Learning about Light

Learning about light is the next step in sharpening your drawing skills. For your paintings to be successful, light, shadows, and reflections must be drawn and painted accurately. Trees—even trees that, in leaf, have basically circular shapes—cast elliptical shadows. If you are drawing a scene that includes water, the shapes reflected in the water must be drawn precisely as they appear on the water's surface. Joan Clark's painting *The Red Boat,* (below), illustrates the differences between painting shadows and reflections. In this painting, the shadows of the posts alongside the dock bend as they extend over the wall of the dock; as reflected in the water, however, the posts bend in the opposite direction from their angle above the water, thus forming watery mirror images of themselves.

Observation is critical. For the painting of my husband's hands as he played his clarinet (page 90), I not only had to be able to draw Stan's

THE RED BOAT
Joan Clark

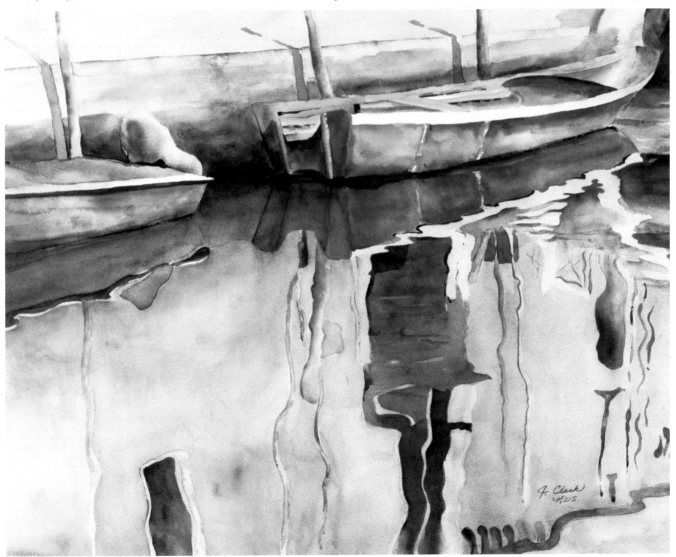

hands properly, but I also had to carefully observe the structure of the clarinet to ensure that the result was realistic. Nothing would have been worse than to have some musician come by and tell me that I had one of the keys in the wrong place! Even my husband's West Point class ring had to have the proper detail.

In the scene I was painting, Stan was sitting in the courtyard on a beautiful California day. The stucco wall behind him was brilliantly lit by the sunshine. This composition would not have worked if I hadn't given strong consideration to the darks and lights—including the way the sunlight hit the tip of the little finger and the area just below the thumb on Stan's right hand. These bright white shapes are critical to the painting's success. Notice, too, how the lighter green shade in the area just above Stan's fingertip at the left shows that light has traveled into that area.

RIGOLETTO
Mary Baumgartner

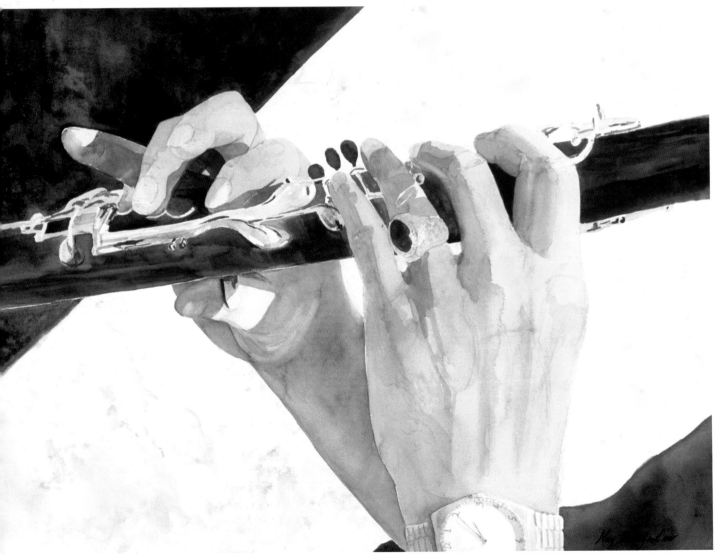

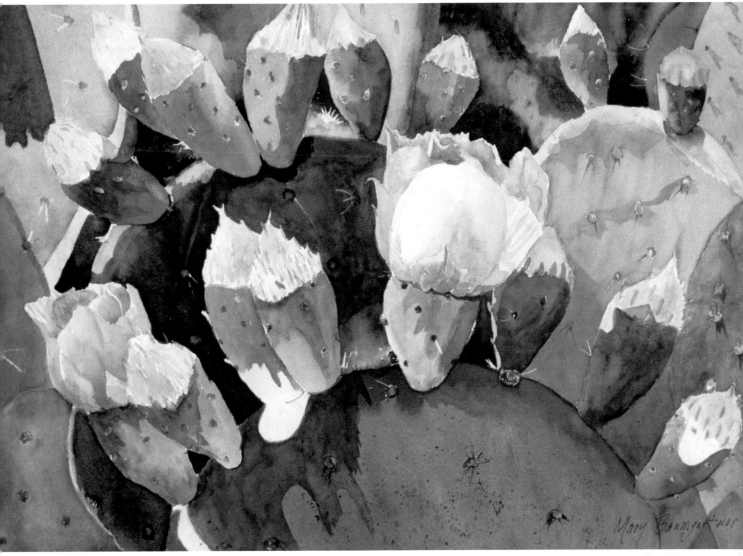

DESERT SHERBET
Mary Baumgartner

I began the painting of the cactuses on location at a lovely desert town in San Diego County at the beginning of the tourist season, when the desert was in full bloom. I didn't finish it there, however. After taking many pictures and doing lots of thumbnails and sketches, I completed the painting in the studio. My objective was to heighten the contrast between the warms and cools, the lights and darks, while making sure the painting contained a lot of color.

The center of interest is obviously the central player in my theater of buds and partly open blossoms. The supporting cast does a good job of holding the viewer's interest. The title of the painting, *Desert Sherbet,* is a play on words—an appropriate pun, I think, since the little buds all look like ice cream cones and the color of the blossoms makes me think of raspberry sherbet.

It is, by the way, very important that artists name their paintings—and the more enchanting the painting's name, the more likely it is to sell. This has been proved time and again at the many art shows my group has given in San Diego. I'm sure we've all attended shows where paintings have dull names—things like "Pears on a Plate #3." But paintings with such names—especially names that indicate that a painting is just one of a series—don't do well in shows. Such titles aren't meaningful or mysterious enough to attract buyers.

DRAWING SIMPLY

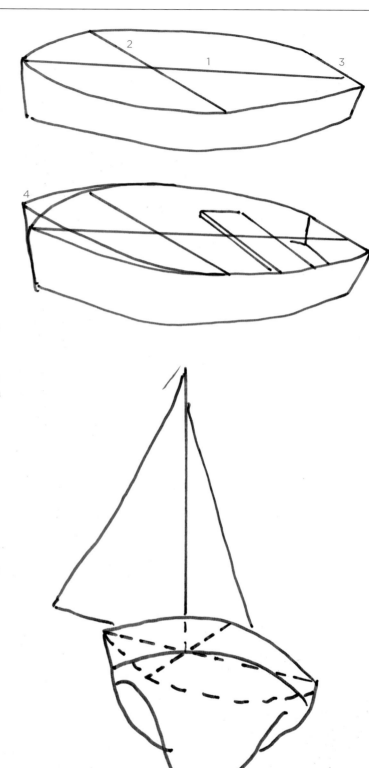

Learning drawing shortcuts is important so that you can capture basic shapes quickly. Here are some techniques that you can use to draw boats and flowers swiftly and correctly.

Many painters like to paint water scenes including boats, but boats are hard to draw correctly. A workshop teacher passed this tip on to me long ago, although I've refined it to include several different types of boats seen from different angles. Try practicing it yourself to see how many different boats you can draw correctly. Here's the procedure:

1. First, draw a straight line from the bow to the stern.

2. Then, draw a second, intersecting line that crosses the boat at its widest point, about a third of the way back from the bow.

3. Next, draw a short line at the stern, making sure you have the perspective right.

4. As you finish the outline of the boat, make sure you raise the lines leading up to the bow. (That's just the way boats are built.)

Below are two more boat drawings. Although the boats and perspectives differ, these sketches were done following the steps given above. After you've studied these drawings, try tracing them and then drawing them by yourself. Then, practice drawing different kinds of boats—sailboats, powerboats, racing boats, fishing boats—in various positions until you've mastered the trick.

Here's another little shortcut—one you can use when painting flowers. As I'm sure you've noticed, petals and leaves sometimes have little twists. To capture those twists, draw a figure-8 shape; the place where the curving lines of the 8 intersect is where the twist occurs. I used this technique when drawing one of the petals of the sunflower in the painting on the opposite page. By comparing the little sketch with the painting, you'll instantly see which petal this is. After drawing the figure 8, you'll have to slightly widen the area where the lines cross to convey the shape of the twisted petal or leaf realistically.

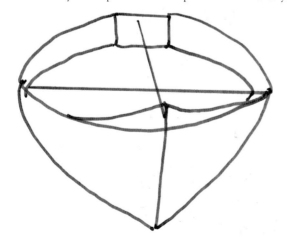

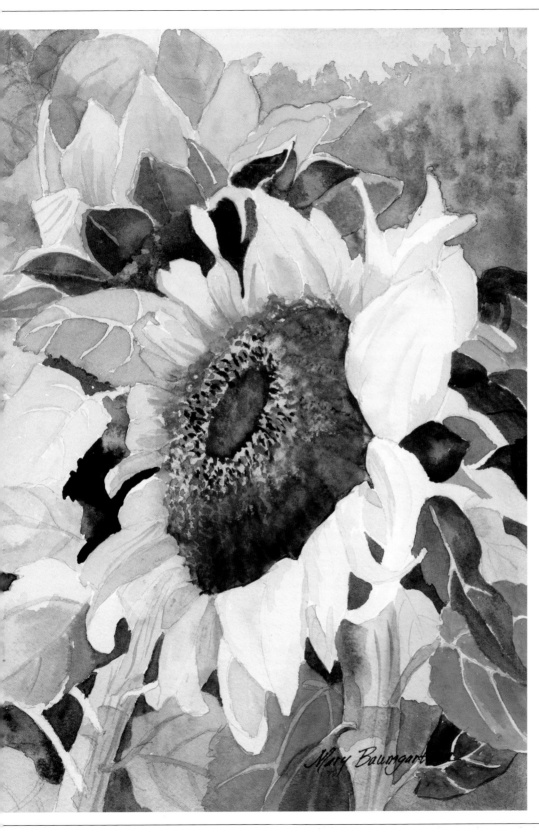

Mary Baumgart

Using Reference Images

A long time ago, before I'd even thought about fine art as a career, I started taking photographs of the interesting things I saw in my travels. As time went on, I became a better photographer, and my photographic files swelled. Now, twenty-five years later, I have a priceless collection of photographs that any of my students may use as reference materials or, if a photograph has a good composition, as the basis for an entire painting.

Having a collection of photographs you've taken yourself can stimulate your creativity and fill a need when you're looking for good subject matter. In my photo collection, I have files of flowers, and then other files that show flowers in close-up so that I can study the detail. I have files containing images of animals, houses, landscapes, and just plain miscellaneous photos. Any of the hundreds of photos in my collection might lead to a painting.

You should begin building such a library of reference images for yourself. Make sure you get a good camera, and that you have prints made (or that you print the images yourself) even if you use a digital camera, since it's so much more convenient to work from hard copies than from images appearing on a computer screen. As you build your collection, devise a filing system that works for you. Your categories and file names might include these: Animals, Barns, Bridges, Flowers, Gates, Houses, Landscapes, and Snow Scenes.

When purchasing a camera, be sure to buy the best you can within your budget. If you don't know much about cameras, make sure that the one you buy has lots of automatic features. You'll also need a zoom lens of at least 28–85mm. This will allow you to get some great close-ups of flowers, roots, and even insects, while also enabling you to take great shots of a building across the street without having to back up to take the picture.

TIP

It is illegal to copy someone else's photographs or artwork in your own painting without written permission. This is copyright infringement and could involve you in a lawsuit. Moreover, there are some materials that are also protected under trademark law. Using trademarked images (which include logos, product designs, cartoon characters, and even some well-known places—like Disneyland—as well as images of celebrities) can get you in serious legal trouble. Painting a sports scene using real players' numbers or uniforms is also very risky, since in such a case you might be infringing on three trademarks—those of the team, the player, and the league. So before you shoot reference photos or paint paintings of a well-known image or scene, make sure you obtain written permission from the trademark's owner to use the image in your work. Penalties for infringement, whether of copyright or trademark, may include destruction of the artwork and the payment of damages (as well as attorneys' fees).

PHOTO FILES
I keep my photos organized by category; the Photograph Organizer files shown (made by Fotoshow; www.fotoshowinc.com) are easy to flip through when hunting for an image.

Taking Drawing Workshops

One of the best ways to improve your drawing skills is to take a few workshops. But be forewarned. During the first day of a workshop, your ego will gasp for breath. By the second day, your ego will have died a painful death. At every workshop, there will always be someone who draws better than you, and you'll always be embarrassed by the work you produce. By the end of the workshop, however, you'll have picked up a lot of useful information to be processed. You will also have been exposed to critiques that make you think of art in a new and different way.

Most workshops I've attended—and most of those I've taught—have been "on location" workshops. Drawing on location helps students develop far faster than they do in a classroom. But be sure that you carefully weigh the desired end result against the pain you'll experience during the workshop before you sign up. At one workshop I participated in, some of the students spent a day in their motel room crying because of the pressure!

GRAPES OF GRAFT
Mary Baumgartner

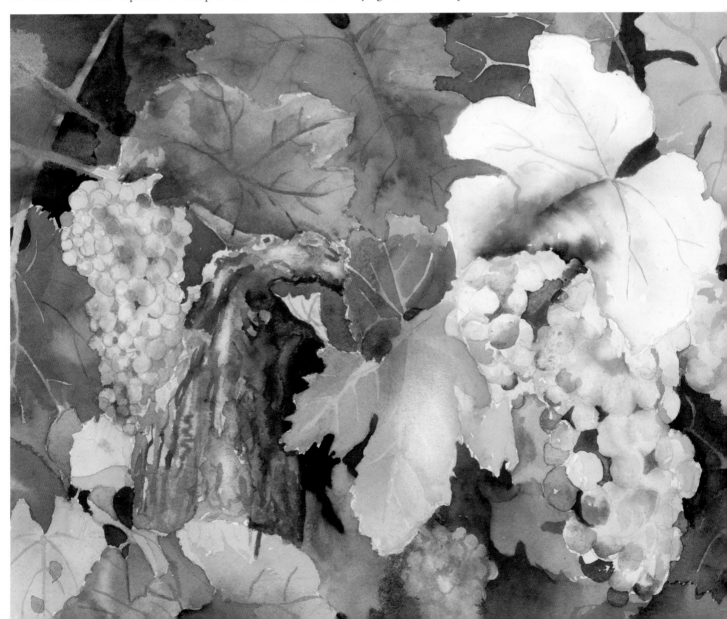

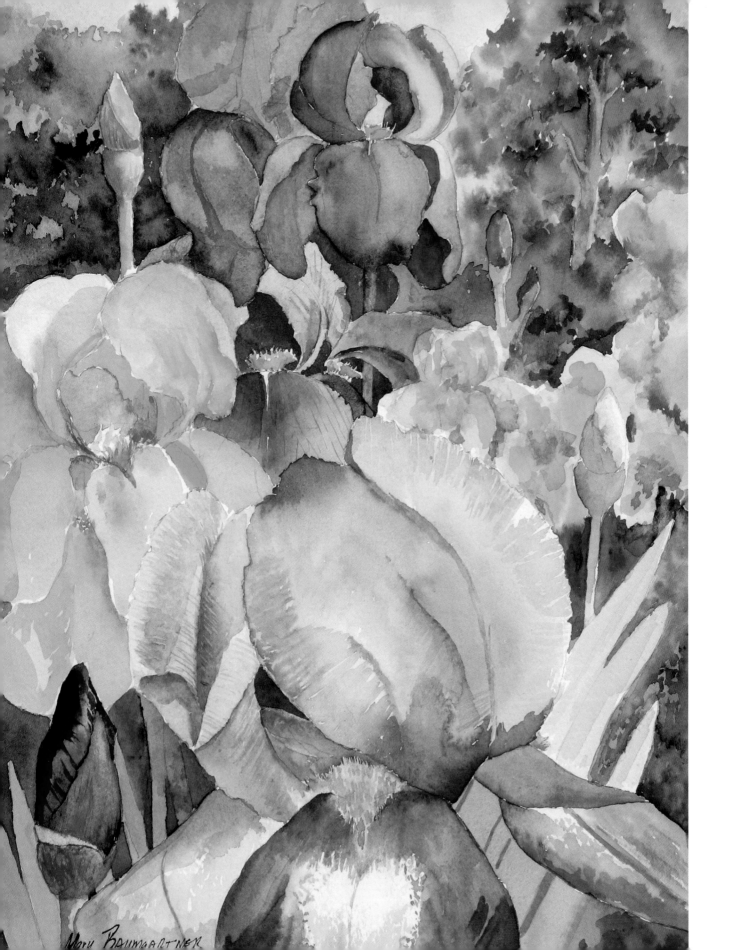

Mary Baumgartner

THE HARD STUFF
Made Easy

Opposite page:
SPRING FLING
Mary Baumgartner

When beginning work on *Table of Color* (page 98), I placed several types of fruit in a pewter bowl and arranged it and a silver pitcher and a potted amaryllis (sitting on a copper plant stand) on a dining table. Behind the table, I placed a wooden dining chair with an upholstered seat. A window with sheer white curtains completed the setup, creating what I thought was an interesting combination of elements—and of colors.

When I started drawing this still life, however, I found that the arrangement just didn't work. My first sketches had to be adjusted rather drastically to come up with the proper composition. I used the computer to achieve the right balance among the elements. Choosing the sketch that I liked best, I completed it to the point where it could be photographed with the digital camera. When I downloaded the photo and looked at it on-screen, I immediately noticed the areas where the composition wasn't working.

As you can see by that original drawing, at right, it was the pitcher's position—and the fact that I'd drawn it at such a straightforward side view—that was giving me the most trouble. The pitcher's handle and the bananas hanging over the edge of the pewter bowl were creating too much conflict near the left edge of the image. After I went a step further and used colored pencils to color in the entire sketch, it became even more apparent that something had to be done. Then, using Adobe Photoshop software, I cut out the pitcher and moved it a little closer to the center of the image. Sad to say, that didn't work either.

Recognizing that nothing more could be done, I started over: I set up the composition again, this time turning the pitcher slightly so that I could view more of its mouth and spout—and so I could see how the handle actually connected with the pitcher's body. When I redrew the arrangement, I could tell the difference immediately. After I'd worked out a few other, more minor details, the drawing began to look the way I felt it should. It was only then that I

A PROBLEMATIC DRAWING
This composition doesn't quite work, because of the position of the pitcher at lower left.

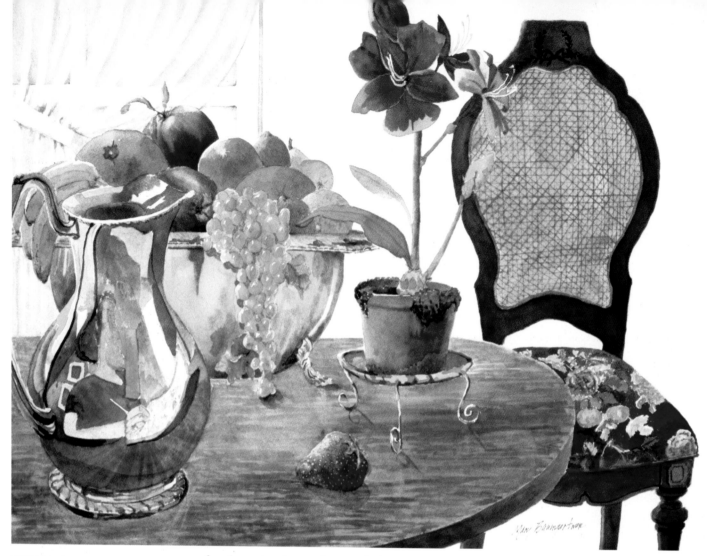

TABLE OF COLOR
Mary Baumgartner

transferred my drawing to the stretched watercolor paper.

The painting that eventually resulted from this adjusted drawing works well, I think—not just as a composition but as a study in how to paint various metals—the shiny surface of the silver pitcher and the duller surface of the pewter bowl. That's why I'm using it in the introduction to this chapter, which is a series of lessons on painting the kinds of things—reflective surfaces, basketry, clouds, and so on—that beginning watercolorists often find so daunting. As you'll see, your fears—though genuine—aren't necessarily well founded. By applying a few tricks of the trade, you'll soon master "the hard stuff."

Before we leave my *Table of Color* behind and get into the meat of this chapter, however, let me mention one other thing. When this painting was finished, I encountered a surprise. While I was painting the still life, I was also doing a little

portrait of myself. Yes, that's me, reflected in the pitcher at lower left. Of course, it's a portrait in reverse—just like in a mirror. It shows me as right-handed when I'm really left-handed.

TIP

The flaws in my drawing were immediately apparent when I looked at the photo on-screen, but there are other ways of detecting composition problems. If you don't have a digital camera or computer, try looking at your initial drawing through a reducing glass. A reducing glass resembles a magnifying glass but works in just the opposite way: Everything appears smaller through its lens, and looking at this smaller version can help you see composition errors more easily. Another method is to hold the sketch up before a mirror: Seeing the image in reverse can also help you understand whether the composition is working—and give you ideas for correcting it.

Painting Silver

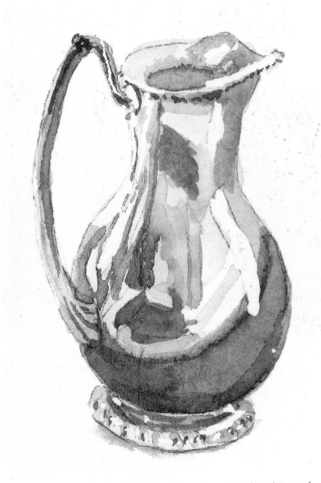

For the exercise of painting a silver pitcher, I used a mixture of Cobalt Blue and Yellow Ochre for the basic metallic gray of the pitcher's surface. The initial washes were extremely watered down. (You could also use a combination of Winsor Green and Alizarin Crimson to achieve the same effect.)

Step 1. After finishing your drawing, use masking fluid to conceal those places where the reflective surface is brightest—the whites and the very lightest lights. Then, lay down a very thin initial wash, or glaze, of gray. Although you're covering the entire (unmasked) surface of the pitcher with this wash, you'll be adding color on top of it as you go along. Only the second-lightest portions of the surface will remain this very light gray color.

Step 2. Now, still working with the gray composed of equal parts Cobalt Blue and Yellow Ochre (or Winsor Green and Alizarin Crimson), lay down a second layer that's about 15 percent darker than the first. This layer should cover only those places where you see the next-darkest reflections in the silver.

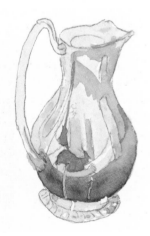

Step 3. My pitcher was sitting on a relatively dark wooden table; therefore, I had to capture the table's reflection curving around the bottom of the pitcher and up the right-hand side. To capture that brown color, I used a mixture of French Ultramarine and Burnt Sienna. (Obviously, if the silver pitcher were resting on a blue surface, the color added at this stage would be blue.)

Step 4. If you're sitting close to the silver object you're painting, you'll see yourself reflected—in a distorted and somewhat unclear way—in the object's surface. To capture my reflection, I painted the shapes and colors I saw: the green of my clothes, the reddish color of my hair, and a skin color composed of Raw Sienna, Cadmium Red, and Cobalt Blue. Try to paint *exactly* what you see in the metal's surface—not what you imagine your reflection looks like.

Step 5. For the final color I added to the surface, I used a mixture of equal parts of Winsor Blue, Winsor Green, and Alizarin Crimson. The dark gray that resulted was perfect for conveying the very darkest reflections. (You could also use a combination of Winsor Green and Alizarin Crimson at this stage; this mixture will require less water.) Once this last layer is dry, peel off the dried masking fluid and see the beautiful silver object you have painted!

Painting Pewter

Pewter isn't nearly as reflective as polished silver, so you'll need to follow a different method—using different colors—to achieve the duller, more matte surface of this metal.

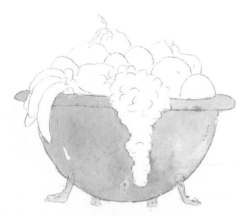

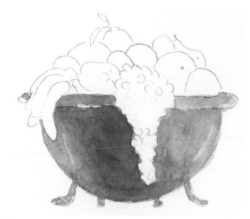

Step 1. I first applied masking fluid to the places where I discerned the brightest highlights—on the sides of the bowl and at the edge of the rim. (These are a good deal dimmer than the bright-white highlights in polished silver, but the mask was used to protect these areas only during this first step.) Then, I began with an initial wash composed of a mixture of about 60 percent Cerulean Blue and 40 percent Indian Red. These two colors are both grainy; when water is added to the mixture, it conveys the matte finish of the pewter very well. When this wash was dry, I added a thin wash of Winsor Violet over the whole bowl and let this dry. To deepen the color, I added another wash of the Cerulean Blue/Indian Red mixture to the darker areas of the bowl's surface (at the bottom and in the middle, to the left of the grape cluster).

Step 2. After the initial washes were dry, I removed the dried masking fluid and painted over the first color with another light wash of Winsor Violet, blotting it on each side, to let the whites preserved by the masking fluid show through. At this point, I had to think about the light again. The darkest part of my bowl was the area to the left of center. (The light was coming from behind the bowl on the right side.) You, too, will have to notice where your light is coming from—and, consequently, where the darkest areas of your pewter object are. I also noticed that there was some reflected light on the left side of the bowl, so I had to be sure to leave that area lighter, as well. So I brushed plain water over the areas on the right and left that needed to be lighter and blotted them until this effect was achieved.

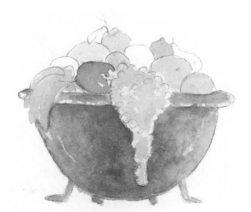

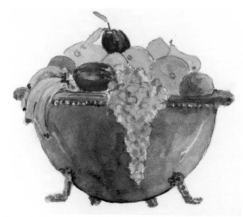

Step 3. As you see, my bowl was filled with fruit, so at this point I began to paint the fruit by laying down initial layers of the appropriate colors.

Step 4. I then finished painting the fruit and added detail to the bowl with a dark mixture of equal parts of Alizarin Crimson, Winsor Blue, and Winsor Green.

Painting Brass

Painting brass is a simple process if you follow steps like these:

Step 1

Step 2

Step 3

Step 4

Step 5

Step 6

Step 1. For a painting of a bowl and candlesticks, I used masking fluid to cover all the places where I saw white in the reflections on the surface of the brass. When it dried, I used a thin coat of Aureolin as a first wash over the entire surface of the brass objects.

Step 2. After the Aureolin wash was dry, I used a slightly darker wash (using less water) of Winsor Yellow for those areas that appeared a little darker.

Step 3. Once that color had dried, I added areas of New Gamboge to those places where even less light was reflected in the brass.

Step 4. Then, I added spots of Raw Sienna to build a foundation for the darks.

Step 5. Now, I smoothed out the edges between the layers of colors by applying a thin wash of pure Lemon Yellow over the entire surface of the brass. When this had dried, I removed the masking fluid.

Step 6. Finally, I darkened the darkest-yellow areas with Quinacridone Gold. The deep darks were made with a mixture of equal parts of Quinacridone Gold and Winsor Violet. Winsor Violet, which is made from artificial pigments, works well when applied over yellows to add depth and shadow. (Note: For the candles in this painting, I first applied masking fluid to the areas that would remain white. When that was dry, I painted both candles with Winsor Red, let that dry, then added Alizarin Crimson along the side edges of each candle to make the candles appear rounded. I then removed the masking fluid and brushed the white areas with water to soften the edges and to create the illusion of reflected light.)

CHROME AND GOLD

Painting chrome is nearly like painting silver (page 99), except that you must use more masking fluid—in more, and smaller, areas—to capture the mirrorlike surface you are trying to convey, as in the chrome-plated hubcap and bumper in this painting by Joan Ward.

Painting gold requires almost the same procedure as painting brass (page 101). To convey the mellower color of gold, use more Raw Sienna when you paint the darker areas. Be careful, however: The paler areas of a gold surface have a lighter tone than the paler areas of a brass surface. (If you compare a gold earring to an object made from brass, you'll immediately see how pale the yellows in real gold are—and the subtlety of the gradations of tone as the contour of the earring moves away from the light. So treat objects made of gold with a very light hand.)

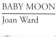

BABY MOON
Joan Ward

Painting Crystal

Painting crystal (or any kind of clear glass) has as much to do with what is *not* there as with what is. In other words, you've got to convey the *invisibility* of the clear glass. The only colors come from objects behind, inside, or reflected on the surface of the clear glass object. As it turns out, that can be quite a lot of color, but you've got to handle the whites very carefully, and you also must distinguish between the truer (and often deeper) colors and harder edges of the nonglass objects and the colors of those same objects as they appear when reflected in or enclosed by the glass. You should paint crystal only when you're willing to spend the time necessary to achieve the illusion of glass.

As with any painting, a watercolor of a crystal object begins with your selection and arrangement of the object you wish to paint, followed by your drawing a well-balance composition. Artist Mary Lynn Miller's *Passing Shadows* is certainly a successful composition. Let's look at the steps she followed in creating the very realistic crystal of the vase.

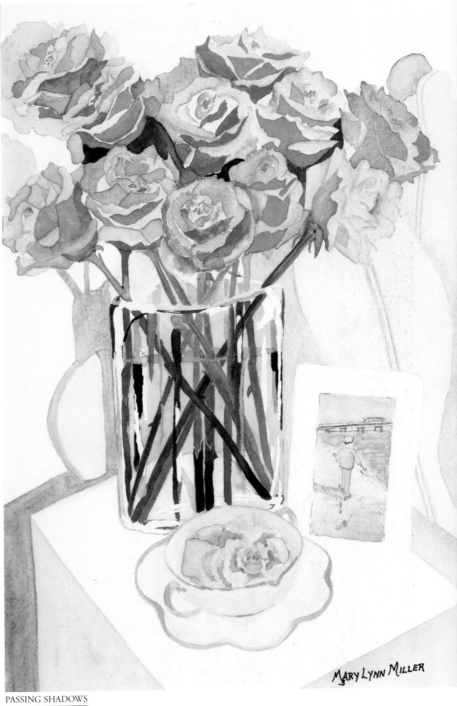

PASSING SHADOWS
Mary Lynn Miller

Step 1 (above left). To begin, Mary Lynn used masking fluid to cover the places where bright white light was reflected in the crystal—and which would therefore remain pure white when the painting was finished. Then, following the rule regarding which colors to use as base washes for objects in the foreground, middle ground, and background, she gave the rose stems in front a pale underwash of Aureolin, those in the middle an underwash of Rose Madder, and those toward the back an underwash of Cobalt Blue. When employing this technique, do make sure that each wash is dry before you apply the next.

Step 2 (above). Mary Lynn then overpainted each stem, remembering to vary the greens used. She made some of the lighter greens by mixing Cobalt Blue and Aureolin, and the darker ones with a combination of Winsor Blue and New Gamboge. When these glazes were dry, she applied a light wash made from Cobalt Blue mixed with Light Red—that is, a gray wash leaning toward blue—over the entire surface of the glass. This can cause the greens to spread, but if they do, this may be a happy accident because it will give a pale green tint to the glass, further defining its form.

Step 3 (left). When the light bluish-gray wash was dry, Mary Lynn gave a medium-blue wash, using a stronger version of the Cobalt Blue–Light Red mixture, to certain areas of the vase's interior, paying careful attention to subtle reflections of nearby objects in the glass's surface. A careful observer will also notice the slightly darker area defining the surface of the water in the vase. This was created with yet a third wash of the Cobalt Blue–Light Red mixture. When this wash was dry, Mary Lynn added areas that were almost black to further define the stems and to indicate dark reflections in the glass. Then, after waiting for these layers to dry, she peeled off the mask.
If you're doing a crystal vase with flowers, you'll want to sharpen the stems a little more at this point, repainting any that blurred when the overwashes were added. Also remember to leave some whites extending through the clear crystal (and through the waterline) so that you can tell the front side of the vase from the back.

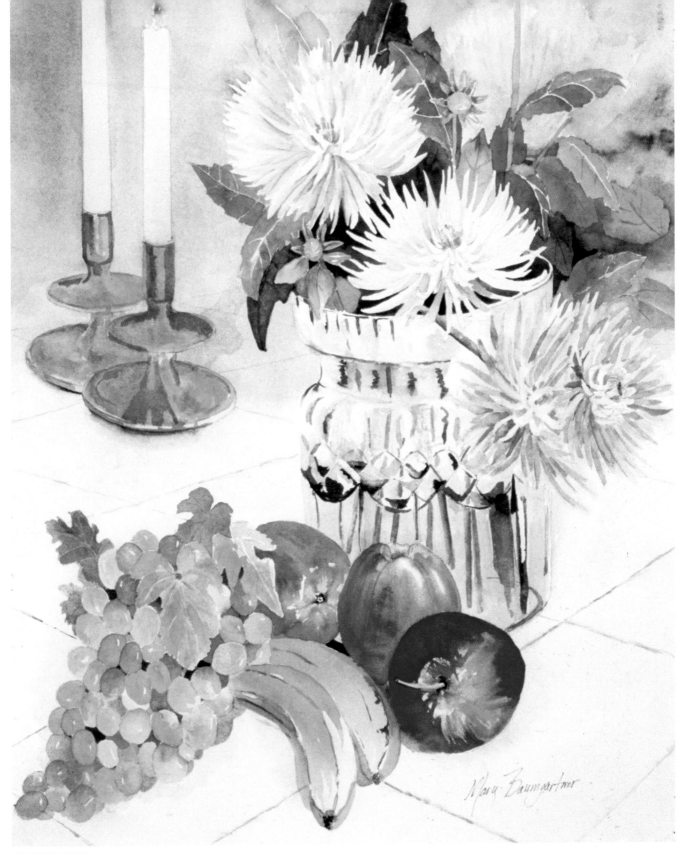

GLASS AND BRASS
Mary Baumgartner

Painting Water Droplets

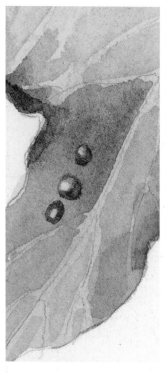

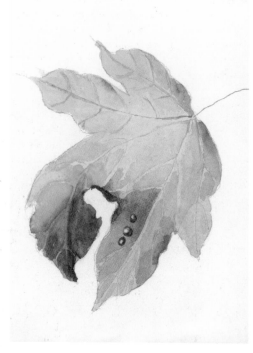

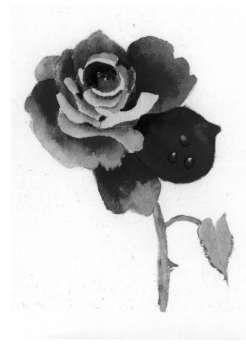

Leaves and petals can be enhanced with water droplets. Including a few water droplets on a petal or leaf can make it look as if the plant has just been watered or is fresh with early morning dew.

Painting a water droplet is easy if you remember to leave a small white area somewhere near the outer extremity of the petal or leaf when you're painting it. Work on the droplet last. Also, remember that the eye delights in odd numbers of objects, and in objects of different sizes. So do one droplet, or three droplets—and make sure they're of varying sizes. Here are step-by-step instructions:

Step 1. Paint the petal or leaf, but leave a small area of white where you want the droplet to appear. This area, which will be smaller than the droplet itself (only about the size of a large pinhead), is the place where the droplet reflects the light. Don't use masking fluid to cover this area, however; it will be more interesting and spontaneous if it is irregular in shape. Also, to ensure that the droplet has the greatest visual effect, place it in an area where there is enough pigment to create a strong contrast between the surrounding color and this bright white spot.

Step 2. When the petal or leaf is dry, use a pencil to draw the shape of the water droplet around the white spot. Keep the shape rounded but slightly elongated at the top, as water is heavy and bulges at the bottom of the droplet.

Step 3. Working inward from the circumference of the droplet, paint the droplet in a slightly darker version of the same color you used for the surrounding area of the leaf or petal, leaving a soft edge as you get close to the little white spot.

Step 4. After the paint has dried, outline the bottom of the droplet with a much darker value, using a number 0 or number 1 round brush.

Step 5. If the white area of the droplet looks too hard-edged, wet the droplet and blend the added color into the white so that this area becomes a sheen rather than a distinct spot inside the droplet.

REFLECTIONS IN WATER

Joan Clark's painting *Late Afternoon* provides an excellent example of reflections in water. Not only has Joan captured the many colors and forms of the boats as they appear reflected in the water's surface, but she has also shown us how to achieve a feeling of movement in the water.

One thing to be especially aware of when painting reflections in water is that the angles of objects above the waterline appear to travel in the opposite direction when reflected in the water below. The angles of these reflections are independent of the light source. Thinking of water as a kind of imperfect mirror can help you solve reflection problems: Reflections appearing in water are mirror images, albeit distorted by the water's movement.

Another general rule is that water tends to even out the values of objects reflected in it: If an object is very light in color, it will appear darker when reflected in water; conversely, if the object is dark, its reflection will look 10 to 20 percent lighter.

Also, be aware that water tends to scatter light—or, rather, to pick up and reflect light from many sources. If you are painting the taillights of vehicles traveling down a rainy street, the reflections will catch the light from many scattered sources and must be painted that way.

Joan Clark's painting shows us just how dazzling a medium watercolor can be. When you paint reflections in water, think of that portion of the painting as a painting in itself. Remember to get as much color as possible into the water. And remember, too, that the patterns formed in the water are part of the whole composition. They don't just reflect what is above them, but they also help the whole painting make a statement. Like other elements, reflections can lead the viewer's eye into the painting and direct the eye all around the painting—toward the center of interest, away from it, and then back to it again. You as the painter control this, and you must work out the compositional strategy beforehand. Be mindful, too, of the ways in which the interaction of cool and warm colors will keep the viewer involved; plan this out in advance—and then carefully execute your plan.

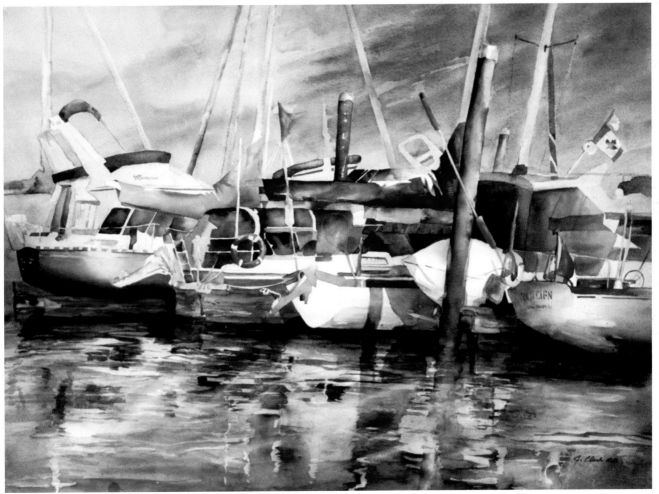

LATE AFTERNOON
Joan Clark

Painting Baskets

I used six different brushes for my painting of baskets. From left to right, these are a Liquitex 6000 series 3/8-inch slanted, a Lowe-Cornell 7020 series number 4 round, a Lowe-Cornell 7000 series number 8 round, a Lowe-Cornell 8550 series 1-inch flat, a Liquitex 6000 series 1/4-inch slanted, and a Lowe-Cornell 7020 series number 10 round. The slanted brushes (sometimes called angular brushes) are very useful for painting the baskets' cross-weaving patterns.

Because of the complexity of their detail, baskets seem as if they would be extraordinarily difficult to paint accurately. But there's a way to accomplish this without too much pain.

The colors used in this exercise are as follows: Raw Sienna, Brown Madder, and Burnt Sienna for the base coat on the baskets; Winsor Blue and Brown Madder for the insides of the middle and right baskets; Cerulean Blue and Alizarin Crimson for shadows; and Burnt Sienna and Raw Sienna for changing the values on the baskets and for details.

Step 3. Paint a wash over each of the baskets, being careful to let the white of the paper show at the places of the brightest highlights. As you do these washes, make sure you're correctly identifying the basic color of each basket (and make the colors work together). In this example, the basket on the left is given a wash of Raw Sienna; the basket in the middle gets a wash of Brown Madder; and the basket on the right, a wash of Burnt Sienna. In each case, carry the wash into the handles, too.

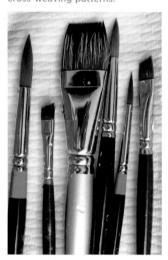

Step 1. Select baskets of different colors and different shapes. Set up at least four compositions, each using an odd number of baskets: three, or five, or seven. Take time to carefully observe the colors of the baskets and the patterns of light and shadow each composition creates. Make thumbnail drawings of the different arrangements.

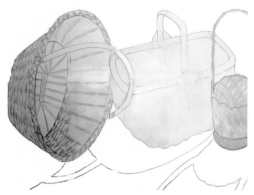

Step 4. Now, paint the vertical "spines" that hold each basket together, starting with the basket on the left. Again, use Raw Sienna, now darkened with a touch of Brown Madder. Then, start adding in the horizontal weave, not paying too close attention to the "in and out" of the weave but focusing instead on the small strokes of color the weave creates. Also paint the crossing lines on the basket's rim. Remember to paint the spines and strokes on the inside of the basket, as well. When you give the basket a second wash of the original color, all these strokes will start to meld into the form of the basket itself. And remember to leave light spots where the light touches the basket.

Step 2. Select the arrangement and thumbnail you like best, and do a value study to identify the background, shadows, and the insides and outsides of the baskets. Draw the basket arrangement and transfer it to your watercolor paper. Now you are ready to begin your painting.

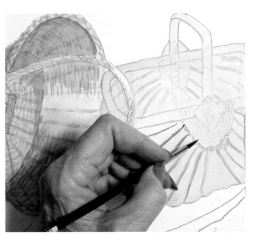

Step 5. After painting the rest of the basket on the left, follow the same process with the other baskets.

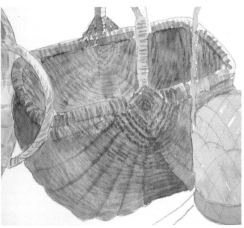

Step 6. When painting a basket like the one in the center, do be sure to follow the spines first and then to add the weave, which in this case travels around the basket in concentric half-circles. Here's where a brush with slanted bristles comes in especially handy. In this case, I dipped the brush into Brown Madder mixed with Raw Sienna to get a mellow color for the round weave of the basket. Don't forget that this is merely one layer, which will be muted when the basket is washed with another glaze of Brown Madder.

BASKETS WITHOUT BOUNDARIES
Mary Baumgartner
Step 7 (below). Here's the finished picture. Note that I added the shadows cast by the baskets last, using a mixture of Cerulean Blue and Alizarin Crimson for the shadow cast by the basket on the left, French Ultramarine and Brown Madder for the middle basket's shadow, and Alizarin Crimson and French Ultramarine for the shadow of the basket on the right. When making shadow colors like these, use equal parts of each color but do not mix them completely; some of each color should show in the final shadow color.

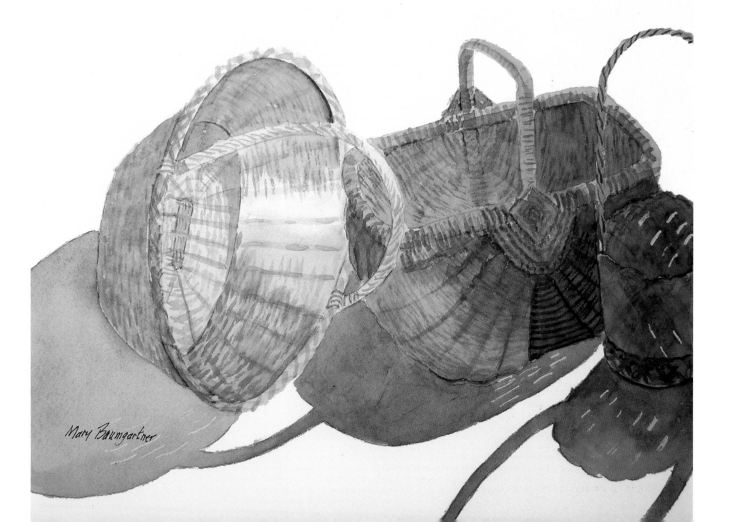

Mary Baumgartner

Painting Rocks

Let's say you're painting a light-colored rock that's lit, at an angle, by the sun. The sequence of color temperatures is as follows:

Step 1. The very top of the rock is cool, since it reflects the sky.

Step 2. As the rock begins to slope downward, away from the sky, and as it begins to pick up the sunlight, the color grows warmer.

Step 3. Then, as the rock begins to slope away from the sky and sun, the color turns cooler again.

Step 4. Finally, the bottom of the rock—away from the sun and sky, and lying in shadow—is both cool and dark. (Note, however, that the color of this area might contain a bit of warmth if the rock is picking up warm, reflected light from grass or earth on its shadowed side.)

It's good to keep this basic sequence in mind whenever you're painting rocks, although the details will, of course, vary from case to case.

When beginning a painting of rocks, you must carefully observe where the light is coming from. Make sure you also spend adequate time observing the actual qualities of the rocks themselves: Rocks near the shore might be covered with pits and holes from the constant pounding of the surf. Rocks in the mountains might have sharp angles and edges from having broken off from the hillsides and fallen into place below. Small seaside rocks may be smooth and rounded from being tossed by the waves. And rocks in a desert might be half-buried in sand or earth—looking as if they've "grown" there.

Rocks may be painted using either a "wet-on-wet" technique or a "wet-on-dry" technique. Let's look at the wet-on-wet method first.

WET-ON-WET TECHNIQUE

With the wet-on-wet method, the washes are applied in a relatively quick sequence. Each succeeding layer of color is laid in before the previously painted layers have dried, which causes the colors to bleed and blend together. Rounded and elliptically shaped rocks should probably be painted wet on wet, since the blending of the colors will help convey the smoothness of the rocks' surface.

Step 1. After determining which side or end of the rock receives the most sunlight (and which will therefore be kept lighter in color as you paint), wet the entire area occupied by the rock.

Step 2. Now, paint a very watered-down wash of Cobalt Blue on the topmost area of the rock.

Step 3. Now, move down lower on the rock, covering this area in a yellow cast, using Winsor Yellow (a cool staining color).

Step 4. As the colors you've already laid down begin to run together, dip your brush into a darker, cooler wash—one that contains a mixture of both a cool and a warm color (for example, French Ultramarine and Brown Madder, or French Ultramarine and Indian Red). Use this darker color to paint the darker areas of the rock.

JEWELS OF THE EARTH
Gail Myers

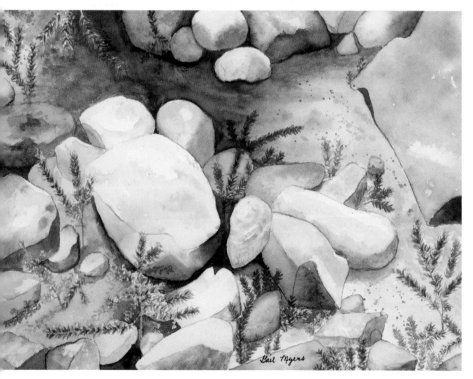

Step 5. Now, allow the colors you have applied to dry, and then further darken the shadowed side of the rock using a mixture of Winsor Blue, Winsor Green, and Alizarin Crimson to make a deep, dark color.

Step 6. Finally, when the rock is dry, use a liner brush, or rigger, to add some "calligraphy" details—thicker and thinner lines indicating cracks and crevices in the rock. These lines should be of about the same value as the surface you're painting on. It's fine to use a different color, but the values should remain very close.

WET-ON-DRY TECHNIQUE

Using a wet-on-dry technique (the same method that we've followed in all of the exercises in this book so far) gives you more control over the result, because each layer of color is allowed to dry before you move on to the next color.

Step 1. Again, apply a light blue wash to the topmost area of the rock, but leave a soft edge where you stop. Allow this color to dry.

Step 2. Next, add a muted yellow wash (such as Raw Sienna) to the area below the top of the rock. Again, leave the edges soft at both the top and bottom of this area. Let this wash dry, as well.

Step 3. Now, make a brown color by mixing together Raw Sienna, Cadmium Red, and Winsor Green, and use a wash of this color to cover the area of the rock between the edge of the yellow area above and the ground below. Allow this coat to dry.

Step 4. Mix a rich dark using French Ultramarine and Burnt Sienna to overglaze the dark side of the rock.

Step 5. The shadow that the rock casts on the ground should be put in last, after the surrounding ground has been painted. Because the shape of a shadow is affected by the contours of whatever surface it falls on, you need to establish the ground before laying in the shadow.

A FEW MORE TIPS ABOUT ROCKS

Don't feel tied to the colors I recommend in the instructions above. These are formulaic ways of painting rocks—and the suggested colors may not convey the qualities of the rocks you've chosen to paint. You might well want to introduce other colors, such as a purple abutting a yellow area that's catching the light of the sun. Granite rocks often appear silver; a good mix for this color is Cerulean Blue combined with Yellow Ochre, with a touch of Cobalt Blue, as well. (But beware: This color can become quite green if not mixed properly; see the Shadow Chart on page 31.) Ocean rocks may appear more blue than gray. Make sure that every rock you paint has some color in it and isn't just a plain, neutral gray. If it's just gray, it will look like cement.

Rocks are often found—and depicted—in groups. If, in your painting, you're placing rocks near a stream or fencepost to achieve some effect, remember the rule about using odd numbers: three, five, seven, and so on. Paint one rock and then skip ahead to another that doesn't touch the first one, so that the colors won't run into each other.

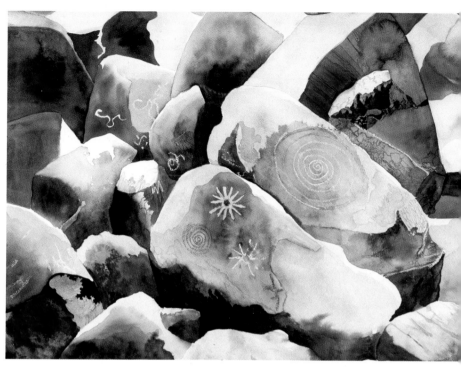

PETROGLYPHS OF THE WEST
Mary Baumgartner
For this rock painting, my first step was to draw the petroglyphs on the rocks and then to mask them by drawing on the paper with the bottom end of a small white candle. This had to be planned very carefully, making sure the petroglyphs were in the right spots, since candle wax cannot be removed from watercolor paper. (You may notice that some of the rocks also have drawings on their sides; these were made with a rigger brush using the "calligraphy" technique mentioned. For such details, I used a darker version of whichever color I had painted the shadow with.)

Each of the colors in *Petroglyphs of the West* was also planned out in advance so that the viewer would feel lost in this maze of rocks and really feel the "electricity" radiating out of them. When I exhibited this painting in a solo show, people told me they could almost feel the spirits conjured up by the petroglyphs. To my mind, that meant that the painting was very successful.

Painting Clouds

SCRUBBERS

Scrubbers look a lot like other brushes, but they're used to remove rather than to add color. They come in a variety of sizes, as shown.

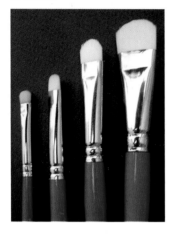

OUT TO SEA

This image of clouds over the sea is an exercise I did. I don't consider it a real painting because there is no center of interest.

Painting white daytime clouds is as much a matter of removing pigment as of applying it. To lift off paint, you can you use either a facial tissue or one of the specialized brushes known as scrubbers, shown in the photo at left. Follow the instructions below for a painting of clouds over an open sea.

Step 1. In your drawing, sketch in the shapes of the clouds as you wish them to appear. Concentrate on creating a good composition, and, remembering that the viewer's eye will be drawn immediately to the brightest areas, carefully plan out which areas of the clouds will show the whitest whites.

Step 2. For a painting of a cloudy sky over an open sea, protect the whole area that will be occupied by the sea by covering it with a piece of paper attached at the horizon line with masking tape.

Step 3. Now, load your brush with water and wet the entire sky area, including the cloud shapes.

Step 4. Mix together Cobalt Blue and Light Red, thinning the mixture with water. But don't make this mixture too watery. Remember that the watercolor paper is now wet, so the color you lay down will have to contain enough pigment to define the clouds' white edges.

Step 5. When the wet paper loses its shine, begin painting around the cloud shapes.

Step 6. Now, lift out the color at some of the edges of the clouds with a facial tissue or scrubber. Don't do this everywhere, however, since the clouds should show a combination of hard and soft edges.

Step 7. Remember that clouds are always shadowed on their bottom sides, away from the sun. Create these shadows with a warm gray color made from a variety of paints—maybe Cobalt Blue mixed with Rose Madder, Cobalt Blue and Brown Madder, or Cobalt Blue and Alizarin Crimson. Make some of the edges of these shadows harder by lifting away the pigment, and make some softer by painting wet into wet.

Below is the cloud painting that resulted from the drawing shown at left.

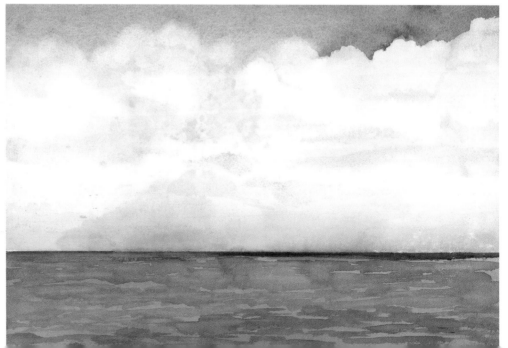

Painting Sunsets

Now, let's do another painting of the sky and sea—this time a view of the sky at sunset, with the sun descending into the sea, framed by a silhouette of palm trees on a tropical island.

As we all know, the sky at sunset can be set ablaze with an array of colors: yellows, mauves, purples, reds, and oranges. You can achieve a beautiful sunset effect by following these steps.

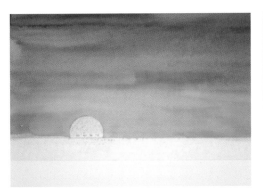

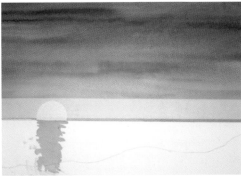

Step 1. (Left) Determine the location of your horizon line, and then paint the whole sky above it with a base glaze of Aureolin or New Gamboge. Let this layer dry completely before proceeding.

If you want your sunset painting to include the sun's disc sinking into the sea, you'll have to mask out that area before going on. An easy way of doing this is to use a coin as a template, tracing its outline onto masking tape and then cutting out the disc. Place the disc on the horizon line, with about half above the line and half below. Also place a strip of masking tape on the painting just below the horizon line.

Now, add another layer of color to the sky using a wash of Rose Madder, Alizarin Crimson, or Winsor Red. This will seal the yellow so that when blues and purples are applied you won't end up with any greens.

SUNSET IN HAWAII
Mary Baumgartner

Step 2 (above). Continue painting, adding bands of orange and mauve washes to intensify the illusion of a setting sun. To do this, begin at the bottom of the sky, adding a thin glaze of Cadmium Red to this area. Now, work your way up, adding a thin glaze of Alizarin Crimson to the middle part of the sky. As you approach the top, lay down a thin glaze of Winsor Violet. Finally, at the very top, include a band of dark blue—perhaps French Ultramarine or Ultramarine mixed with a little Alizarin Crimson.

When the sky is dry, peel off the masking-tape sun and the strip of masking tape at the horizon line. Sketch in a foreground of hills.

Step 3 (above right). Now, paint an uneven splotch of yellow (New Gamboge) below the sun's disc to indicate the sun's reflection on the water. When it has dried, partly cover this area with some roughly drawn lines and drips of masking fluid. Also, cover the bottom portion of the sky with a strip of masking tape attached at the horizon line.

Paint a dark line along the horizon, and fill in the area of the water with a moderately dark wash of Cobalt Blue mixed with Light Red. Then add a wash of Opera at the horizon line, which will help show the warm glow cast across the water by the setting sun. After the water area is dry, lift off the masking fluid and add more color to the sun's reflection, as needed. Let this area dry.

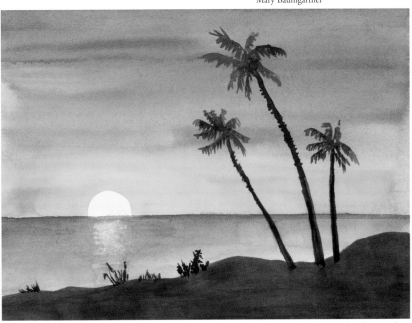

Step 4. Finally, paint the land area in the foreground with a mixture of French Ultramarine and Indian Red. When this layer is dry, add a wash of Winsor Blue. Paint the silhouettes of the palm trees using these same colors.

Creating Volume in Foliage

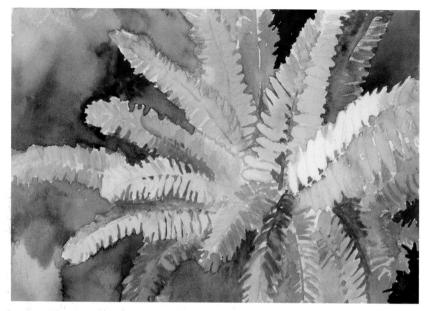

Painting foliage so that it really appears to have volume can be tricky. Artist Lisa Curry carried it off well in her painting opposite. The small grasses and plants in the foreground and the rows of reeds and trees in the middle ground were painted in the following manner:

Step 1. Note how the light catches the tops of the reeds and trees. Leave some small areas of white exposed to show the brightest highlights.

Step 2. Paint a thin wash of Aureolin over all the areas occupied by trees, shrubs, and grasses (except, of course, for those small areas that you are leaving pure white). Let the yellow coat dry, then paint a thin wash of green (made from Aureolin and Cobalt Blue) over the initial wash. Leave some of the initial yellow wash uncovered near the tops of the trees, shrubs, and grasses, where the light is strong. Allow this layer to dry, as well.

Step 3. Now, apply a deeper wash of green to the darker areas. As you do so, you will begin to see the volume of trees, shrubs, and other vegetation really begin to pop out and become three-dimensional.

Step 4. Finally, apply a green of a much darker value to areas separating the darks from the lights. As you can see in the small study of the fern at left, the very dark areas emphasize the lights around them.

When painting evergreen trees (below), leave portions of the trunks in the foreground light (paint them lightly with Burnt Sienna), and paint the foliage of the foreground branches a light greenish-blue. The darker foliage behind these front trunks and branches should be a deeper blue-green (a mixture of Winsor Blue and New Gamboge or Raw Sienna).

When all the greens are in, paint the background trunks, woody branches, and the shadowed sides of foreground trunks in an appropriate range of darker browns. Make sure to leave a light side on any trunks that face strong light. You should be able to feel the roundness of the trunks and also the relative sparseness of the foliage on the evergreens' branches.

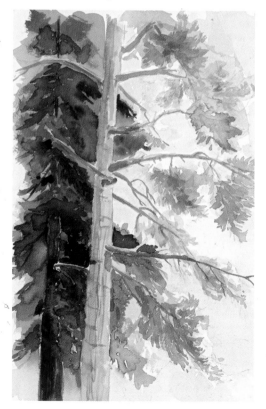

Opposite page:
SEDONA SUNSET
Lisa Curry

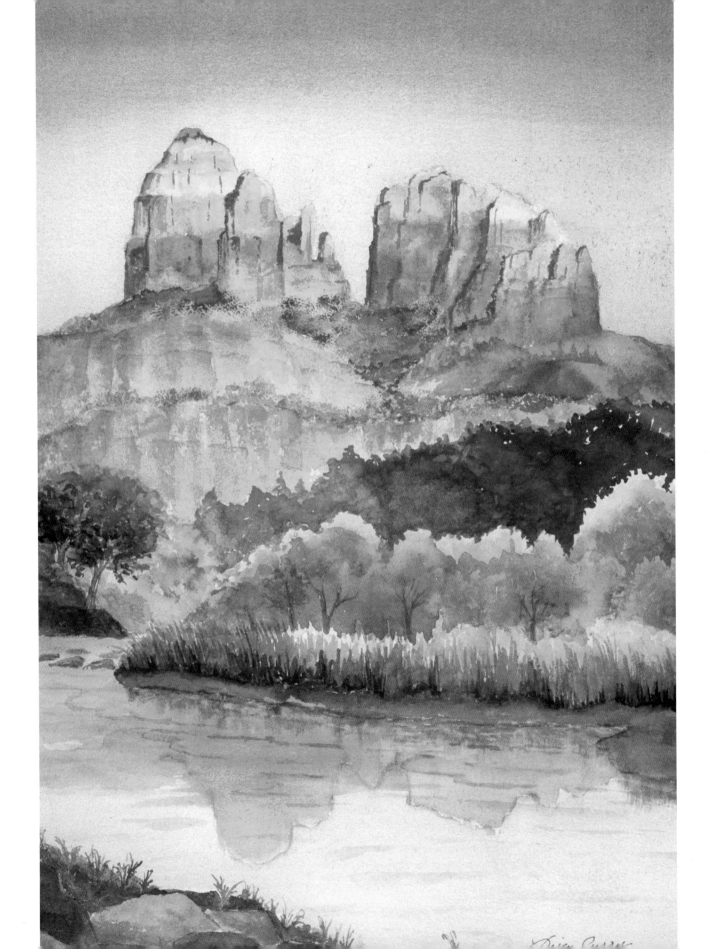

How to Paint Your Cat

I painted the gray Persian opposite from a photograph of a lovely cat I once knew, who, unfortunately, met an untimely end. A very headstrong lady, she didn't believe her owner when she told her she'd be in trouble if she went outside the house into the big world beyond. She disobeyed, and the coyote that had been lurking around for months was waiting for that one mistake!

Before beginning work on a painting of your cat, you should draw, and draw, and draw. By drawing your cat often, you'll be better able to capture the animal's own personality—not just the breed and coloring but all the little quirks and idiosyncrasies that each cat has.

When planning your composition, be sure to carefully observe where the light is coming from. That light source will produce a white highlight in each of the cat's eyes—which are where the viewer's gaze will naturally gravitate. When drawing a cat's eyes, remember that the eyeballs themselves are per-fectly round—it's the eyelids that give a cat's eyes their elliptical shape. Depending on how widely they are dilated, the pupils in the eyes might be narrow vertical streaks, round orbs, or skinny checkmarks. Note that the pupil seldom connects with the lower lid, so you should usually leave a space between the two. (The pupil does connect with the top lid, however.) If the pupil is a vertical streak, make it fatter in the middle than at either end.

Here are some specific steps I followed when painting my portrait of Charlotte, the gray Persian. Although some of these recommendations would apply to any cat painting, you'll have to adjust the instructions depending on your own cat's colors and markings.

Step 1. Use masking fluid to mask out the highlights in the eyes. To make the eyeball seem round, the highlight should cross at least a portion of the pupil; this will heighten the sense that the pupil is *inside* the eye, with a glassy-looking curve in front of it. Also use masking fluid to set in the whiskers. These are very narrow lines, so apply the masking fluid with a toothpick or the end of a paper clip.

Step 2. The first washes over the fur should be off-whites, both warm and cool. Apply the cooler off-white to those areas near the ground or floor and on the side away from the light. Let these washes dry before continuing.

Step 3. Mix a darker purple-brown color to use on feet and ears. If you use a thin coat of Rose Madder inside the ears and then intensify that color with further applications, you'll capture the warm reddish glow that illuminates a cat's thin-skinned ears as the light passes through them. Use a darker coat on the face, being sure to paint through the nose and under the eyes. When you paint clumps of fur, try using the "negative painting" technique of cutting backwards with the brush, away from the clump of fur.

Step 4. After the initial washes on the face have dried, add darker colors, carefully following the pattern of your cat's fur above its eyes and around

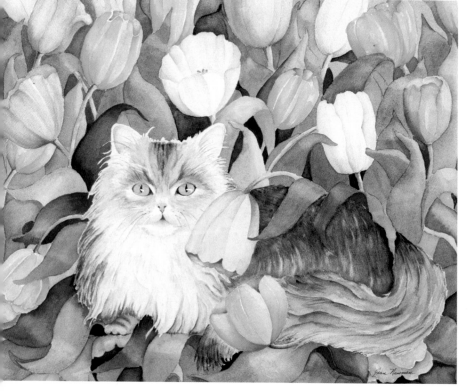

HOLLY IN THE TULIPS
Jean Newman
This painting was a commissioned piece. I'm sure Jean found it hard to do because of the pressure of working for a client, but she pulled it off and did a beautiful job.

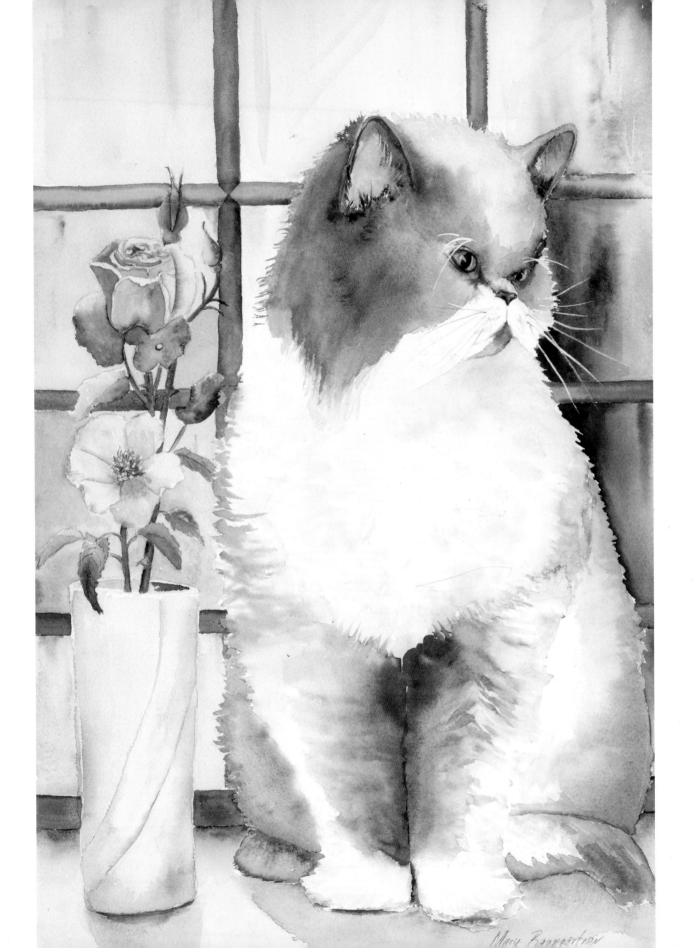

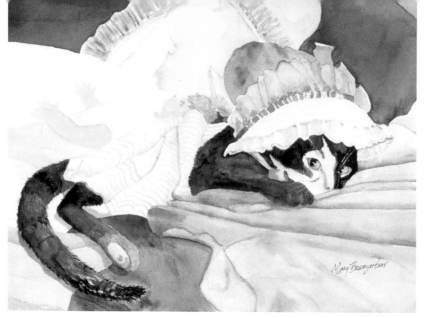

the sides of its face. Don't forget to save the lights on the side nearer the light source.

Step 5. Add a darker color of paint to the tail—it might even be as dark as the cat's legs. Remember to keep the color varied.

Step 6. When the face is dry, float washes of Cerulean Blue, Viridian, and New Gamboge into the eyes and let them dry completely. Then outline each eyeball with a darker color, but interrupt the line in places along the top of the eye so it doesn't look totally outlined. Now paint in the pupil. Then, using a color that's darker than the darkest dark in the face, paint the nose, the line that extends down from the nose to the lips, and the lips themselves.

Step 7. Use darks from the Dark Chart (page 32) in the shadowed areas of the cat's tail and back. To define the fur, cut into the hairs on the cat's tail and back using the negative-painting technique.

Step 8. When everything is dry, remove the dried masking fluid from the whiskers and the highlights in the eyes. Soften the edges of the white highlights in the eyes if they look too sharp. To add variety to the whiskers, paint some narrow dark lines in addition to the white lines left by the masking fluid.

Step 9. Finally, add shadows cast by the feet and body, painting in the pattern that the direction of the light suggests.

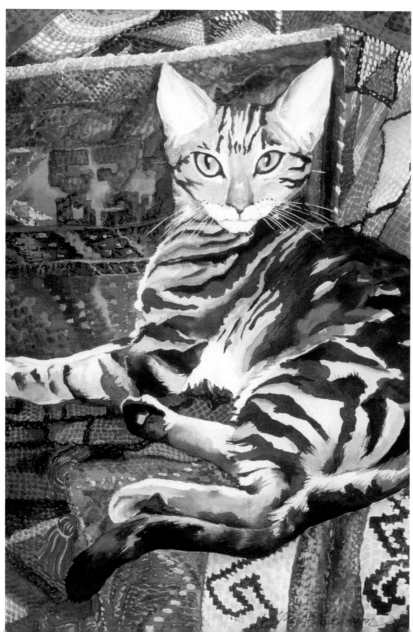

Above:
OH, GOOD GRIEF
Mary Baumgartner

Left:
EXOTIC TREASURES
Mary Johnson

Making Corrections

It happens. Sometimes, after doing some thumbnails, selecting the best composition, creating a working drawing, transferring it to your art paper, and getting halfway through the painting, you suddenly make a big mistake. Watercolorists dread such moments—but they're not always fatal to a painting. So what do you do when such an error occurs?

Well, this is why I listed the tools called scrubbers among the suggested supplies. Scrubbers come in a variety of sizes suitable for correcting various sizes of mistakes!

Use the scrubber gently, working first with the side of the bristles and then, if that doesn't scrub away enough color, with the tips. Wet and rewet the scrubber often, each time thoroughly washing out the color that has collected in the bristles. Lift away the scrubbed paint by carefully dabbing the surface with a facial tissue.

Eventually, you'll remove enough color for you to repaint this portion of the painting without the mistake showing. Of course, you'll never be able to reclaim the pristine whiteness of the original, but if you scrub it well, only you will notice the place where the mistake was made. (Remember, too, that I recommended that you use Arches watercolor papers because of their ability to hold up under scrubbing. Arches papers will even stand up to being scrubbed with a toothbrush over large areas.)

If you need to be extra careful with your scrubbing, tape around the area to be scrubbed with masking tape. When the error has been lifted, let the spot dry completely before peeling away the masking tape. And do be very careful when lifting the masking tape, as it might pull away some of the paint beneath.

There are more radical ways to remove an error. For a larger area, carefully tape off the places you want to remain as they are, using masking tape. Take your painting to the sink and run water over that section (being as careful as you can not to splash the rest of the painting), and use a toothbrush to scrub out the area. You can actually do this rather vigorously without ruining the paper. The scrubbing may cause little lint-like fragments of the paper to gather in the scrubbed area. Ignore them—and keep scrubbing and washing. If you're lucky, you'll soon recover the white of the paper. (This, by the way, is why I recommend using 140-pound Arches cold-press paper: It holds up well under such "abuse"!)

When all else fails, you might try bleaching out the mistake—but do this only as a last resort. To do this, first protect your hands and clothing, and carefully surround the area of the painting that you want to remove with masking tape. Fill the cap of a bottle of liquid chlorine bleach one-third full with bleach, adding water until the cap is full. Fill an eye dropper with this solution, gently squeezing it onto the error on your paper. Let it soak in for just a few seconds, then wash it with water. You can repeat this three to five times, but make sure to thoroughly wash the spot with water between each application of bleach, or you risk the bleach eating through the paper.

These "radical" steps aren't perfect solutions. Though they will remove the error, they will also change the surface of the paper. If you plan to repaint the area with watercolor, begin with weak, thin colors, as the paint will soak into the affected area and may spread into areas nearby.

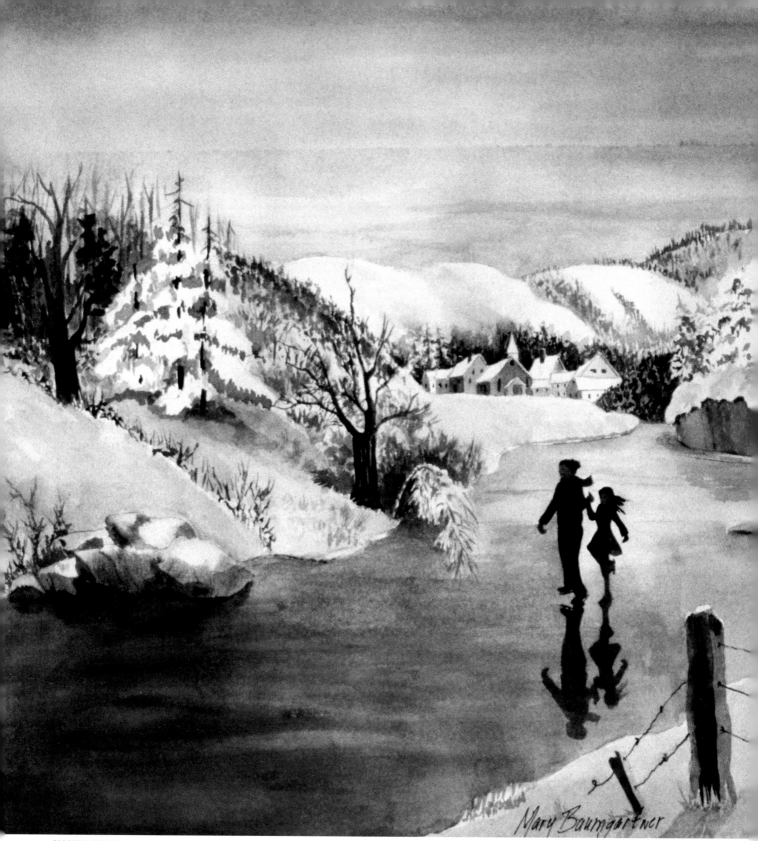

ON MILL POND
Mary Baumgartner

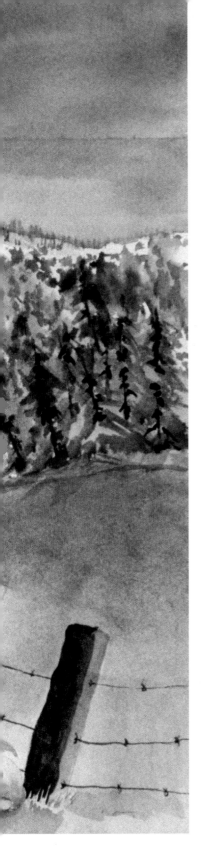

PAINTING A STORY

Remember the joy you felt as a child when you saw a new puppy or kitty, or when you were given an ice cream cone? Remember the happiness you felt when you first got a tricycle, as you climbed onto it and began to ride? That's the kind of emotion that should be expressed in a painting. In a successful painting, wonder and joy are spontaneously transmitted to the viewer.

I think that my painting *On Mill Pond,* opposite, has that kind of emotional impact. The frozen river and snowy hills make the viewer feel cold. The sun has gone down and darkness is approaching, making the viewer want to hurry home to a warm, cheery fire.

But the essence of this painting is the shared joy of the skaters—a father and daughter. Its impact depends on the emotion it evokes. The little rabbits huddled together on the bank of the river nearby even seem surprised that people are still outside at this late hour on a wintry day. (They're probably also wondering what they themselves are doing out in the cold!) Unless a painting captures emotion, it's just an act of copying.

I'm often asked where I get my ideas for paintings. Do I copy photographs? Do I see things that make me want to paint them? Well, number one, I never *copy* anything. I do see things that make me want to paint—and I imagine things to paint, as well. The painting of the skaters reminds me of my childhood, and of a small waterway near my home that would freeze over in winter and was used by ice skaters. It takes me back to my growing-up years, when things were much simpler. I've always pictured winter looking like this, so it wasn't much of a stretch to paint what was in my head.

Speaking to Your Viewer

The next time you look at a painting, pay attention to whether it summons an emotion in you—maybe something from your past that you can identify with. Or is it just a pretty picture?

When you go to art shows, do you find that there are some paintings you connect with immediately and others you just pass on by? The one thing that we artists all strive for is to make viewers stop in front of our work and give it at least a moment of their time. So ask yourself: Do your paintings make connections with the people who view them?

To make those connections—and to ensure that viewers won't just pass your work by—your paintings have to have some of the basic elements we've been discussing—light patterns, contrasting values, and colors that complement each other. But your work also has to tell a story. It has to trigger an emotional response in the viewer. It can't just be wallpaper design.

Communicating the Essence

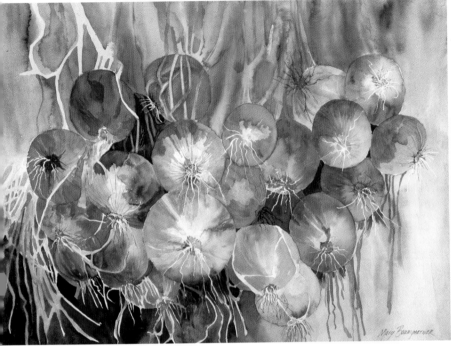

You've also got to find—and communicate—the *essence* of the images you paint. I think that the painting below, which was painted partly on location and then finished in the studio, captures the essence of the particular place and moment portrayed. The fishing boat hasn't yet left the dock, but there's the promise that today will be a good one. In painting it, I tried to identify with the fishermen and their expectation of catching nets full of fish. (The painting's title, *Baubles, Bangles, and Beads,* refers, of course, to the beautiful necklace formed by the buoys and other gear hanging over the side of the boat.)

Do your own paintings spontaneously communicate the essence of what you see? Nineteenth-century French painter Edgar Degas once remarked, "My art is in no way spontaneous—it is entirely contrived." Does that mean you shouldn't be concerned with spontaneity or essence at all? No. The bottom line here is that you must do the work necessary to make viewers stand in front of your work and feel captivated by what they see.

SOUTHERN DRYERS
Mary Baumgartner
I often dip into my memories when coming up with subjects to paint. For instance, this painting also takes me back to my childhood. At harvest time in the South, where I grew up, people pull up the onions from their gardens, bundle them together, and hang them from the ceiling of the garage so that they can dry and be used all winter. That's where the idea for this painting came from.

BAUBLES, BANGLES, AND BEADS
Mary Baumgartner

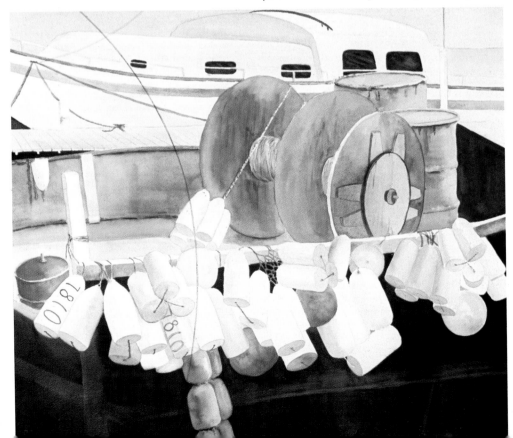

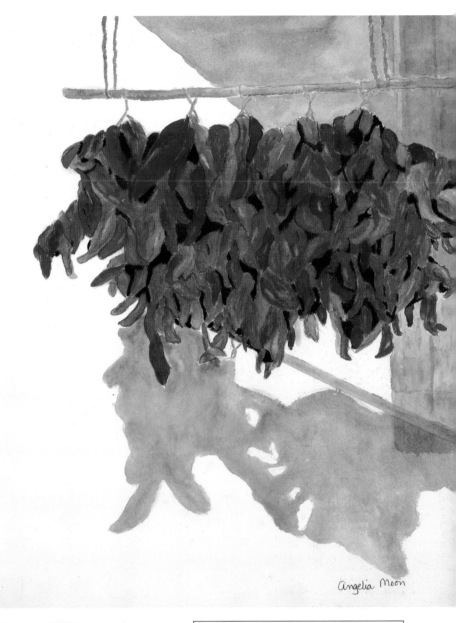

I don't want to give you the idea that if a painting doesn't speak to you, it's necessarily bad art, but I do want to get the message across that you control what you paint, and if your goal is to reach out and touch someone's spirit, then you must "contrive" a way to do this. Of course, your style dominates your art, but your spirit should equally dominate your art.

The painting at right, by artist Angelia Moon, was based on a photograph of a cluster of chile peppers that hung from Angelia's kitchen ceiling. In my opinion, you can feel the spirit and soul of the place because of the skill with which Angelia captured the essence of the scene. The painting reproduces the beautiful reds of the chiles so well that you can almost smell the fragrance of chiles cooking in a pot.

The time of day is obvious because of the shadows on the wall. The cool colors of the shadows complement the warm hues of the peppers. (By the way, sometimes white space can heighten an effect, if you don't overdo it. I think it's acceptable for Angelia to have left the area around the subject white, because more than 75 percent of the painting is covered with color.) Actually, it's the shadow shape that really makes the painting work, as do the many shades of red Angelia created to convey the individual chiles' subtle differences in color. Here are some of the steps Angelia followed in developing this painting:

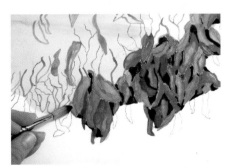

Step 1. Angelia drew a section of the cluster of peppers to set up her composition. Then she painted a small section of the peppers to get the feel of the light patterns playing across them and the darks between them.

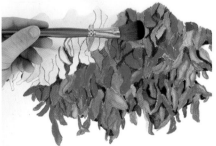

Step 2. Angelia then painted a yellow wash over the area she'd painted to intensify the yellows she'd used in the chiles.

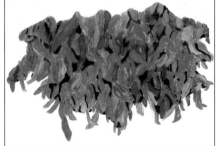

Step 3. Here, the cluster of peppers is finished. Note how well the darks work. After completing the cluster, Angelia painted the shadow and the other elements that you see in the finished painting.

Using Shadows

Without shadows, a painting is without light—and without life. Shadows help define shape and depth; they establish what kind of day it is; and they can even provide the perfect device for unifying the elements of a composition, bringing the viewer's eye into the painting.

Shadows vary according to the shape of the object casting the shadow, the angle of the light, and the nature of the surface they fall on. Look at the little studies of trees and their shadows below. As you can see, neither is just a round shape with a line connecting it to the base of the tree's trunk.

To see for yourself just how changeable shadows are, experiment with a golf ball. Drill a hole in the ball and push a pencil into the hole. Let this represent a highly simplified tree shape. Now, hold the "tree" upright on a piece of plain white paper, and shine a flashlight on it from various angles—from the front, from behind, from left and right, higher up and lower down, even directly overhead. As you do so, carefully observe the different shadows that are cast. Some are short and some long, and the shapes vary according to where the light is coming from.

Unless the light is directly above your little golf-ball "tree," the shape of the shadow will never be perfectly round. It will always be an ellipse—sometimes more compact, sometimes very stretched out. The same kind of effect is, of course, observable in nature, where the shapes of shadows vary as the sun moves across the sky over the course of the day.

Beyond shape, you must also pay attention to a shadow's color. Is there enough color in the shadow to keep the viewer's interest? Many artists make the mistake of painting their shadows a neutral gray color that looks like cement. But shadows are seldom if ever a neutral gray. They always reveal some of the color of the surface they're cast upon. The color of a shadow cast by a tree, for example, will show some of the color of the ground beneath. The temperature of the shadow's color, however, may be cooler than that of the surrounding ground. On a warm, sunny day when the sun is high in the sky, the shadow cast by a tree will be cool under the leaves and near the trunk, although it will grower warmer near its perimeter. When painting, you can use cool shadows—blues and purples—to emphasize the warmth of the surrounding area. If the surrounding ground is brightly sunlit and yellowish in color, a complementary purple shadow will heighten the contrast.

The next time you are out for a walk, pay attention to the shadows you see. Note, for example, how the holes in a tree's foliage show up as soft edges in the shadow the tree casts. Look for the colors inside the shadows. You'll be amazed at the shapes that shadows take, especially if you walk at different times of day. And when you're painting, put what you see into your work. Good results happen when you're a good observer.

In the painting opposite, artist Lois Wiser has expertly captured a powerful summertime mood: the brightly colored zinnias, the bench they sit on, and the bright sunshine—communicated by the contrasting, darker values of the shadow shapes—all convey the pleasant feeling that winter is a long time away.

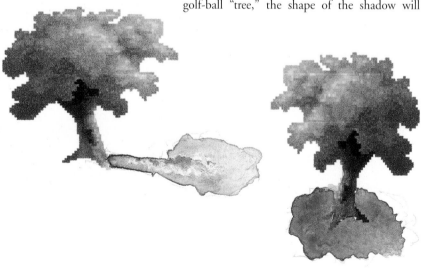

IN THE GOOD OLD SUMMERTIME
Lois Wiser

Making a Statement

SO MANY SHOES—SO LITTLE TIME
Mary Baumgartner

Creating an unforgettable painting requires more than just good composition, skillful execution, and imaginative use of color. To stick in your mind, the painting has to make a statement. It has to communicate the emotion the painter was feeling, and it has to make the viewer feel something, too. If you're painting summer flowers and a bubbling stream on a hot, humid day, you want to make the viewer sweat—as if the humidity were getting to him or her, as well. If you're painting a sailboat tacking down a river, you want the viewer to so identify with the experience that he or she can feel the waves rippling under the boat. One of the strongest statements I've ever made was a painting of former Dallas Cowboys running back Emmitt Smith catching a football for a touchdown run. I exhibited this painting (not for sale) at one of my California shows and was amazed by how many men gathered around it. We called it a "male magnet." The statement was made.

I think the painting at left tells a great story about shoes. Looking at it, you might find yourself wondering about the whens, wheres, and whys of the various shoe purchases—and you'd have plenty of time to wonder, since the carefully planned whites in the painting act to hold your eye inside the image. I painted *So Many Shoes— So Little Time* when I suddenly realized just how many pairs of shoes I own—and thought about how much fun it would be to depict them (or *some* of them!) in a painting.

You can find inspiration anywhere: in nature, buildings, kitchen utensils, or even in shop tools, as in Marguerite McCampbell's painting at the top of the facing page. Learn to *look* for inspiration wherever you go. If you ride a bicycle, begin looking more carefully at the scenery when you go cycling. When you're looking at a natural scene, analyze the colors you are seeing, and pay attention to the *depth* of the color, noticing how colors often appear to be made from *layers* of color. In other words, learn to see the essence of whatever you're viewing—and let your heart and hand reveal that essence in your painting. Communicate your feelings to the people viewing the painting. Make a statement!

JOE'S WORKBENCH
Marguerite McCampbell

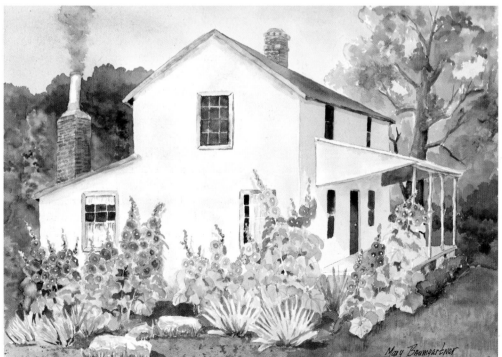

HOLLYHOCK HOUSE
Mary Baumgartner
This painting portrays a little country cottage in West Virginia. The heart and spirit of the place are shown by the care given to the landscaping. The house is well kept, the paint job is fresh, and the stones decorating the garden are artistically placed. The hollyhocks, especially, make the house very inviting and give it an old-fashioned feeling. As a whole, the painting makes a strong statement about an orderly, welcoming, and comfortable home.

Enhancing Your Paintings

Here are a few tricks of the trade—some new tips as well as some reminders of things we've covered at greater length—that you can use to enhance your paintings' appeal:

• To keep the viewer interested, include a few "lost edges" in your painting—places where the border between two areas disappears because they are so similar in value.

• Use odd numbers of objects, as the eye delights in odd numbers.

• Make sure each painting has both warm and cool colors. Even if you are depicting a very cool, gloomy day, use some warm colors in the windows of houses, for example, or in the berries on a bush.

• When painting snow, use all three primaries in the "white" areas. Wet the paper, then drop light, watery splotches of Aureolin, Rose Madder, and Cobalt Blue at random over the white. In some places, these colors will overlap to produce subtle purples and greens. The technique will give the effect of "something going on" in the white space.

• When painting a white flower, be sure to change the colors of the petals around the flower. The light falling on the flower will make a few petals (or portions of petals) bright white, but other petals (or portions of petals) will show subtle shadows as they turn away from the light source. The variety of off-white colors will enchant the viewer. Surrounded by darker colors, they may seem white at first glance, but the subtle differences in tone will speak to the viewer's eye.

• To make a painting appear three-dimensional, be sure to adhere to the rules of perspective. Don't forget about aerial (atmospheric) perspective, which conveys the illusion of depth through color temperature, with objects in the foreground painted in warmer colors and those in the background in cooler colors.

• Make an object seem to turn by placing cool colors near the edges of the object.

• When painting a vase, can, bottle, or other cylindrical object that's sitting upright on a surface, knock off the "corners" at the bottom, where the vertical sides of the object begin to rise upward. As perceived, the bottom of the object is elliptical, and getting rid of those corners will allow the eye to imagine the roundness of the cylinder.

• To enhance your whites, be sure to place your darkest dark against your whitest white.

• Think about the background before you begin a painting. Work out what your background will do for the composition as a whole. Will it enhance the composition or distract the eye from the central focus? If your foreground is interesting and has lots of activity, keep the background simple. Let the viewer know where to look.

• If you're painting foliage, try the "veiling" technique. Leave some areas of the foliage white, paint darks around these white areas, and then, after those colors are dry, paint another coat of dark over the first one, dragging your brush through the whites. This can help create interest in the large flat areas of your piece.

• Avoid creating "mud." If you've laid down a coat of yellow and then add a red that contains some blue (for example, Alizarin Crimson) on top, you won't get orange—you'll get mud. If you

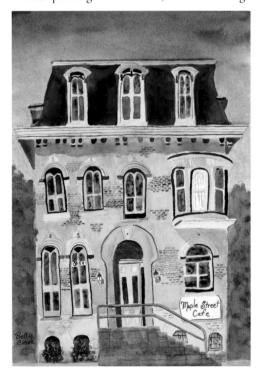

MAPLE STREET CAFÉ
Betty Crowe

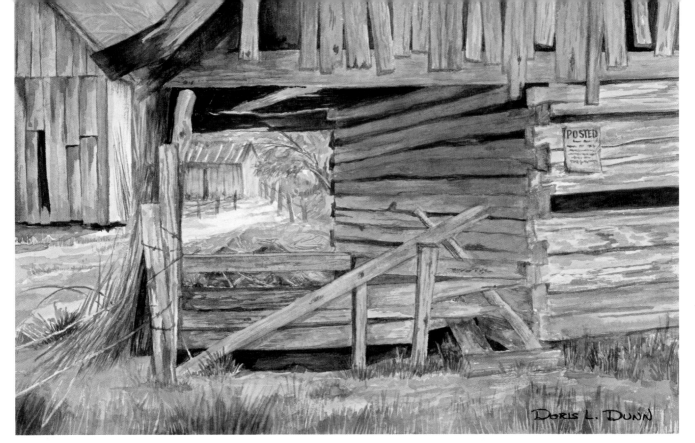

add a blue that contains red (French Ultramarine) to the yellow, you won't get green—you'll get mud. To get orange, use Winsor Red or Cadmium Red on top of yellow. To get a pure, fresh green, use a neutral blue (like Cobalt Blue) atop a clear, cool yellow (like Aureolin or Winsor Yellow).

• Your main subject should be placed near the center of the painting, but *not* at dead center (unless you're doing a portrait).

• Direct the viewer's eye through your painting by using carefully planned patterns of lights and darks. It has been proved that the eye, when viewing an image, tends to move in a circular, counterclockwise pattern, so make sure the whites are planned accordingly.

• Remember that the first color the eye sees in a painting is the *lack* of color—white. Be sure your whites are in a good starting place for the viewer.

• To check the arrangement of values and the strength of your composition, try holding a finished painting up before a mirror. You can also do this by squinting when you look at your painting or by viewing it through a reducing glass, which will shrink the painting down to a tiny, circular image that immediately shows any flaws. Also, include a piece of French Ultramarine transparent glass in your "must have" equipment; this blue glass, available at stained-glass shops, makes everything viewed through it appear to be one color and thus helps you see the values.

• If you are painting a still life or landscape, try using a prop to lead the viewer's eye into the painting: a rope connecting a string of onions, a flower that has fallen from a bouquet. But make sure you plan the placement of such props so that they lead the eye toward, and not away from, the painting's main focus.

• Conversely, do not lead the viewer's eye out of the painting with a river, a line of telephone poles, or even a strong color that "points" to a corner of your painting. Capture the viewer *inside* the painting, and don't give his or her eye any way out.

• Railroad tracks that vanish in the distance can be an effective device for getting the viewer into the painting. But before trying this, make sure you have the rules of perspective down. The timbers tying the tracks together should "lie down" and appear to grow closer together as they recede in space.

• Constantly think of which direction the light is coming from. What time of day is it? Does the image contain other light besides the light coming from the main source (for instance, reflected light)?

OLDE MEMORIES
Doris Dunn

• Use color to enhance a painting's mood. Lots of vivid primary colors make for happy paintings; cold, gray colors create somber, gloomy paintings.
• Make sure your grays are interesting and full of color. Otherwise, they'll look like cement.
• Place your shadows so that they are integral parts of the composition and help direct the eye through the painting.

• To keep your viewer interested, try using complements side by side. But don't let this technique take over the whole painting. If you've painted a red barn in the distance, play down the red by adding fall colors around it, so that your viewer won't be drawn to the barn if that's not your focal point. (The viewer's eye should go to the focal point first, then to the secondary areas.)

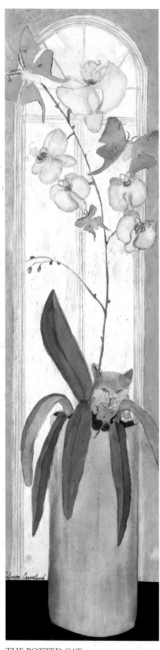

THE POTTED CAT
Rebecca Crossland

DON'T BE BORING!

The best, most important tip I can give is this: Don't make boring paintings! Every square inch of each of your paintings should be entertaining. When I was just beginning as an artist, I had a teacher who said about one of my paintings, "This is seven levels of boring: one, two, three, four, five, six, and seven." He announced this to the whole class, and as he counted off the numbers, he swiped his hand over each of the areas. In hindsight, I see that he could have handled the situation a lot better, but I never again painted a boring picture. I certainly don't think these giraffes could be called boring. Neither do others, apparently. I've had prints made of the painting, and several have been sold by a local gallery. And the original has been in several art shows.

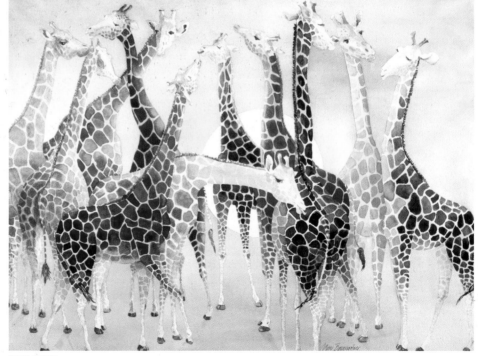

TALL TALES
Mary Baumgartner

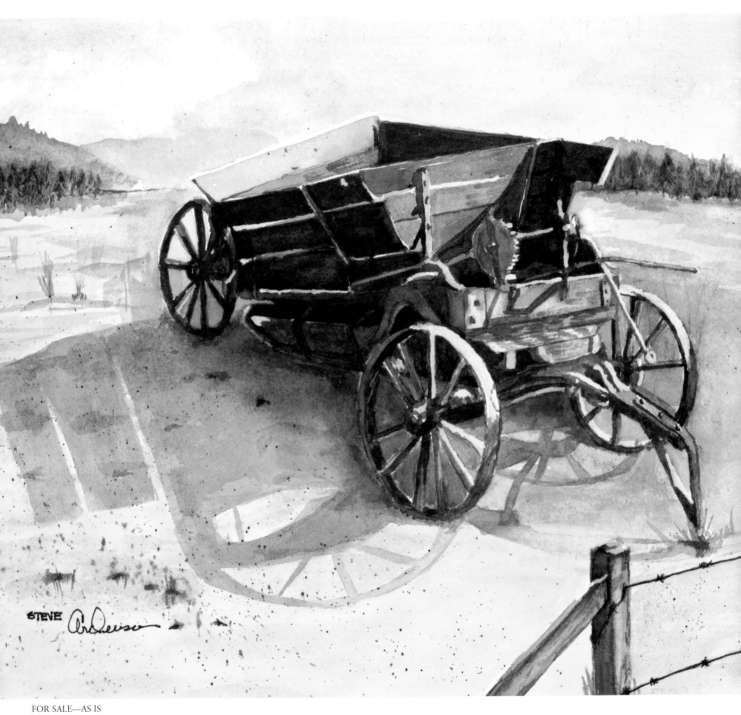

FOR SALE—AS IS
Steve Anderson

YOUR CAREER
AS AN ARTIST

This book and your own pursuit of excellence will help you achieve your artistic goals. If you paint two or three times a week, look at as much art as you can, and read as much *about* art as you can, you'll be surprised how quickly you reach your goals. Sometimes success comes very quickly. The painting *Princess,* left, was artist Ginger Baxter's first watercolor painting. She took one of my classes and was eager to complete a project that she liked—and that won her classmates' approval. She did better than that. The painting was entered in a student show, and a local newspaper even published an article about her and the painting.

Usually, though, you have to work hard to get your paintings seen and to begin developing an audience for your work. In this chapter, we'll talk about entering competitions, selling your work through galleries, and doing the marketing and public relations work that can lead you to a successful career as a watercolor painter.

ENTERING COMPETITIONS

As an artist, an art teacher, and the leader of a group of artists, I've learned there are three kinds, or levels, of painting: First, there's the painting you do because you *want* to do it; you see something that you just *have* to paint, and so you do. Then, there's the painting that someone commissions you to do. And, finally, there's the painting you do for a show or competition. To my mind, the first kind of painting is the best. (And the second kind is the worst—but we'll get to that a little later.) As for painting for competitions, it does sometimes happen that a painting you really wanted to do—one that contains all that emotion and joy—will win a prize in a competition or be juried into a show. Unfortunately, this doesn't happen as often as one might wish.

There are lots and lots—an amazing number, really—of watercolor competitions that you might consider entering, as well as competitions that are open to painters working in all media, including watercolor. Competitions are sponsored by the major national watercolor societies; by regional, statewide, and local watercolor soci-

eties; by art magazines (including, to name just three, *American Artist Watercolor, The Artist's Magazine,* and *Watercolor Artist*); by arts-related foundations and other arts organizations; by galleries; and even by some of the larger art-supplies companies. To keep abreast of competitions—and to find out about deadlines and specific entry requirements—you've got to read the magazines (which publish competition announcements as well as advertisements for competitions) and pay regular visits to watercolor societies' and other sponsoring organizations' websites. (A few of the most important of these are listed in the Resources section on page 143.) Do be aware that some society-sponsored competitions are open only to members; many, however, are open to all artists.

Most competitions are extremely specific about submission requirements, including deadlines, entry fees, the type of work they will accept (including maximum and minimum sizes and, sometimes, subject matter), and the format of the photographs of the work you're entering. Even today, some competitions will accept slides

LOOKS LIKE A WINNER

Melinda Wysocki's painting *Dock of the Bay* strikes me as a perfect entry for a watercolor show. I have the feeling that the angle at which the boats are shown would especially appeal to a jury: There are lots of watercolor paintings of boats, but few that portray their subject at such an unusual angle. Moreover, Melinda has handled perspective masterfully, and the painting is alive with lots of color—and great *variation* in color. The composition is very well designed, with a definite foreground, middle ground, and background. Personally, I feel that *Dock of the Bay* could successfully compete with any other painting entered.

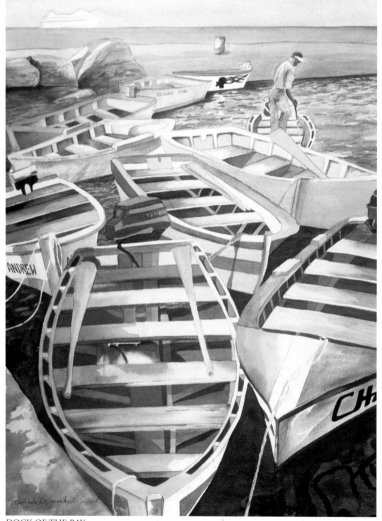

DOCK OF THE BAY
Melinda Wysocki

only (not digital photos), and the slides must be of the highest quality. (If a competition does accept digital images, the images must be of a very high resolution.) When entering a competition, make sure that your submission conforms exactly to each and every requirement; otherwise, it will be tossed aside without the jury even giving it a look. And you'll be wise to have your paintings photographed by a professional photographer; the quality of the images you submit—whether slides or digital images—is of the utmost importance.

The juries of major watercolor society competitions are usually composed of well-known watercolor painters and sometimes of writers in the field—people, in other words, who know a lot about the subject and who are familiar with many artists working in the medium. I wish I could say that you, as a new artist, will be competing on an absolutely equal footing against others entering a competition, but, unfortunately, that isn't always the case. Even though submissions may be judged "blind"—that is, without the names of the submitting artists being revealed to the judges—it's always possible that members of the jury might recognize a particular artist's style and give that person's work greater consideration because they feel that including it will make for a better show.

Winning a prize in a competition (many competitions award a number of different prizes) can be a great boost—to your career *and* your ego. You might win some cash (some competition prizes are substantial); you might have your work published in a magazine; and, if the competition includes an exhibition of winners' paintings, your work will be seen by the public. In some cases, that public can be quite large, since the competition exhibitions organized by the major national watercolor societies travel to several galleries around the country. But even if you don't win, the experience of entering a competition can be worthwhile—if you feel that you're ready and if teachers, friends, and fellow artists are encouraging you to do so.

If your work has won a prize or has been accepted into a show, you'll probably be notified soon after the jury has made its decision. If not, your slide or slides will be returned to you by mail. If your work is going to be in a show, you'll have to ship it to the sponsoring organization (or hand carry it there, if the organization is nearby). Shipping the work properly can be expensive and requires a special carton designed for just this type of thing. The sponsoring organization will save the carton and use it to return your painting to you when the show is over.

Although, as I say, some of the major shows travel, most competition shows hang for about a month. Usually there's an opening-night reception at the museum or gallery where the show is engaged, and, if you can, you should attend the reception. Not only is it exciting to see your work on view alongside that of other artists, but such shows often coincide with the annual meeting of the sponsoring organization's membership, and there's frequently a good speaker.

And while we're on the subject of membership, I should add that you might consider becoming a member of one or more national or regional/local watercolor societies. Benefits can include workshops and other programs, invitations to special events, receiving the society's newsletter, and reduced competition-entry fees, as well as the valuable experience of being able to socialize and talk about your work with other watercolorists. Most societies, by the way, have two levels of membership: general (or associate) membership, which is open to anyone who pays the annual dues, and "signature" membership. For you to become a signature member, your work must be accepted into the society's exhibits a number of times. (Specific requirements for signature membership vary from society to society.) Since the major societies' competitions typically draw hundreds or even thousands of submissions, having your work accepted several times is a difficult task and sometimes takes years to accomplish.

SELLING THROUGH GALLERIES

If you approach a gallery or are approached by a gallery, remember this: Being represented by a gallery is both good and not-so-good. On the one hand, your work will be seen in shows mounted by the gallery—and you'll have a "middleman" to take care of much of the business side of your art career. On the other, reputable galleries typically take a high percentage of a work's sale price as commission, and you may sometimes find it difficult to get paid in a timely manner.

If you're searching for a gallery, buy the book *Artist's & Graphic Designer's Market,* published by Writer's Digest Books and updated annually. (Or, better, check it out of the library.) From its listings, you may learn about the kind of work that galleries in your area show. You'll also benefit from visiting galleries in your area to see whether they exhibit watercolors and from browsing the Internet to look at galleries' websites. Some cities also have cooperative galleries that you can join and that will show your work if you pay a membership fee (and agree to pay the gallery a small percentage of the price of any work sold there) and, often, if you work at the gallery for a few hours a month.

When you contact a gallery, make sure you prepare a good-looking package, including a short cover letter, a biographical sketch, and professionally prepared images of your work—either slides or high-resolution JPEG or TIFF images burned onto a CD or DVD. (Before sending a package to a gallery, call them to find out which format or formats they prefer.) Always include a self-addressed stamped envelope, with the right postage, so that the gallery can return your package to you.

If you actually get the chance to talk to gallery owners or managers, ask them what sells well. Ask which sizes of paintings they prefer. Ask them which price range sells best. Find out whether they sell prints, and if prints sell more quickly than original work. Find out how long the gallery intends to keep unsold work, and whether you can take work back if you need it for

a show. Find out, too, whether the gallery will let you sell your work yourself, in case you find buyers on your own.

And, by all means, find out how they price work and what sort of commission the gallery takes. This is extremely important for two reasons: First, it will determine the amount of money it's possible for you to earn. Second, it may determine whether your work is even salable, since paintings that are priced unrealistically high won't find buyers. If the gallery's cut seems too high, try to negotiate a fairer commission. Also ask about how (and whether) your work will be insured while being exhibited or stored at the gallery.

Get all your questions answered—and answered to your satisfaction—before you sign a contract or agreement with a gallery. (An excellent resource for examples of contracts is *Business and Legal Forms for Fine Artists,* by Tad Crawford [3rd ed., New York: Allworth Press, 2005].) As part of your agreement, make sure you get an inventory list, signed by the gallery owner, of all the works you're placing with the gallery. And once a gallery has begun to represent you, be proactive in your dealings with them. Check in often to see whether any of your paintings has sold, and, if so, when you will receive your share of the sale price.

Some galleries prefer to arrange for the matting and framing of the works they show. That's fine, but you should be very wary of a gallery that says it will take your work on consignment but then asks *you* to pay the costs of matting and framing up front. This is a recipe for trouble, since you'll end up having lost money if the gallery does not sell your work.

Some galleries are reluctant to take work from new artists—the reason being that new artists often can't keep up the production schedule necessary to satisfy their market. If the gallery is able to sell your work quickly, they'll want new work regularly. And even if your work doesn't sell so quickly, the gallery will still want to keep its walls fresh with new work. You must have a large inventory to keep things moving, and you must always be able to show the gallery new work in progress. So, when you talk to a gallery, give them some clue as to how many paintings you can provide, when you can send them in, and how frequently you'll be able to replace the "stale" stuff.

Yes, dealing with a gallery can definitely be an experience. But don't be put off by my warnings. They are meant only for your protection.

DOING COMMISSIONED WORK

Frankly, I don't recommend that you do commissioned paintings. If you do accept a commission, price your painting twice as high as you would any other painting of a similar size. Believe me, you'll earn it! You don't have to demand money up front, but be sure to tell the buyer that if he or she doesn't like the finished painting, you'll still require full payment—and that you won't do it over. (If it makes you more comfortable, ask for half of the fee in advance.) Make sure you have a written contract with the buyer, and make sure that the contract includes a clause stating that the buyer will be breaking the contract if he or she demands changes once the work is finished.

Despite my own better judgment, I do take on commissions occasionally. One commission I accepted was for a painting that would be done on a full sheet of watercolor paper (22 × 30). The buyer visited me while I was on location making the initial sketch for the painting. He immediately told me that my drawing wasn't big enough. I finished that drawing, but then I bought a piece of double-elephant size watercolor paper (29½ × 41) and began again. (I was able to transfer much of my original drawing to the new, larger paper, although I obviously had to make some changes. But I didn't abandon the first drawing. Later, I did a painting based on it and sold it in the gallery representing me in San Diego.)

My next encounter with the buyer occurred when the painting was nearly finished. He walked into the studio, pointed at the painting, and said, "I told you I wanted three white puffy

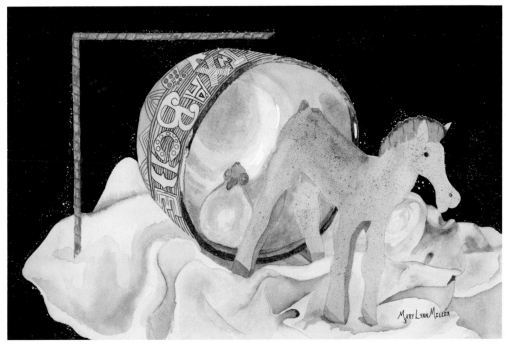

STONED ENCHANTMENT
Mary Lynn Miller

clouds." Frankly, it was the best sky I had ever done, with lovely cloud formations and striations in the sky. But it wasn't what the client wanted. So I had a lot more work to do to create the "three white puffy clouds" that the client demanded. Let's just say I earned my money on that job. (Luckily, I had priced it very high and wasn't responsible for the matting or framing.)

NAMING AND SIGNING YOUR WORK

Always name your paintings. Sometimes the name alone can earn the work a spot in a show. Be short, but be clever. Naming a painting something like "Pears #3" shows no imagination, and, reading a name like that, prospective buyers might feel that the painting itself lacks creativity. The painting by Mary Lynn Miller above is called *Stoned Enchantment.* The picture *and* its unusual title would both grab attention at a gallery.

Always sign your paintings, too—and always in the same identical way. A recognizable signature will help your name become known in watercolor circles. Most artists sign their paintings in the lower right-hand corner. I do the same, and I use a pen with lightfast ink so that my signature will remain visible for years to come. (The Sharpie marker pens made by Sanford are a good choice. For signing, get the Sharpies with ultrafine points.) Be proud enough of your work to make your signature large and legible.

MAKING PROMOTIONAL MATERIALS

To be a successful artist, you've really got to promote yourself. Self-promotion is easier than it used to be, since the computer gives you so many options. Software abounds for making business cards, stationery, greeting cards, brochures, and other types of promotional materials.

Having a digital camera helps, too. After photographing your finished work, you can upload the pictures onto your computer, manipulate them with Adobe Photoshop (or other, similar software), and then transfer the images to a graphic design program.

Think about it: You can adorn greeting cards with your paintings. You can design invitations, notepaper, even calendars with a different painting for each month. Brochures are a little harder to design, but a well-done brochure can be a very effective tool for introducing galleries and prospective clients to your work. Once the brochure has been designed, you can print out as many as you need, when you need them. (Alternatively, you can have your cards or brochures printed by one of the many Internet-based companies now offering digital-printing services for a reasonable price.)

Business cards displaying your logo and artwork are invaluable promotional tools. I designed my own (above), using Photoshop and graphic design software, and then I used my inkjet printer to print them out on the business-card stock made by Avery, which comes in standard, 8½ × 11 sheets. (Each precut sheet holds ten cards, which can easily be broken apart after printing.)

Many independent bookstores, gift stores, stationery stores, and art supplies shops will accept greeting cards made by local artists. If you can negotiate a decent price, this can be a good way of selling your work. When designing such cards, leave the inside blank so that buyers can write their own messages, and be sure to put your name and the name of the painting on the back.

I even use my inkjet printer to make 11 × 14 prints of my paintings. The quality of the prints is quite good, since my Epson printer uses pigment-based ink and I print them on real 140-pound cold-press watercolor paper, cut to the proper size.

Some galleries sell prints as well as original paintings. If you're talking with a gallery about representing you, ask them whether they do so. Of course, prints you make yourself may not be of a high enough quality to sell in a gallery. But there's an easy and relatively inexpensive way to have super-high-quality prints made. On the Internet, you can find a number of vendors that make what are called Giclee prints. These fine-art-quality prints are made with top-of-the-line Iris printers, which use standard process colors (cyan, magenta, yellow, and black) and produce prints at a resolution of 1,800 dots per inch. The reproduction is so accurate that even experts can have trouble distinguishing a Giclee print from the original artwork.

Giclee prints can be ordered one at a time or in multiples. (The unit cost goes down as you have more copies printed.) If you deal with a Giclee printmaker, be sure to ask whether they use pigment- or dye-based inks, and also ask them how many years they anticipate their inks will last if the print is protected under glass and does not hang in direct sunlight. (Pigment-based inks, which are estimated to last for up to ninety-five years, are better.) Also find out whether the Giclee printmaker uses 100 percent acid-free paper. This, too, is essential, since the print will last only as long as the paper and ink it's made from.

Giclee prints of my paintings were sold by a gallery in Knoxville, Tennessee, and one of those prints went on a long, strange journey. It was a print of my painting of elephants, *Zambezi Tuketela* (page 54). A few years after the Knoxville gallery had sold the prints, I went to see my accountant in San Diego, California. There, on the wall of his office, was a beautifully framed print of my elephant painting. I couldn't have been more surprised or delighted.

CERTIFYING AUTHENTICITY

Galleries that sell prints often require that each print be accompanied by a certificate of authenticity, so that buyers can be sure that the prints were made with the artist's approval and oversight. (Buyers may also find the certificates useful for insurance purposes.) A sample certificate is shown on page 140.

Providing galleries with these certificates is your responsibility. (The gallery owner will fill in the name of the buyer when the print is sold.) Note that the certificate shows the number of the print as well as the total number of prints made of the piece. (This information should also appear on the print itself. Write the number of the print, a slash mark, and then the number of the total print run in pencil directly below your signature. For example: If a print is number 23

HOLIDAY GREETINGS AND GIFTS

I encourage my students to make their own holiday cards. One student I taught had a huge collection of teddy bears, and each fall she painted a new teddy-bear scene to use for her Christmas cards: a group of teddy bears gathered around the tree, a teddy bear opening a present, and so on. I, too, make a new painting every year to use for my Christmas cards, and in 2006 the art center where I hold my classes sold my cards as a fundraiser.

Prints of paintings make great gifts. If you have a good color inkjet printer, you can print them yourself on watercolor paper and then take them to a frame shop for matting and framing or frame them yourself using standard-size mats and frames bought at your local crafts shop. My painting *The Benson Babies* was commissioned by the Benson family, which also purchased prints from me to present as gifts to other family members.

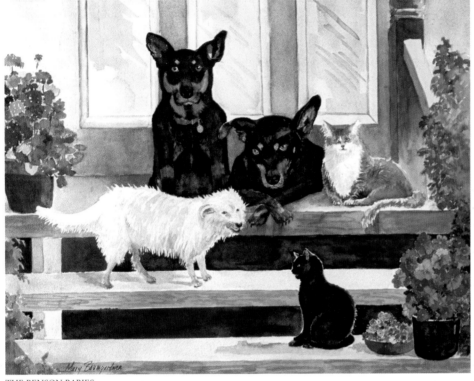

THE BENSON BABIES
Mary Baumgartner

out of a total run of one hundred, you would write 23/100.) In your own files, keep good records of the number of prints issued of each piece that you have printed, as well the date when each was purchased and the name of the buyer. This information can be invaluable. It can help you legally if, for example, a printmaker should copy one of your prints and sell these additional prints (with additional numbers falsely added to the run). It can also help you answer questions that occasionally arise. For example, I was once contacted by a lawyer settling the estate of a married couple who had died. They had owned one of my prints, and the lawyer wanted to know its current price so that he could enter that figure into the inventory. Without my records, I would have had trouble recognizing the piece merely from his description.

I also think it's a good idea to provide an "artist's statement" to accompany each print. The statement will tell the buyer a little about why you painted the watercolor and what you were feeling as you worked on it. In other words, the statement is a brief history of the painting on

Certificate of Authenticity

This certificate is presented to

Name of Buyer Here

Buyer of Print #_____ of a limited edition numbering _____ prints.

Name of Painting

Name and Address of Artist here

which the print is based. You might want to include other interesting information about the painting—for instance, listing any exhibits it has appeared in. Here's the statement I wrote to accompany prints of my painting *Zambezi Tuketela*:

The transparent watercolor *Zambezi Tuketela*, by Mary Baumgartner, is based on a photograph that one of Mary's students took when she visited Africa. The photograph showed a group of elephants gathered around a watering hole near her campsite.

Mary first painted the elephants exactly as they were depicted in the photograph. Later, noticing that the elephants' heads, tusks, and trunks formed an intricate pattern, she realized that focusing on the heads alone would result in a far more interesting painting. She also decided that she should experiment with color in the new version of the painting.

Mary's favorite author is Wilbur Smith, who writes about life and wildlife in South Africa. In naming the painting, Mary took the first word of its title, *Zambezi,* from a river in South Africa. The second word, *Tuketela,* is the name of a rogue elephant in one of Wilber Smith's books. Mary imagines the elephant in the right foreground as a rogue elephant of the Zambezi River.

The original of this painting was exhibited for a month at the Arrowmont School of Arts and Crafts in Gatlinburg, Tennessee. It was also exhibited for a month in the Wonderful World of Watercolor show at the Poway Center for the Performing Arts in Poway, California. The original remains in the collection of the artist, but prints are owned by collectors in Virginia, Delaware, California, Tennessee, and England.

AND FINALLY . . .

This book was written with the love I feel for anyone who wants to use their creative abilities to express what is in their mind and heart. The creative process starts with anxiety and self-doubt, but as you progress in understanding, your hands will accomplish what your mind imagines. If you are already a painter, I hope you'll use the ideas in this book to make your paintings better. If you're just starting to paint, remember that today is the beginning of the rest of your life.

Let me close by mentioning that my website, www.wonderfulworldofwatercolor.net, invites your participation. For a nominal yearly membership fee, you'll receive answers from me to your own questions about watercolor art, as well as my critiques of your works in progress. I look forward to meeting you online!

GLOSSARY

Backwash Undesirable circular effect created when fresh paint is added to painted area that is not completely dry.

Blossom Undesirable flowerlike effect of circular patterns with uneven edges created when fresh paint creeps into a painted area that is not completely dry.

Cold-press paper Watercolor paper with a moderately rough finish; absorbs water readily.

Complementary colors Colors that are across from each other on the color wheel; red and green, yellow and purple, and blue and orange are complementary colors (also referred to as "complements").

Crepe rubber cement pickup An artist's tool, made of crude rubber (crepe), that can be used to remove masking fluid or graphite from the surface of art paper.

Double-elephant paper Oversize watercolor paper; dimensions: 29½ × 41.

Dry cleaning pad Small pillow-shaped pad for removing erasures and graphite from art paper.

Ferrule The metal part of the brush between the handle and the hairs.

Flat Brush with flat, square tip used for laying down washes.

Full sheet (of watercolor paper) Standard size of paper, measuring 22 × 30; may be bought by the individual sheet or by the pack.

Giclee print High-quality, extremely high resolution (1,800 dpi) print produced with an Iris inkjet printer.

Glaze A layer of watercolor paint; sometimes used to mean a thin, smooth, shiny coating produced by adding a layer of transparent watercolor to an already-painted area.

Half sheet (of watercolor paper) Half of a standard-size full sheet; measures 15 × 22.

Hot-press paper Watercolor paper with smooth surface; absorbs water less readily than cold-press paper.

Lifting (of color) Removal of some or most of the color of a painted area to lighten the area or correct a mistake.

Lost edge A border between different areas of a painting that is not well defined because the areas are of the same or very similar value.

Masking fluid Latex fluid that dries quickly to form a protective coating to keep watercolor paint out of a specific area of a painting.

Negative painting Painting darker colors around lighter ones to help define shapes.

Neutral color A color that, temperature-wise, is neither warm nor cool.

Opaque color A watercolor color that contains enough pigment to obscure other colors when it is laid down on top of them.

Overglaze A thin layer of color laid down over another color to enhance its strength or effect.

Palette A flat, welled container used for storing and mixing watercolor paint; also refers to a particular selection of colors.

Perspective The visual perception of objects or lines receding into space as they grow more distant.

Plein air A French term (meaning "open air") referring to painting done out of doors to capture the natural effects of light and atmosphere.

Primary color One of the three colors (red, blue, and yellow) from which all other colors are created.

Quarter sheet One-fourth of a standard-size full sheet; measures 11 × 15.

Reducing glass A small lens that functions as the opposite of a magnifying glass, reducing the size of objects seen through it; used by watercolorists to evaluate the success of a painting's composition

Rigger Narrow brush with long hairs, used for line work; also known as a liner.

Rough paper Watercolor paper with very rough surface (significantly rougher than cold-press); absorbs water very readily.

Round Pointed brush whose hairs gently curve from the ferrule to the tip. Rounds are used for many purposes in watercolor painting; smaller rounds are often used for detail work.

Scrubber Brush with oval-shaped tip and stiff white bristles, used for lifting paint.

Secondary color One of the colors (green, orange, and purple) created by mixing two primary colors together.

Stainer A color that tends to dye a color it covers and that is difficult to scrub out if it is applied in the wrong place or in the wrong density.

Taboret A small table or cart, often containing drawers and often wheeled, used to hold art supplies.

Temperature (of color) The perceived warmth or coolness of a color.

Tertiary color A color containing all three primary colors

Thumbnail sketch Small sketch done quickly to establish a basic composition.

Transfer paper Paper, resembling carbon paper, that enables an artist to precisely transfer a drawing onto art paper.

Transparent color Watercolor color that is transparent enough to allow colors beneath (or the white of the paper) to show through.

Tube color A full-strength watercolor color as it appears when removed from the tube, with only enough water added to enable the brush to hold it.

Underglaze A thin glaze, or wash, laid down on white paper and serving as a foundation for other colors that will be added on top of it.

Value The relative lightness or darkness of a color.

Value study A preliminary drawing in which the relative values of the different areas of a composition are shaded in.

Veiling Painting technique in which a white area is surrounded by a color and then painted through with another coat of the same color.

Wash Basic watercolor technique in which a thin layer of paint is laid down with a smooth horizontal stroke of the brush; washes may be solid or graded.

Wash brush Large flat brush used for applying washes.

Wet on dry Watercolor technique in which wet paint is applied to an already-painted area that has been allowed to dry completely.

Wet on wet Watercolor technique in which paint is applied to an area wetted with water or an already-painted area that is still wet; also called "wet into wet."

Weight (of paper) A way of classifying paper according to the weight (expressed in pounds) of a ream of paper when sheets are cut to a certain dimension; fine-quality watercolor papers come in weights of 140 pounds, 300 pounds, and 400 pounds.

CONTRIBUTING ARTISTS

Kay Alexander, of Dandridge, Tennessee, is a former nurse and military wife who decided to become a watercolorist. She loves the transparency and fluidity of watercolor and is thrilled when others enjoy her paintings.

Steve Anderson, of Knoxville, Tennessee, is an employee of Oak Ridge National Laboratory. At age 53, he decided to fine-tune his talents, and watercolor has opened many creative doors for him. His work has been accepted into two watercolor shows.

Ginger Baxter, of Knoxville, is a former gymnast who now serves on the boards of a number of philanthropic organizations. She and her husband, Bill, love to travel.

Jossie Beck, of Temecula, California, studied with Mary for fifteen years. She has shown (and sold) her work in California; her last six paintings were bought by an automobile dealership.

Jane Benson, of Knoxville, started her art career about ten years ago, taking classes with Mary in California and Tennessee. She now has a gallery in her garage. When not painting, she works as the office manager of an auto parts store.

Joan Clark, of Dana Point, California, is a signature member of the National Watercolor Society. After taking classes with Mary, she continued her study in France. Her work reflects that European experience, as well as the scenes she sees at Dana Point Harbor.

Rebecca Crossland, of Knoxville, who works as the principal broker for an international conglomerate, believes that God wants her to rescue and take care of His creatures. Animals, including her pets, often appear in her paintings.

Betty Crowe, of Knoxville, is a recently retired music teacher with a lifelong interest in art. She has produced many paintings during four years of study with Mary, and she, her husband, and her family all feel that her progress can be seen daily.

Lisa Curry, of Leucadia, California, is president of Standard Process; her watercolor paintings and prints decorate her office in Oceanside. A member of several watercolor societies, she has sold many paintings at art shows in southern California.

Carol Cuyjet, of Voorhees, New Jersey, is an adjunct associate professor of art at Gloucester County College in Sewell, New Jersey. She has illustrated a series of children's books.

Ruth DeBusk, of Knoxville, is a realtor with Coldwell Banker. A former oil painter, she has studied watercolor with Mary since 2004 and has already done a number of commissioned watercolor pieces in addition to showing at local art shows.

Charlotte Dorsey, of Knoxville, is a retired school administrator. She began studying watercolor with Mary in 2005 and later started painting in oils, as well. Now, she switches back and forth between the two mediums.

Mike Dowell, of Vista, California, is a retired Air Force fighter pilot who took up watercolor after deciding that golf did not present him with sufficient challenge. He is also a successful carver of duck decoys.

Doris L. "Dee Dee" Dunn, of Norris, Tennessee, began taking watercolor classes with Mary two years ago. A transplanted New Yorker, she enjoys Southern living; the scenery around her home near Norris Dam provides lots of inspiration for her paintings, though she has recently begun doing portraits, as well.

Christine Harness, of Knoxville, is a retired middle-school art teacher. She studied at the University of Tennessee and has been a juror of art shows. She is the show director for "Scholastic Art" and serves on the board of the Fountain City Art Center.

Mary Holley, of Knoxville, is a retired massage therapist. She studied watercolor with Mary at the Arrowmont School in Gatlinburg and now spends time each day working on her art. She has done a few commissioned pieces and has sold her work at shows.

Mary Johnson, of Point Loma, California, is a puppet maker. Puppets created in her Puppet Safari shop are used in schools and libraries across the country—and now her puppets also appear in her watercolor paintings. A forthcoming children's book will feature characters that she created in watercolor.

Marguerite McCampbell, of Knoxville, is a world traveler and the "retired mother" of eight children. She has studied watercolor off and on for twenty years but feels she has made great progress since joining Mary's class in 2004. Her work has appeared in several local shows.

Mary Lynn Miller, of Knoxville, is a retired educator exploring a new career as an author and illustrator of children's books. Having studied with Mary for two years, she aspires to become a watercolorist whose work combines nature, art, and life experience.

Linda Moreland, of Knoxville, works as a physical therapist at a nursing home—and has turned to watercolor for her own therapy. She is represented by a local gallery and regularly sells her work.

Angelia Moon, of Knoxville, works as a regional consultant for Big Brothers Big Sisters of America. She had never picked up a brush before attending a Wonderful World of Watercolor class. Now, three years later, she is entering shows and selling her work.

Gail Myers, of Elizabethton, Tennessee, is a statistician for the University of Tennessee. She studied with Mary for three years and has had her work accepted into two local art shows.

Jean Newman, of Escondido, California, was a student in Mary's first watercolor classes, in California in 1985. She is now board chairman of Country Friends, a philanthropic organization in Rancho Santa Fe, California, but continues to work on her art.

Doris Prichard, of Knoxville, is a retired University of Tennessee librarian who, as an artist, has realized her goal of producing work that would sell commercially. She has won first place in a juried art show.

JoAnn Seipel-Finchum, of Knoxville, was one of the first students to join Mary's classes in Tennessee in 2004. She is now selling her work. She and her husband, Rick, volunteer for East Tennessee Children's Hospital.

Joan Ward, of Knoxville, started drawing when she was eight years old and has never stopped. She is now treasurer of a local art center. A print of one of her paintings hangs in the newly renovated town hall in Bell Buckle, Tennessee.

Lois Wiser, of Knoxville, has painted in acrylics for a number of years and has also made crafts and sold them at local shows. Taking a Wonderful World of Watercolor class opened her eyes to a new way of earning money through her art. She has done several commissions, and one of her paintings is in the permanent collection of a local art center.

Melinda Wysocki, of Oceanside, California, began her watercolor career in 1990. She later became a radiologist and now works in a local hospital, though she continues to pursue her art.

SUGGESTED READING AND RESOURCES

Books

D'Aleo, Angela. *The Purpose of Painting*. New York: Watson-Guptill, 1989.

Dobie, Jeanne. *Making Color Sing,* New ed. New York: Watson-Guptill, 2000.

Gould, Jean. *Winslow Homer: A Portrait*. New York: Dodd-Mead, 1989.

Henri, Robert. *The Art Spirit,* New ed. New York: Basic Books, 2007.

Kunz, Jan. *Painting Watercolor Portraits That Glow*. Cincinnati: North Light, 1998.

Metzger, Phil. *The Art of Perspective: The Ultimate Guide for Artists in Every Medium*. Cincinnati: North Light, 2007.

Metzger, Phil. *Watercolor Basics: Perspective Secrets*. Cincinnati: North Light, 1999.

Meyer, Susan E. *40 Watercolorists and How They Work*. New York: Watson-Guptill, 1978.

Wilcox, Michael. *Blue and Yellow Don't Make Green,* Updated ed. Cincinnati: F&W Publications, 2002.

Wolf, Rachel Rubin, ed. "Splash" series. Volumes in the "Splash" series of watercolor books have been issued by F&W Publications since 1991. As of this writing, there are nine books in the series.

Periodicals

American Artist Watercolor. For information, visit www.myamericanartist.com.

The Artist's Magazine. For information, visit www.artistsmagazine.com.

Watercolor Artist (formerly *Watercolor Magic*). For information, visit www.watercolorartistmagazine.com.

Art Supplies, Mats, and Frames
Visit these vendors' websites for direct ordering or to order a catalog.
ASW Express: www.aswexpress.com

Blick Art Materials: www.dickblick.com

Cheap Joe's Art Stuff: www.cheapjoes.com

Daniel Smith: http://danielsmith.com

Graphik Dimensions, Ltd.: www.pictureframes.com

Jerry's Artarama: www.jerrysartarama.com

Watercolor Societies
Web addresses for the major national watercolor societies appear below; visit their sites for information on membership and competitions.
American Watercolor Society: www.americanwatercolorsociety.org

National Watercolor Society: www.nws-online.org

Transparent Watercolor Society of America: www.watercolors.org

INDEX

Artists, contributing, 142
Authenticity, certifying, 138–40

Baskets, painting, 108–9
Blue/green and brown chart, 28
Brass, painting, 101
Brown and blue/green chart, 28
Brown chart, 30
Brushes
 selecting, 37
 types of, 37, 38
 using, by type, 39

Career tips, 133–40
Cats, painting, 116–18
Certifying authenticity, 138–40
Chrome, painting, 102
Clouds, painting, 112
Color charts, 22–33
 about, 22–24
 brown, 30
 brown and blue/green, 28
 dark, with complements, 26, 32
 gray, with complements, 26
 green, 27
 off-white, 25
 purple, 29
 red, 33
 shadow, 31
Color(s)
 choosing, 9
 contrasting values, 65–66
 Directional Color Flow Chart, 20, 21
 mixing, 14–15. See also Color charts
 recommended palette, 10–11, 38
 setting up palette, 13
 temperature, 18–21, 66, 72, 75, 110,
 128
 understanding pigments, 16–17
Commissioned work, 136–37
Communicating. See Story, painting
Competitions, 133–35
Complexity, reducing, 55
Composition
 making it work, 61–63
 perspective and, 57–59
 from photographs/reference images, 56, 94
 reducing complexity of, 55
 thumbnail sketches of, 51–53, 86–87
 using computer for, 97–98
 using shapes in, 54, 68–69
Contrasting values, 65–66
Copyright, 94
Correcting work, 119

Crepe rubber cement pickup, 42, 44
Crystal, painting, 103–5

Dark charts, with complements, 26, 32
Directional Color Flow Chart, 20, 21
Drawing
 lighting and, 89–91
 from reference images, 94
 shapes, 85
 shortcuts for, 92–93
 thumbnail sketches, 51–53, 86–87
 "working" drawings, 88
 workshops for, 95
Dry cleaning pad, 44

Edges, controlling, 40
Enhancing paintings, 128–31

Foliage, painting, 114–15

Galleries, working with, 135–36, 137–38
Glazing, 76–81
Glossary, 141
Gold, painting, 102
Gray chart, with complements, 26
Green chart, 27

Holiday cards, 139

Lifting paint, 82–83
Light, learning about, 89–91
Lighting, in studio, 46

Masking fluid, 41–43
Metallic surfaces, painting, 99–102
Mistakes, correcting, 119
Mixing colors, 14–15. See also Color charts

Naming works, 137
Negative painting, 67

Off-white chart, 25
Opaque colors, 9, 19, 72–75

Palette
 recommended, 10–11, 38
 setting up, 13
Paper
 choosing, 35, 38
 stretching (and board for), 36, 38
 tracing and transfer, 44
Pencils and erasers, 38
Perspective, 57–59
Pewter, painting, 100

Photographs and reference images, 56, 94
Plein air painting and supplies, 48–49
Promotional materials, 137–38
Purple chart, 29

Red chart, 33
Reference images, 56, 94
Reflections
 in metallic objects, 99–102
 in water, 107
Resources, 143
Rocks, painting, 110–11

Scrubbers, 37, 112, 119
Shadow chart, 31
Shadows, using, 124–25
Shapes
 drawing, 85
 using in composition, 54, 68–69
Signing works, 137
Silver, painting, 99
Sketches. See Drawing
Sketch pad, 38
Spray bottle, 38
Statement, making, 126–27
Story, painting, 121–31
 communicating essence, 122–23
 enhancing paintings, 128–31
 making statement, 126–27
 speaking to viewers, 121
 using shadows, 124–25
Stretching paper (and board for), 36, 38
Studio, setting up, 45–47
Sunsets, painting, 113
Supplies, 35–44. See also specific supplies
 optional, 44
 plein air (on-location), 48–49
 suggested, 38

Temperature, color, 18–21, 66, 72, 75, 110, 128
Thumbnail sketches, 51–53, 86–87
Tracing and transfer paper, 44
Transparent colors, 9, 10–11, 16–17, 19, 21,
 72–75
Trees, painting, 114–15

Values, contrasting, 65–66
"Veiling" paint, 40

Water, painting, 106–7
Water container, 38
White space, using, 70–71
"Working" drawings, 88
Workshops, 95